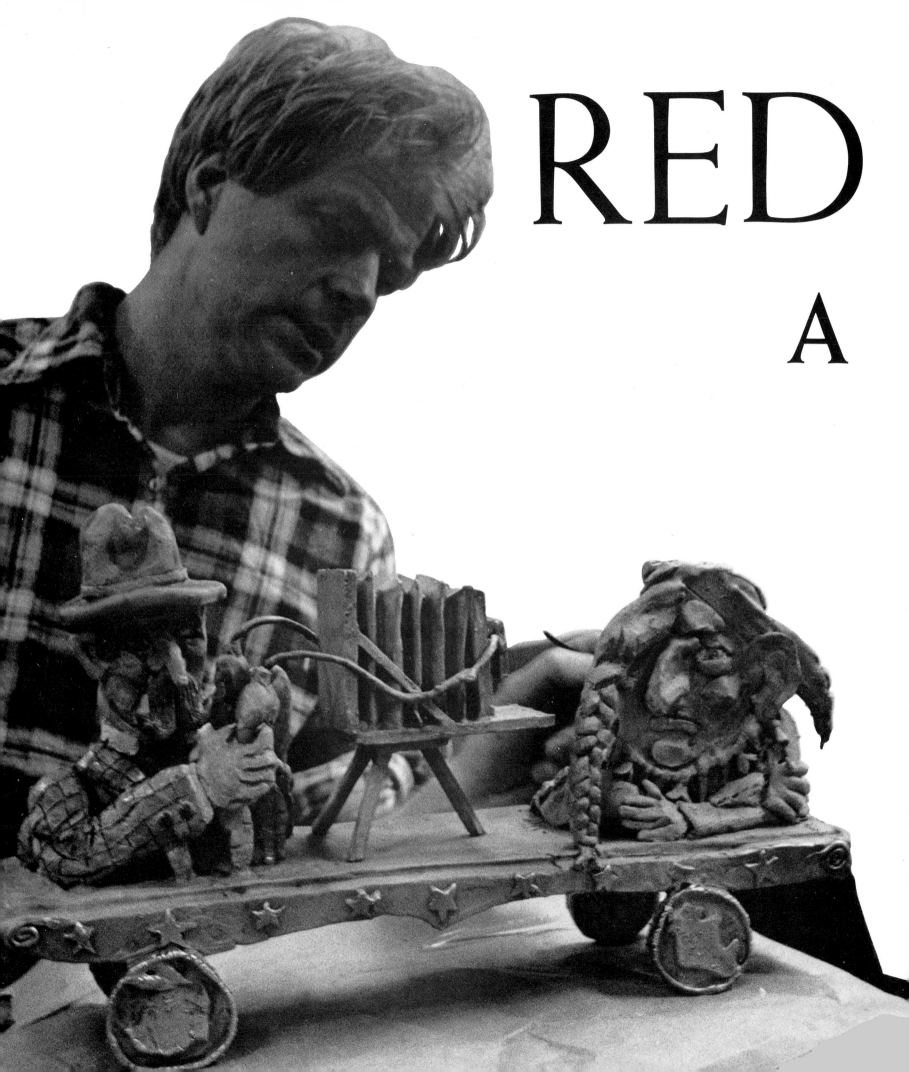

RED

A

GROOMS

Retrospective

1956-1984

Essays by

Judith E. Stein
John Ashbery
Janet K. Cutler

Pennsylvania Academy of the Fine Arts

The exhibition and publication of this catalogue have been partially and generously funded by a grant from the Atlantic Richfield Foundation.

Library of Congress Cataloging in Publication Data
Grooms, Red.
 Red Grooms, A Retrospective, 1956-1984.
 "Pennsylvania Academy of the Fine Arts, June 21-September 29, 1985; Denver Art Museum, November 2, 1985-January 5, 1986; Museum of Contemporary Art, Los Angeles, March 12-June 29, 1986; Tennessee State Museum, Nashville, August 17-October 26, 1986."
 Bibliography: p. 226
 1. Grooms, Red—Exhibitions. I. Ashbery, John.
II. Cutler, Janet K. III. Stein, Judith E.
IV. Pennsylvania Academy of the Fine Arts. V. Title.
N6537.G72A4 1985 700′.92′4 85-3698
ISBN: 0-943836-03-04

This book was produced in Italy.

Contents

Exhibition Itinerary

Pennsylvania Academy of the Fine Arts
Denver Art Museum
Museum of Contemporary Art, Los Angeles
Tennessee State Museum, Nashville

June 21–September 29, 1985
November 2, 1985–January 5, 1986
March 12–June 29, 1986
August 17–October 26, 1986

Foreword

One's initial attraction to Red Grooms's work, in all its many forms, is sensual; these vivid oils, raucous sculpto-pictoramas, cunning "stick-outs," and spectacular films gratify the senses. The modern, particularly urban energy that defines America's big cities runs all through Grooms's work, as does the artist's bald appreciation of the failings of big-city America. Grooms's oeuvre, in all its dimensions, *is* contemporary American life.

As such, it commands repeated consideration. It is the artist's wide embrace of life, rather than his humor, that sustains the viewer over time. Grooms loves life—its myths and realities, its complexities and contradictions, its past and present. And he respects life; he cares immensely about people. The whole, incredible mix of twentieth-century existence is processed through his highly original mind, and through his art Grooms returns to us all the love, the noise, the scents, the festivity, and the foibles of our time.

The Pennsylvania Academy of the Fine Arts is proud to have organized "Red Grooms: A Retrospective, 1956-1984," which was made possible through the generosity of the Atlantic Richfield Foundation. Thanks are also due to colleagues at the Denver Art Museum; the Museum of Contemporary Art, Los Angeles; and the Tennessee State Museum. To the authors—John Ashbery, Janet Cutler, and Judith Stein, the exhibition's organizer—we express our gratitude. We are indebted to the lenders. And, of course, we are immensely indebted to Red.

Frank H. Goodyear, Jr.
January 31, 1985

All Around The Cobbler's Bench with Red Grooms

Judith E. Stein

*All around the cobbler's bench
The monkey chased the weasel.
The monkey thought 'twas all in fun.
Pop! Goes the weasel.*

*Up and down the City Road,
In and out the Eagle.
Mix it up and make it nice.
Pop! Goes the weasel.*

There is a traditional element of monkey business in Western art. Not only do monkeys often represent the artist's imitative skills in aping nature, but they are also used to satirize the base, foolish, and vain side of human behavior. The monkey, with its dual implication of mimetic art and mordant commentary, could well serve as a symbol for the artist Red Grooms. For twenty-nine years, he has been using his representational talents to monkey around with the clichés of popular culture and the pieties of art history, and to subvert the received values of the art world.

Red Grooms belongs to a generation of artists who, in G.R. Swenson's words, "took the world too seriously not to be amused by it."[1] At times Grooms's humor has an absurdist streak, full of the impetuous energy and preposterous puns of the Marx Brothers. He shares a comic sense with Bob and Ray, whose straight-man/funny-man teamwork plays off against the mundane conventions of daily life. As an empiricist with a keen political sense and a retentive memory for visual facts, Grooms follows in the tradition of William Hogarth and Honoré Daumier, who were canny commentators on the human condition.

Because his art is often so enjoyable, Grooms has been likened to such affable, boyish fellows as Huck Finn and Peter Pan. But these superficial characterizations fail to account for what the artist himself has called his "double nature," or what his friend Rudy Burckhardt has termed his "fierce" side.[2] Anarchistic, brutal, or politically savvy, this other dimension takes many forms. In *Shoot the Moon*, 1962, celebrants are seen shredding library books to make confetti. In *Ruckus Manhattan*, 1975, a window in the Woolworth Building reveals an office clerk mauled by a grotesque pair of hands, and the World Trade Center towers rise high above the body of a fallen construction worker.

"Question Authority," a slogan of the sixties, is a sentiment embodied in *Patriot's Parade*, 1967 (pl. 134). Not only an antiwar statement but also a moving indictment of the persecution of demonstrators, it is one of the most powerful examples of the protest art of the Vietnam era, even though it is little known. Futilely proffering flowers, a young woman is trod underfoot by a soldier. A doll-like Miss Napalm and the lethal symbol of skull and crossbones visible inside President Johnson's ten-gallon hat allude to the devastations of war. *Nuclear Nuts*, 1983 (pl. 137), a pull toy that kinetically describes the alternative peace initiatives of the Americans and the Soviets, is a more recent sample of his targeted comedic insights.

At times Grooms's contrariness takes the form of a Rabelaisian raspberry. The energetic Mr. Ruckus, an alter ego derived in part from the Pasty Man of the early Happenings, is a rude and irrepressible spirit. In the film *Hippodrome Hardware*, 1972, he eats to excess, belly dances, and cleans his nose in public. Other characters, sharing his disdain for conventional niceties, are shown in the "john," with their trousers at their ankles, or rocking the bed with their conjugal exertions. A Dada personality, Mr. Ruckus has been described by April Kingsley as "an ugly mischievous clown somewhat akin to W.C. Fields in his aggressive deviltry and his pleasure in putting something over on the gullible."[3]

Beginning in the late 1970s, a wide variety of sexual themes surface in Grooms's work. In the print series *Nineteenth Century Artists*, 1976, Rodin cavorts in drag before his marble *The Kiss* (pl. 80), while Cézanne lasciviously fondles his still life (pl. 79). The progenitor of modern art comes in for scrutiny again in *Tie Cez*, 1977 (pl. 78), where he is shown bound and gagged, encircled by a bevy of his bathers. *Night Raid on Nijo Castle*, 1983-84, contains a

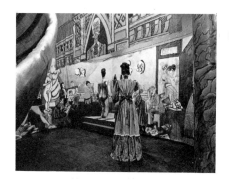

Fig 1. Detail, *Philadelphia Cornucopia*, 1982.

vignette describing the libidinous pursuits of its inhabitants, who are endowed with organs of mythic proportions in the fashion of Japanese erotic prints.

<p style="text-align:center">* *</p>

As early as 1963, Grooms's broad talent in such diverse genres as painting, sculpture, printmaking, and movies prompted critic Sidney Tillim to label him affectionately "the leading contender for the decathlon prize of the New York School Olympics."[4] Not only did Grooms early demonstrate his virtuoso mastery of a multitude of media, but he soon invented new categories of his own:

> I started making "stick-outs" early in 1963 after spending a year making movie sets. We talked a lot about "3-D-ing." This, and an earlier experience of working frantically in thick muddy paint, losing the whole thing and using cardboard glued in quickly to regain a clearer image, plus an inexhaustible amount of wood and cardboard supplied by N.Y.C. wastebaskets led me to "stick-outs."[5]

Hovering at the boundary between painting and sculpture, the "stick-outs" often depicted characters and events from the turn-of-the-century Parisian art world (pls. 75, 76, 77).

Many of these new works had found objects incorporated into them: ". . . in Florence I never 'found' anything in the streets I could use, so I was concentrating on painting. When I got back [to N.Y.C.] I made [*A Light, Madam*, 1962 (pl. 110)] out of a pickle barrel cover I found."[6] An ingenious improviser, Grooms can utilize almost anything for his artful purposes—the hidden framework inside the sitter's outsize feet in the portrait of *Alex Katz*, 1963 (pl. 37) consists of empty boxes from Nashville's favorite sweet—Goo Goo clusters.

Today Grooms is recognized as a pioneer of site-specific sculpture and installation art. The first of his walk-through, room-sized environments, which he termed "sculpto-pictoramas, "created with his wife, Mimi Gross, was the *City of Chicago*, 1967 (pl. 54). Larger-than-life-size sculptures of Mayor Daley and Hugh Hefner were joined by such historical figures as Abraham Lincoln,

Al Capone, and fan-dancer Sally Rand, accompanied by a sound track featuring gunfire and burlesque music. Grooms's genius for rendering the intricacies of architectural ornament is vividly apparent in several three-dimensional vistas of Chicago's famous buildings. Evident here and in the numerous other cityscapes Grooms has created is his extraordinary ability to capture a sense of place with a great sensitivity to detail.

Ruckus Manhattan, the enormous, traversable "sculpto-pictorama" of New York City that Grooms created with a team of assistants in 1975, is likely his best-known and most ambitious construction. Made of fiberglass, wood, metal, fabric, and Celastic (a plastic cloth that becomes malleable when dipped in acetone), *Ruckus* pulsed with the authentic beat of the city. Other examples of his large-scale environments include: *Discount Store*, 1970-71, an interpretation of a midwestern chain store; *The Astronauts on the Moon*, 1972, inspired by the launching of Apollo 15; and *Ruckus Rodeo*, 1976, which presents Red's version of a full-fledged western rodeo, with bucking broncos and high-riding cowgirls. Unfortunately, public access to these projects is limited, since some are often in storage and others are in private collections.

One exception is *Philadelphia Cornucopia*, 1982, commissioned by Philadelphia's Institute of Contemporary Art to mark the Tricentennial of the city's founding. Purchased by civic-minded patrons, it is now on view in a National Park Service building. Here a ten-foot General Washington greets visitors from the helm of a Ship of State *cum* carnival float. One wanders past a colonial courtroom and spies the liberation of Marcel Duchamp's famous modernist nude, sashaying down the front steps of the Philadelphia Museum of Art. Nearby, the ornate Victorian facade of the Pennsylvania Academy of the Fine Arts, complete with a portrait of its architect, Frank Furness, looms above Thomas Eakins's daring life class (fig. 1).

From the days of his earliest Happenings to the most recent installations, Grooms has periodically worked with assistants, retaining his role as director/producer. Collaboration has always been a form of collage to him. In a 1981 interview with *New York Times* critic Grace Glueck, Grooms described his current working method:

As we go along, we do lots of improving. . . . We talk over ideas. Tim [Watkins] or Rolla [Herman] may have an input. The pieces do change; I'm that much into chance. When something gets miscommunicated, at least half the time it comes out better. . . . One reason we can improvise, we're so close to Canal Street we can get anything we want in five minutes. We put some 75 percent of our effort into the idea; 10 percent into esthetic problems, and 15 percent into visiting the hardware store.[7]

Those inspirational hardware store visits are only a slight variation on the serendipitous street finds of earlier years.

"I try to create a . . . proletarian style," Grooms told interviewer Paul Cummings in 1974. "I think in a way you try to create a style or an image that is supposed to work with what you're interested in."[8] Downplaying the obvious uniqueness of his expression, Grooms enjoyed stressing his commonality with popular culture. "My style, especially my broadest comic-strip style, which is the *Discount Store* style more than any other, is public knowledge anyway. Everybody knows about it."[9] While working with Mimi Gross on some of the large environmental pieces of the 1970s, a shared style passed easily back and forth between the two artists: "[Mimi's] a wonderful painter and really I've conceived my stuff in a lot of ways in the way she paints. I've picked up a style from her in a way, especially when I work with her."[10]

Red's characteristic mode, with elements of cartoonlike renditions, willful distortion, and exaggerated perspectives, is the expression of a master draftsman. In attempting to define Grooms's special graphic style, which he regarded as "part caricature, part affectionate humor," Hilton Kramer noted in 1975: "It is a little like reading a brisk and accurate translation of a witty French poem into an American vernacular style. We experience a double pleasure."[11] Addressing a related issue, John Russell praised the artist in 1981 for "a mimetic ability that can give us both the thing seen and the commercialized view of it in one and the same image."[12]

One of the hallmarks of Grooms's career is his ability to allow each new medium to refresh and regenerate his subject matter. Every material elicits a distinct stylistic han-

dling, which may change as the artist changes. The early ink and bamboo stick drawings have a German Expressionist intensity (pl. 5), while later examples resemble van Gogh in their linear complexity (pl. 104). His frequent travel sketches were done in felt-tip pens until he discovered how fleeting their color could be. Traditionally Grooms reserved gouache for made-up imagery and used watercolor to depict things observed. After his 1977 trip to France, he turned more and more to watercolors. In Brittany during the summer of 1980, Red worked on a small scale and took his cues from the soft color harmonies of the atmosphere. He began to limit his palette to just a few tonalities—light red, gray-blue, muted greens, and pale yellow, exerting great control over their impact.

The purchase of a hot-glue gun in 1973 initiated several masterpieces of paper sculpture; for example, *Sam* (pl. 43), a portrait of Sam Reily, who appeared in *Fat Feet*; and *Gretchen's Fruit* (pl. 107), a tour-de-force still life. Grooms was introduced to the more enduring medium of bronze in 1979 when he spent a week teaching at the University of New Mexico, in Albuquerque, at the invitation of his friend Paul Suttman. Regarding the several western and football themes which he worked in the metal (pl. 122), Grooms has commented: "It looks just like my regular stuff, but it's for the ages. . . . It turns out to be easier to work with than less durable materials."[13] His outstanding skill at utilizing the lost-wax method of casting is seen at greatest advantage in the monumental *Lumberjack*, 1977-84 (pl. 154), cast from a whimsical woodsman Red made as a gift for artist Neil Welliver.

Grooms has been working as a printmaker since 1958. The poster for his 1977 Paris exhibition was printed at the Mourlot print shop in Paris where Henri Toulouse-Lautrec worked at the turn of the century. Red particularly delighted in his association with Mourlot because he vividly recalled the scene in the film *Moulin Rouge* in which Lautrec, after carousing all night, enters the shop in the morning and commences to work.

Grooms's commitment to the populist aspects of printmaking has been influenced by the work of José Posada, the politically active, late-nineteenth-century Mexican

printmaker. Cognizant of the potential for commercial exploitation of prints, a medium of multiples, Grooms has used this awareness itself as an inspiration for one of his prints. According to master printer Steven Andersen, founder of Vermillion Editions, Minneapolis: "Red chose [Salvador] Dali as the subject of his print because Dali has been a supreme exploiter of the print medium, turning out so-called limited editions that number in the thousands."[14] *Dali Salad*, 1980-81 (pl. 89), is printed on vinyl and paper and combines such different techniques as silkscreen and lithography, as well as handpainting and cutting.

Andersen's account of the origin of another Grooms print, *Lorna Doone*, 1979-80 (pl. 155), is worth recounting in full:

Once when Red was here, he needed to send a card to some friends back in New York, so he left the studio for a few minutes to drop into a card shop he'd seen down the street. Well, a few minutes later he came running back in, shouting, "Quick, where's something I can draw on?" There were some lithographic stones laid out on the counter, and he began to draw right onto one of them a caricature of this new-wave girl who was the clerk at the card shop. She had purple hair and sunglasses, and he put her in this leopard-skin outfit. Then behind her he added some silos and put the reflection of a truck in her sunglasses. She was supposed to be the Minneapolis version of "Christina's World". . . . He couldn't think of a name for her, though, so he went back to the card shop and asked what her name was. It was Lorna Doone. That name absolutely made Red's day—his week."[15]

Grooms has always been attuned to the dress and behavior of real people as well as to the overlay of art history that influences the nature of his perceptions. In *Lorna Doone*, an actual person inspired an art-historically allusive image.

Grooms often uses art to comment on its own history. In *Notre Dame de Badminton*, 1980 (pl. 96), we see vivid indications of the Romanesque madonnas that clearly inspired the piece. Dignified and majestic, Grooms's Virgin sits resplendent on a margarine box throne. Haloed by a badminton racquet, her wine cork nose and hair curler locks are crafty features of her stylized face. In the Child's hand rests a shuttlecock or birdie, a consummate visual pun on the bird that is a traditional symbol of the winged soul.

To survey the many self-portraits by Grooms in the course of his career is to be permitted backstage to watch as the artist "grooms" himself before a mirror. Unsparing in his observations, Red allows us glimpses of his early Expressionist *Weltschmerz* in plate 3, his multiplicity in flat Alex Katzian planes in plate 162, and his recognition of the irony of being alone in the presence of another in plate 170. The artist is fond of insinuating himself in other contexts as well: he is the redheaded taxi driver in *City of Chicago*, 1967, and he plays the awe-struck counterman waiting on Edward Hopper in *Nighthawks Revisited*, 1980 (pl. 98).

A recurring theme in Grooms's work is the group portrait of family and friends. *Loft on Twenty-sixth Street*, 1965, one of the best-known works in the Hirshhorn Museum, is a small-scale sculptural re-creation of the artist's living space, peopled with an extraordinary cast of simpatico souls. Here Grooms depicts himself slicing potatoes, and in the related *Maine Room*, 1965 (pl. 40), he is immersed in a card game. A shared summer rental forms the backdrop for *Slab City Rendezvous*, 1964 (pl. 39). As Red walks away from us and into the house, we survey Edwin Denby, Mimi Gross, Alex Katz and his son Vincent, Yvonne Jacquette with the infant Tom Burkhardt, and her husband, Rudy, placidly painting on the roof.

The large wall relief, *William Penn Shaking Hands with the Indians*, 1967 (pl. 97), is a re-creation of Benjamin West's famous painting (in the collection of the Pennsylvania Academy of the Fine Arts) of the founding of Pennsylvania. It was intended as an homage to West, the principal American painter who revolutionized the Grand Style of history painting by depicting contemporary events with truthful portraits and modern dress. In notes he wrote as a catalogue accompaniment, Grooms commented:

To tell the truth I did [the work] more because of Mr. Benjamin West than Mr. Penn. Benjamin West is a hero for American Art. . . . As I understand he set up the whole tableau for "The Treaty" on his estate using actors from a

touring Shakespeare company. Then he had an easel installed in the basket of a hot air balloon tethered at 60 feet, and with the help of sandwiches and birch beer hauled up to him by his wife, painted this great masterpiece in six days. To me, this is exemplary American behavior.[16]

Part history painter, part genre painter, part painter of modern life, Grooms himself may well be the most American of our contemporary artists.

"I like to make sort of documentaries. Something you can see as it happens—what people wear and do," Grooms told a reviewer from *Time* magazine in 1965.[17] This flair for journalistic reportage surfaces in various works. *Harry Watley's Mad Dash up Walker Street*, 1975 (pl. 60), documents the escape, directly in front of Grooms's doorway, of a prisoner-trustee who was sent to buy coffee and decided to make a run for it. The homey details of daily life hold equal attraction for Grooms, as in the intimate scene of Mimi taking a snooze with the cat (pl. 30), or a view of Mimi feeding their infant daughter, Saskia (pl. 31).

<p style="text-align:center">* *</p>

In the past twenty-nine years many critics have sought to clarify the relationship of Red Grooms to the art of his times. Commenting on his work in the context of the 1960s, Grooms himself has joked: "I wanted to be a contrast to the heavy esthetic side of art. There [was] so much formalism in art that I felt like LeRoy Neiman or something."[18] In 1969, Peter Schjeldahl noted similarities between Grooms and Marcel Duchamp, because both embodied "a movement of one man that is open to everybody."[19] A year later John Canaday remarked that Grooms "belongs to no school and no clique. There is no one quite like him."[20] More recently Grooms has been likened to Sam Maverick, the nineteenth-century Texas pioneer, who in choosing not to brand his cattle so upset the established order that his name has come to signify an independent or a loner.[21]

Never a part of the Pop art phenomenon, Grooms has been excluded from the full honors the art world showers on its heroes. Until relatively recently, few of his major works were in public collections. Carter Ratcliff early analyzed the complex issue of Grooms's critical reception: ". . . the critics who don't find a place for him in their systems are so far from doing so that they don't mention him at all, hence the constant raves from those who don't rely on systems."[22] Writing at the time of the debut of *Ruckus Manhattan*, Paul Richard noted, in appreciation: "His art is too excessive to be entirely in fashion—it's too torrential, too extravagant. He's not a minimalist, he's a maximalist."[23]

In 1973 Rutgers University Art Gallery organized a small retrospective exhibition that included several paintings, sculptures, paper movies, and three large-scale environmental pieces. Writing for the *New York Times* about the show, which was seen in New York at Huntington Hartford's ill-fated New York Cultural Center, John Canaday testily noted:

> This is an exhibition that would have been held at the Museum of Modern Art or the Whitney—not to mention the Metropolitan—if the curators at any of those institutions had the first idea of what art is all about—instead of a lot of exquisitely developed secondary ideas."[24]

A decade ago, some curators shied away from supporting Grooms, who created a ruckus by not fitting within a convenient historical niche. In fact, Grooms consciously works against the art world's orderly groupings: "I've always felt that it's good to have the art context because it gives you something to go against."[25]

Grooms's cunning style of monkeyshines not only entertains but also holds up a mirror for an introspective glance. Although his work rouses an immediate reaction of laughter, the punch behind the humor often requires a double take. In 1966 poet Ted Berrigan alluded to the rewards of a second reading of Grooms's art: "It's friendly and it's colorful, and it's informal and shrewd, and a little show-offy, but when you stand back from it, you begin to think about just where this guy might be at. And it counts a lot on your doing it, too."[26]

Notes

1. Swenson's comment, made in the context of a 1961 *Art News* review of the work of Robert Indiana, Stephen Durkee, and Richard Smith, is quoted in Lucy R. Lippard, *Pop Art* (New York: Praeger, 1966), p. 75.

2. Grace Glueck, "Odd Man Out: Red Grooms, the Ruckus Kid," *Art News*, 72 (December 1973), p. 25.

3. April Kingsley, "New York Letter," *Art International*, 18 (March 20, 1974), p. 51.

4. Sidney Tillim, "In the Galleries: Red Grooms," *Arts Magazine*, 38 (December 1963), p. 64.

5. Quoted in Edward Bryant and Daniel Robbins, "New Talent: Old Problems," *Art in America*, 52 (August 1964), p. 108.

6. Quoted in *The Early Sixties: Red Grooms and Peter Saul*, exhibition catalogue (New York: Allan Frumkin Gallery, 1983), unpaged.

7. Quoted in Grace Glueck, "Red Grooms Reshapes His Loony World," *New York Times*, March 29, 1981, sec. 2, p. 20.

8. From the transcript of an interview conducted for the Archives of American Art, Smithsonian Institution, by Paul Cummings, March 4, 1974, p. 130.

9. *Ibid.*, p. 98.

10. *Ibid.*, p. 106.

11. Hilton Kramer, "Red Grooms," *New York Times*, March 29, 1975, p. 11.

12. John Russell, "Ellsworth Kelly and Red Grooms Shows," *New York Times*, April 17, 1981, p. C 18.

13. Quoted in Grace Glueck, "Red Grooms Reshapes His Loony World," p. 20.

14. Camille Howell, "Troubled Times for a Premier Printmaker," *Picture* magazine, *Minneapolis Tribune*, April 1, 1984, p. 18.

15. *Ibid.*, p. 19.

16. *Symbols of Peace: William Penn's Treaty with the Indians*, exhibition catalogue (Philadelphia, PA: Pennsylvania Academy of the Fine Arts, 1976), unpaged.

17. "Grand Pop Moses," *Time*, April 9, 1965, p. 76.

18. Quoted in Todd Strasser, "Interview: Red Grooms," *Ocular*, 4 (Winter 1979), p. 54.

19. Peter Schjeldahl, "Red Grooms: He Dares to Make Art That Is Fun," *New York Times*, June 15, 1969, sec. 2, p. 25.

20. John Canaday, "Happy Thing in Art; 'Discount Store,'" *New York Times*, February 4, 1971, p. 28.

21. Michael Leja, "Mavericks," in *Aspects of the 70's—Mavericks*, exhibition catalogue (Waltham, MA: Rose Art Museum, Brandeis University, 1980), p. 2.

22. Carter Ratcliff, "New York Letter," *Art International*, 16 (February 20, 1972), p. 32.

23. Paul Richard, "Red's Big Apple: Mad Hatter's Manhattan," *Washington Post*, November 19, 1975, p. G 1.

24. John Canaday, "Ruckus on Columbus Circle," *New York Times*, December 16, 1973, sec. 2, p. D 25.

25. Cummings interview, p. 110.

26. Ted Berrigan, "Red Power," *Art News*, 65 (December 1966), p. 46.

Red's Hero Sandwich

John Ashbery

In 1957 the twenty-year-old Red Grooms emigrated from his native Nashville to New York and almost immediately met three people who would play an enormous role in shaping his life and his career. One was Mimi Gross, daughter of the sculptor Chaim Gross, who would become Grooms's wife and collaborator on a number of art projects, culminating in 1976 in the epic *Ruckus Manhattan* (after which the couple separated). The others were the fifty-four-year-old critic and poet Edwin Denby and his close friend Rudy Burckhardt, a Swiss-born photographer, filmmaker, painter, and occasional writer.

The fact that the latter two men shared at least six artistic hats among them undoubtedly helped determine Grooms to take on as many forms of expression as possible: painting, sculpture, theatrical Happenings, film, and the unique environmental creations of which *Ruckus Manhattan* is the largest and most famous example and which seem to be Grooms's own invention, though one could cite precedents (Kurt Schwitters's *Merzbild* constructions and Antonio Gaudi's *Parque Güell* come to mind, and there are successors too, such as the fantastic "rational" architecture of Siah Armajani and the miniature reconstructions of fictive ancient cities by Anne and Patrick Poirier). Another significant happenstance was the fact that Denby, Burckhardt, and some of their artist friends lived in New York's Chelsea district, then a rather obscure and rundown, half-commercial, half-residential section of Manhattan just to the north of Greenwich Village, now largely gentrified but hardly prettified. Grooms took a loft there too; it was conveniently close to his job at Times Square's Roxy Theater, where he briefly worked as an usher. Besides, Chelsea was and is "funky," though the word may not have had its present-day resonances when Grooms first arrived. With its 'traffic and clutter, its mix of races, its quaint rowhouses squeezed between industrial buildings, it was a kind of sampler of New York City life at its most jarring and weirdly colorful. Certainly it nourished the work of Denby (who from 1934 to his death in 1983 occupied the same loft on Twenty-first Street, long before lofts were regarded as living spaces) and Burckhardt; they and others (including Virgil Thomson, who still resides at the Chelsea Hotel) were known to their friends as the "deep-Chelsea set." It was only a step from the confusion of Chelsea's streets to Happenings, like those Grooms would shortly begin to stage in his own gallery, the Delancey Street Museum.

Still another important quality of the Denby/Burckhardt influence was the penchant of both men for remaining determinedly "underground," while participating in and eagerly absorbing the vital cultural contributions of other New Yorkers often younger and better known than they. Burckhardt's short sixteen-millimeter films are screened at local film societies and the St. Mark's-in-the-Bowery Poetry project; he has consistently eschewed the urge, if he ever had one, to do something larger in this medium. Similarly, though he is a remarkable painter whose renditions of New York's dour commercial vistas are unlike anyone else's, they remain known to only a few fans, though they would undoubtedly attract a much larger public if Burckhardt cared to promote them even a little. And Denby, after a brief stint as ballet critic at the *New York Herald Tribune* in the 1940s, retired to the peace of his loft, from which he would very occasionally issue a slim pamphlet of poems, sometimes illustrated with Burckhardt's photographs, or an even less frequent collection of essays on dance, the latter widely regarded as the most influential writings on the subject by a contemporary American. He can be spotted playing zany Caligari-esque roles in some

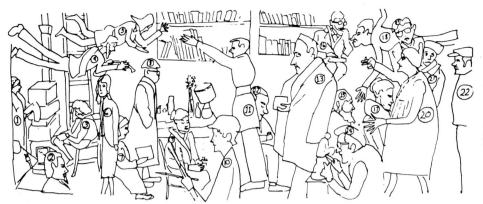

Fig 1. Key to Via Guelfa, 1961.

1. Geraldine Brussel, *American painter*; 2. Roberto Parini, *Italian painter*; 3. Mimi Gross Grooms, *American painter*; 4. Peter Stanley, *English musician*; 5. Katherine Kean, *American explorer*; 6. Gwin Suttman, *American painter*; 7. Antonia Ratensky, *American poet*; 8. Cabbel Brussel, *American sculptor*; 9. Mrs. Chaim Gross, *wife of American sculptor*; 10. Red Grooms, *American painter*; 11. Leonard Fligel, *Canadian painter*; 12. Raffaelo Majoni, *Italian musician*; 13. Zarko Levak, *Yugoslavian anthropologist*; 14. Teofrasto Russo, *Italian sculptor*; 15. Paul Suttman, *American sculptor*; 16. Kent Holloway, *American painter*; 17. Gaila Yarin, *English sculptress*; 18. Mordecai Moreh, *Israeli painter*; 19. Antonio Raffo, *Italian translator and writer*; 20. Diane Holloway, *American painter*; 21. Tomasso Musakio, *Italian philosopher*; 22. Giovanni Montefiore, *Italian painter*.

of Burckhardt's films, and once appeared in a theater piece by Robert Wilson, whose genius, like that of Grooms, Denby was one of the first to recognize.

Thus, almost from his arrival in New York, Grooms was presented with a number of intriguing alternatives to the popular image of the young avant-garde artist as Horatio Alger hero, to "making it" in the blockbusting sense that this city commonly understands it. Chelsea was an "off" place to live for an artist then, and it suited Grooms's temperament fine. Spreading oneself thick in a number of media was a somewhat unorthodox way of proceeding; so was staying in close touch with the most exciting currents of the moment and letting them influence you while determined to work in ways that wouldn't really fit in with what was going on.

And what, in fact, was? Another major element in the work Grooms would produce was the timing of his arrival on the scene, though he couldn't have known how fortuitous it was. Abstract Expressionism was still monolithic in 1959, big in the pages of *Art News* certainly, though cracks had begun showing up in the monolith. Its energy and solemnity couldn't be sustained forever; a reaction was bound to set in and it would take the form of soup cans and Happenings, garbage and graffiti, as shocking then as Abstract Expressionism had been to the art establishment of a decade earlier. (And today of course, Pop Art has itself been canonized, as in the Whitney Museum's recent show called "Blam," a twenty-fifth-anniversary celebration of the "Great Splat" of 1959.)

Yet Grooms had no difficulty avoiding being drawn into the cogs of this Manichean struggle between the forces of light (the "heroic" generation of Abstract Expressionists) and darkness (anybody who tried to challenge them). Or rather, he was active on both fronts, delightedly running with the hare and hunting with the hounds, taking whatever he found useful for the art he was only just beginning to elaborate. Sometimes he painted beautifully in an abstract expressionist mode (*Three Bathers* of 1959), though the results had an offhand, intimist air that was out of keeping with that style's heaven-storming aspirations. And looking at photographs documenting *The Burning Building*, one can see how vastly that performance must have dif-

fered from the Happenings of Allan Kaprow and other exponents of the medium, which must have seemed like fundamentalist homilies next to Grooms's airy festivity. I doubt that an audience today could sit through any but a very few of those exercises in programmed outrage: what kept people in their seats then was their absolute certainty that they were watching the very latest thing. Yet I would very much like to see *The Burning Building*. Its manic panic, horror and hilarity, gestural flames, heroic firemen; its shrieks, squawks, and clangs; and above all its hybrid mismatching of so many contemporary styles must have prefigured the euphoria that was to come in Grooms's art, no doubt proving once again that the artists who survive from any given period are those who smash and combine the existing norms, rather than set up headquarters in them. "My problem with Pop paintings at this time was the way the subject matter was used," Grooms said recently. "I liked Pop imagery, but I liked it to have a warmness to it. I didn't grasp giving it a sterile look. Pop was all about being cool, and I knew I didn't fit in with that."

As if to compound his renegade position, Grooms abruptly took off from the New York scene in 1960 to spend a year and a half in Italy, at a time when American art chauvinism was at an all-time high and younger European artists were themselves beginning to emigrate to New York. He wanted to look at Giotto, and he also found himself traveling with Mimi from town to town in a horse-drawn cart in which they staged puppet performances of their own design for the locals—hardly the sort of thing that would be viewed with favor by the Tenth Street art crowd. Again the result for his work was remarkable. The large *Via Guelfa Studio* (pl. 32) done in Florence in 1961 must have been one of the oddest pictures painted anywhere in that year. "Mimi and a friend, Katherine Kean, had a studio on Via Guelfa, and I stayed with them," he explains disarmingly. "They already had a whole crowd of friends around them. *Via Guelfa Studio* is different from what I had been doing just previously. When I got to Europe I got interested in 'going European,' that is, being more precise in my work."

A nice compliment for Europe, which should be considered along with another of Grooms's observations: "I'm al-

ways subdued in Europe"—a remark made after a stay in Paris, whose orderly grandeur he found difficult to come to terms with in painting. He has since changed his mind, however, after looking more closely at the fantasy behind the grandeur in such Paris attractions as the cemetery of Père Lachaise or a shop near St. Sulpice that specializes in antique lead soldiers. The city is unlikely to engender a Ruckus version of itself, however, since there Grooms finds "everything's done properly. What's the phrase? *Comme il faut.* So, I wouldn't want to take extreme liberties. I want to be factual, with just enough sense of play that even though you might not actually see it—this overwhelming fanciness and grandness—you feel it." And this is just the note he had struck so many years before in *Via Guelfa Studio,* which is also fancy, pretty, and orderly, but whose decorum is intersected and offset by its several airborne figures (commonplace in Giotto and Pontormo, two of his favorite artists) as well as the confusing physical and psychological perspectives that connect or divide the less volatile inhabitants of the studio. Some seem unaware of each other's presence, to have wandered in from some other painter's picture, or to be about to leave this one. The unexplained miniaturization of some figures and the expansion of others play roles in this drama of apartness and togetherness, as does the rich, warm, "Florentine" palette, enfolding the whole curious drama in its sober sensuousness. It is an archetypical Grooms situation, which will be echoed later in the crowded group portraits of his friends in cluttered interiors; in homages to masters of past time such as *Mr. and Mrs. Rembrandt* and *Le Banquet pour le Douanier Rousseau;* in the careening subway cars of *Ruckus Manhattan,* peopled with drunks passing out in the laps of horrified orange-haired ladies; and in his vision of the entire city in that work and others like *Danny's Hero Sandwich,* a sort of human corn-popper where everything and everybody has just been launched into separate, mad orbits.

This acceptance of things as they are (but only after a deep, knowing, and satirical glance untinged with malice) animated and amplified by a superb feeling for materials and colors, and an innate knowledge of what goes with what and of "just how far one can go too far," resonate throughout Grooms's work, linking the Via Guelfa studio with the recent *Blue Restaurant,* painted on Eleuthera in the Caribbean. It's a "booths for ladies" kind of place with midnight-blue walls and a pool table surrounded by muscular blacks fiercely intent on their game, next to a table where a white couple (Grooms and a friend) are addressing themselves no less earnestly to plates of fried conch. This is perhaps a median Grooms work, halfway between the exuberance of a Ruckus piece and the more consciously sought sobriety of the 1981 gouaches he made on the beaches in Brittany. The latter are what he means by "subdued," but Grooms has been called everything but serious and I am not going to limit the astonishing range of his art by using that adjective, either. There are moments when euphoria seems to dominate and also quiet moments, like in the Breton scenes, when the light is muted and the human comedy seems to be taking a siesta. And there are many unclassifiable moods such as the nocturnal mystery of *Night Raid on Nijo Castle,* which proposes a tale of rape, murder, and arson, of a jewel-like pagoda beset by horrific violence. Yet even in this curious work the message seems affirmative, and not just because of half-joking allusions to dozens of Samurai movies. The artist's own vigor is more than a match for his message of a civilization about to meet its doom: life is what is being celebrated.

"But I think that what makes me an impure artist or maybe not an artist at all, is that I'm totally fascinated with people, and I'm more into the personage than trying to make whatever it is—the sawdust-filled bag of bones or whatever," Grooms told Anne Waldman recently in an interview. "That's what interests me—the whole psychology. But I love art and I like the formalist stuff and everything of other artists." In other words it isn't necessary to give up something you love in order to accept something else: everything from Rembrandt to Ruckus to us can be accommodated, once the artist gives in to his suspect urge to welcome in absolutely everything. At a time when art seems to waver between extremes of homiletic purity and an impurity that also wants to see itself as somehow exemplary, Grooms offers a salutary third alternative: formalism and psychology, the pure and the impure, the raw and the cooked, all ingeniously layered in a hero sandwich of which Danny himself could be proud.

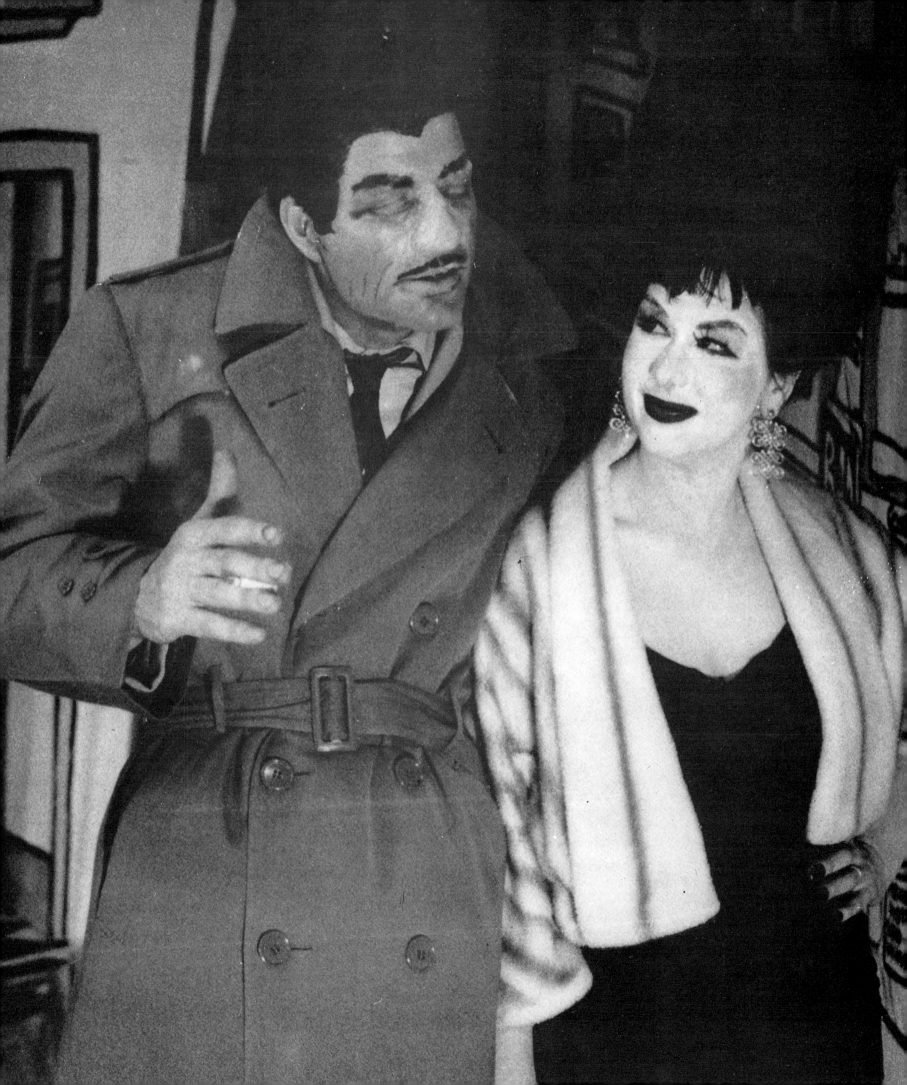

The Films of Red Grooms
The Home Production as Spectacle

Janet K. Cutler

The films of Red Grooms,[1] like his paintings, sculptures, and spectacular environmental pieces, offer audiences endless variety—a delightful, unpredictable mix of elements drawn from fairy tales, cinema, theatrical performances, circus imagery, comic strips, and popular music. As inventive as they are affectingly innocent, the films are a grab bag of ideas in search of a form, rather than finished, polished products. Nor do the films conform to the codes of conventional filmmaking: for all their hopscotching of classical cinema genres, these are "home productions"—extremely ambitious, personal films made in collaboration[2] with "our friends" (family members and fellow artists)—that freely mix within single works live action and animation, black-and-white and color, narrative and documentary. The result is a body of work that is as surprising from moment to moment as it is from film to film. Although Grooms's films employ radically different subjects and styles, a principle underlies and unifies all of them: these "Ruckus Films" (the name Grooms uses for most of his productions) raid every aesthetic tradition, high and low, in an effort to set in motion an avalanche of juxtapositions, a "commotion" that is at once startling, comic, and profound.

The films fall into roughly two categories: narrative films, ranging from tiny, single-joke vignettes like *The Big Sneeze* to fully developed story lines like *Shoot the Moon*, and documentaries like *Ruckus Manhattan* that show Grooms and his crew designing and constructing major environmental sculptures. Even these distinctions are somewhat arbitrary. *Tappy Toes*, for instance, is essentially an extended dance performance that takes Grooms's sculptural *City of Chicago* as its stage set, while *Hippodrome Hardware* consists in large part of footage shot during Grooms's performance piece of the same name.

Such homages to film as *Shoot the Moon* and *Tappy Toes*

make clear that Red Grooms loves movies. Impressed by the Hollywood spectacles and action films of his childhood,[3] Grooms's own productions both emulate Hollywood genre films and elaborate on them. His cottage industry studio has turned out specifically "Groomsian" versions of science fiction, horror, musical, and gangster films, as well as newsreels and cartoons. Film personalities figure prominently as subjects for some of Grooms's work in other media: his *Way Down East*, 1978, a sculptural nod to early cinema that depicts D.W. Griffith with megaphone, Billy Bitzer with camera, and Lillian Gish in the ice floe sequence, celebrates the process of filmmaking;[4] Buster Keaton, Jean Harlow, James Cagney, and a host of movie-inspired cowboys and Indians have served Grooms well as imagery for his paintings, drawings, and "stickouts." Long before he shot his first eight-millimeter film sketch (*The Unwelcome Guests*) with Mimi Gross near Florence in 1961, Grooms imagined himself working in film, either as a director or art director. Inspired not so much by a particular film as by individual shots in film that break with conventions, Grooms dreamed of making films that would consist entirely of such exciting shots.[5]

Red Grooms's directorial debut, *Shoot the Moon*, made in 1962 with cinematographer Rudy Burckhardt, is a reworking of Georges Méliès's early cinema classic, *A Trip to the Moon*, 1902. It seems appropriate that Grooms turned to the first years of film for his first fully articulated venture into filmmaking. Like the films of the turn-of-the-century magician and showman Méliès, which stress design elements and stage effects, Grooms's films stress the theatrical and the miraculous. Indeed, Grooms makes clear that he has always been fascinated with a certain kind of filmmaking: "More than photographic filmmaking . . . I like the artificial kind."[6] Méliès proves a perfect model for Grooms: a consummate theater designer, performer,

writer, and director turned enthusiastic filmmaker, he brought together all of his talents and many of his friends and colleagues to make movies. Furthermore, Grooms's films from *Shoot the Moon* on have a rough, unfinished quality commonly associated with "primitive cinema," as well as a spirit of experimentation and wonder that characterizes the work of cinema's pioneers.

One of the most startling things about *Shoot the Moon* (aside from what a winning debut film it is) is the way it addresses so many of the concerns of Grooms's later films. A charming science fiction tale that achieves epic sweep on a "home movie" scale, *Shoot the Moon* can be described in the same words Grooms uses to characterize the original Méliès work: "beautiful, funky, and handmade."[7] This is most clear in the "look" of the film, and especially in its design elements. Yvonne Jacquette's delightfully exaggerated costumes parody those of Méliès's Victorian explorers, while the crude/clever props, sets, and special effects provide satiric commentary on those of Hollywood's "high-tech" spectacles. Grooms's film appeals to the sweeping imagination engaged in creating spectacle while making no attempt to conceal its means of construction: his moon peaks are unmistakably drawn flats that come to his characters' knees and wobble when struck with pick-axes, and a gentleman in the expedition is shown in close-up to be a woman with a luxurious, false beard.

Indeed, materials are tossed together in *Shoot the Moon* with a slapdash urgency that implies that the film's physical construction barely kept pace with the outpouring of ideas about it, and that, if the mechanics of stagecraft/filmmaking were apparent, so much the better. The primacy of *the idea* is a key concept in understanding Grooms's films, both in terms of their shifting, collaborative lines of authorship and their non-homogenous shifts of style and form. Grooms speaks to this when he says, "An artist isn't necessarily a technician at all. You see, inside an artist is a person that has visions and all an artist tries to do is try to do them. And that's why anybody else could do them too. You could tell somebody else to do them. . . . I work with other people a lot. I'm not that hung up on whether I do them or not."[8] *Shoot the Moon* is a cornucopia of witty, original solutions to doing spectacle on a shoestring, and

much of the delight in viewing the film comes from an appreciation of just how cleverly it was made.

Throughout *Shoot the Moon*, as in Grooms's later films, there are clear indications that an artist is making decisions, that the film is not factory-produced. Juxtaposing different materials and modes, Grooms uses two- and three-dimensional objects interchangeably, alternates between full-size and scale models, and mingles live action with animation. In the service of an idea any form will do: the rescue at sea is animated; stop-motion photography is used to show rivets appearing magically in the rocket during its construction; stars drift by outside the window of the spaceship on a paper roll; an explorer writes in his journal with a cut-out quill pen. The film's music, an original score by Seymour Barab,[9] is also not of a piece, but collages musical styles in various music/image relationships. Sometimes these can be comic (crashing cymbals provide equivalents for exploding cigars), charming (turn-of-the-century dance music sets the tone for the Plushwell's parlor), or haunting (cello music adds mystery to the moon face on the horizon). There is even an eerie, silent moment when the explorers leap from their ship and gambol on the moon's surface.

Grooms's fixation with popular theater, carnival, and circus acts—he recalls, "I would go to the carnival where there would be such an absolutely fantastic array of characters and life that I would almost have a panic, this feeling that I wouldn't be able to remember and wanting to remember."[10]—had a lasting effect on the narrative structure of his films. Like early cinema, which also grew out of those popular entertainment forms, Grooms's plots consist of a series of performances or acts that characters give either for an audience or for each other. *Shoot the Moon* begins and ends with the rising and falling of a curtain, and its central scene, titled "Moon Magic for a Captive Audience," depicts the explorers, now prisoners of the moon men, applauding a number of "turns" performed by their captors. To effect their escape, the explorers match act with act: their leader takes the stage and magically produces huge cigars under the smoke of which they make their getaway.

Both the journey to and from the moon are occasions for

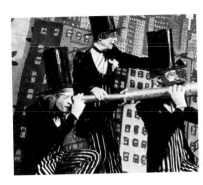

Rudy Burckhardt, Edwin Denby and
Alex Katz in *Shoot the Moon*, 1962

song[11] and dance (even a comet and a rocket dance a rhumba in a sequence entitled "Encounter with an Uncharted Comet"). Ceremonial performances include much speech making before the launch and the formal presentation of the explorers to the audience/populace in the "Heroes' Welcome" sequence that ends the film.

Shoot the Moon, like many of his films, features Grooms as a performer; here, he plays the Moon Wizard, a grotesque with huge feet and long nails, traits further exaggerated by their cinematic treatment. Breaking with the tableau style of the rest of the film, which views characters dispassionately from a distance, the "Palace of the Moon Wizard" sequence employs high angle shots from the Wizard's point of view and low angle shots of the Wizard that further distort an already expressionist costume. Though the Moon Wizard is not a major character, the filmmaking and special costuming lend a disturbing quality to his presence in the film.

The Moon Wizard is last seen flat on his back from an exploding cigar attack, one of many slapstick moments in which chaos erupts. A major comic theme in Grooms's work is the subversion of order by chaos. Grooms dated the beginning of this strain to high school skits he and his friends performed in an attempt to deflate the repressed, "squaresville" atmosphere of the early 1950s: "Like, say, I would be called on to give a public announcement of some sort and on the way up to do it, I would take a horrible fall and that would be it. . . . It was like a little subversion to doing things straight. . . .It was to me like a thread that made me want to continue doing it."[13] Early in *Shoot the Moon*, the mayor's[14] speech is interrupted by the accidental lift-off of the rocket. That surprising and disorienting moment gives way to a serene ride through space, which is interrupted by encounters with the comet and the moon. The entire set is tipped back and forth; lights flash, props fly through the air, and dials spin wildly. Flying teapots are the stuff of Grooms's work, which has a strong anarchistic streak. Though at one point an inter-title proclaims, "Moon Order Restored," that stability is threatened again and again.

Shoot the Moon is especially ambitious because it takes one of the most revered, complex, and intricate classics of "primitive cinema" as its point of departure, not just fearlessly but with great gusto, high spirits, and invention.[15] Not only is it necessary to create the parlors and foundries of a Victorian world and the surface of the moon with its inhabitants, but Grooms must also create an urban downtown area. *Shoot the Moon* opens "high above the city" with a view of a sleepy, moonlit metropolis and ends with a "Heroes' Welcome" sequence that depicts in exhaustive detail an entire city block and the crowds gathered there to greet the returning explorers. What remains with the viewer after seeing the film is the feeling of amazement that its maker could have constructed the film and its city with such charm and intelligence and with such limited means.

In some ways *Fat Feet*, 1966, made in collaboration with Mimi Gross, Yvonne Andersen, and Dominic Falcone,[16] takes the ending of *Shoot the Moon* as its starting point; here, however, we see Grooms's ambition to construct not just a brief street scene but a fully articulated "city symphony," cataloguing in great detail all its people and events. Further, *Fat Feet* takes the extreme physical exaggeration of *Shoot the Moon*'s Wizard and extends it to all the city's inhabitants: a policeman's arms stretch to incredible length as he directs traffic, a woman walks the streets under an enormous beehive hairdo, and almost everyone has feet the size of steamer trunks. Grooms amplifies these distortions of body type by placing his actors in a comic strip world of flat, cut-out costumes, props, and sets.

Grooms's cityscape is as full of disorienting surprises as his surface of the moon. Peopled by a rogue's gallery of grotesques and fraught with sudden danger, the film bristles with urban iconography; rats, bag ladies, gangsters, burning buildings, taxis, and hold-ups jostle for position. However, Yvonne Andersen's cinematography presents these bizarre people and events in such a deadpan way that the ensuing chaos and disaster seem normal, everyday.

The opening section of the film is especially rich in this regard. The viewer is readied to "expect the unexpected" by a series of droll jokes involving comic reversals: a cat chases a rat into a garbage can, but after a scuffle, it is a fatter rat that emerges; a bag lady witch (played by Mimi Gross) empties a garbage can by levitating its treasures

Mimi Gross in *Fat Feet*, 1966

one by one, then is pulled in headfirst to replace them.

Fat Feet is another film in which Grooms integrates disparate materials, but their mix here is much more radical than in *Shoot the Moon*. In the opening moments, a two-dimensional fire hydrant, post-office box, and wastebasket round a corner and begin an animated dance, only to be interrupted by a policeman (played by Dominic Falcone) who appears on the scene to order them to their appropriate places on the sidewalk. When a fire is accidentally set, the otherwise black-and-white film blossoms with vivid red-orange flames, and its hand-drawn urban environment gives way to an actual brick firehouse on a rural road. Live actors playing firemen burst from the door carrying a life-size, cut-out fire truck; they race through the streets before arriving at the constructed "burning" set in which even the flames and smoke are painted flats. Throughout *Fat Feet* live action gives way to animation (as in the scene depicting the rescue from the burning building) when photography fails to provide ample scope. As is often the case in Grooms's films, the ideas are strong enough to unite the radical shifts in style and material employed by Grooms to create spectacle.

Tappy Toes, 1968-70, is Grooms's send-up of a classic American movie genre, the backstage musical. Using his environmental sculpture *City of Chicago* as the setting, *Tappy Toes* is a dance film in the manner of Busby Berkeley, complete with last-minute cast replacements, large-scale production numbers, sequined costumes, and kaleidoscope shots of dancing feet and singing faces. Lacking the polish of the studio-produced 1930s musical spectaculars from which it draws its inspiration, *Tappy Toes* offers compensatory charms, such as a man and woman romantically enmeshed by spinning ribbons that suggest the lines of a musical staff, and a couple swinging on a large, cardboard musical note.

A rapid-fire collage of clichés begins the film: a sobbing starlet, unable to tug a tap shoe over her mountainous plaster cast, whines to her dressing room mirror, "I can't go on." The show's director, after receiving an (animated) sock in the jaw, gets a "bright idea" (a light bulb dances overhead as his view of the ingenue's feet dissolves to frantically tapping toes) and replaces his female star and her

drunken male counterpart (played by Grooms) with untried youngsters whom he urges on saying, "The show must go on. . . . You've got talent. . . . Get out there and show your stuff. . . . God bless you!"

What follows is a thoroughgoing attempt to integrate life-size dancers and a sometimes-scale model *City of Chicago* installation. A dancer peers over the top of a shoulder-high cityscape, dances with it as her backdrop, and is finally miniaturized and superimposed onto its streets and into its tableaux. In a shot that is emblematic of this strategy, Grooms splits the screen horizontally to wed in a single image his "chorus line" of dancers gliding across the upper half of the screen on musical notes, and a line of hand-drawn cars and trucks (seemingly the same size) tracing a similar path below.

Superimposition, double exposure, and split screen cinematography are not new techniques; rather, they were common currency for many turn-of-the-century filmmakers who stood with one foot in spectacle theater and the other in "the photoplay." Grooms's contemporary use of such "magic" tools of cinema points up his artist's understanding of film's qualities. In cinema human figures are no more rounded than painted flats or animated line drawings, and camera placement can give small objects a stature that dwarfs human scale. In *Tappy Toes* Grooms capitalizes on the optical quirks of cinema to create Ruckus worlds in which people can move seamlessly through wholly artificial environments, even populate paintings.

Tappy Toes also exhibits a progression from the real world to the world of fantasy that parallels its backstage musical model. This is not to say that its opening sequence is naturalistic, except in relation to the rest of the film. But spatially the world of the film expands at exactly the same moment and in exactly the same manner as *42nd Street* or *The Gold Diggers of 1933*: young dancers move from their dressing rooms to face a packed house (as in so many of his films, Grooms has provided his performers with a "cast of thousands" audience of painted figures, taking the opportunity to catalogue exhaustively every person in the hall); they begin to sing and dance on a small stage, which then miraculously opens out to an unlimited, amorphous

space of the imagination, one which could not be contained within a theater's proscenium. The moment is telling, for Grooms began filmmaking in part as a reaction to the limitations he encountered in his theatrical pieces.

Nor does Grooms allow the medium of cinematography to limit the scope of his narrative. When *Tappy Toes* requires a *really big* production number involving Picasso dancing down a huge staircase spiraling around a central, rising tower on which scores of dancers perform, Grooms simply switches to animation.[17] Other such moments that "open out" the stage space of *Tappy Toes* include animation of the El "looping the loop" and a King-Kong-like creature with the face of Mayor Daley destroying buildings and terrifying crowds.

The star of the film is the *City of Chicago* installation. Its function as theater/film set corresponds to Grooms's feeling that his large-scale environmental sculptures "that you walk through and move around in"[18] can accommodate "spin-off" uses and are more closely related to theater than sculpture. At once scaled-down and encyclopedic, Grooms's city sculpture proved almost too cramped to lend itself to cinematography,[19] all the while encompassing in a concentrated way most of Chicago's major sites and historical events. The setting speaks to Grooms's affinity for things with epic sweep (asked by Alan Frumkin to create a Chicago piece he opted to construct the entire city) as well as his fascination with performance (while many of Grooms's films feature performers and audiences, this one consists almost entirely of "production numbers" performed by dancers who stroll through, pose within, or interact with Grooms's colossal construction).

The film *Hippodrome Hardware*, 1973 (revised by David Saunders in 1980), extends and elaborates on Red Grooms's 1972 "live performance" of the same name. As Mr. Ruckus, the ringmaster figure who presides over this circuslike vaudeville show, Grooms holds up the name of each successive act, then broadly and farcically mimes a number of roles: animal trainer (he presents a puppet play featuring a wooden dog), sculptor (he sculpts an audience member), opera singer (fruit is thrown as he "sings"), dance instructor (an audience member is his partner), dentist (he extracts the prop of a bloody tooth from an audi-

ence member), and house painter (paint is eaten and bricks are painted). Even more than *Shoot the Moon*, then, *Hippodrome Hardware* showcases a series of performances inspired by popular theater.

Woven into Mr. Ruckus's act is a trio of clownlike workmen (one never knows when their activity will shift from background to foreground status) who use huge tools and comic props to construct "Grandmother's house." Introduced separately into the film in silent-screen-style, slapstick scenes, each is shown variously waking up, energetically making love, defecating, shaving with an oversize razor, and finally leaving for work carrying an enormous tool (a saw, a hammer, a measuring stick).

Complex and challenging, *Hippodrome Hardware* succeeds in equating apparently disparate ideas—theatrical performance and the construction of a house. Grooms begins the film with a title card dedicating the film to the Hippodrome (the biggest theater in New York) and his grandmother, explaining that its subject will be *hardware*: the tools used to build his grandmother's house and the tools of spectacle employed in the Hippodrome. The fact that the housebuilding occurs onstage as a backdrop for Mr. Ruckus's antics suggests that construction can be viewed as performance (recalling the 1958 performance piece *Fire*, in which Grooms "just came out and made a painting in front of an audience"[20]). For Grooms a thin line exists between acts of construction and performance, both being built of separate elements by "workers" (Mr. Ruckus's enigmatic role encompasses both master of ceremonies for the show and contractor for the house).

Special effects, both theatrical and cinematic, are the subject of the second half of the film. Recalling a moment early on, when the theater pipe organ and its player rise mysteriously from the orchestra pit shrouded in shadows and flickering lights, the set is again plunged into darkness. As the workmen sleep, flickering lights reveal a woman high atop stilts and devil figures emerging from a red-lit pit, creating a spooky, fun-house atmosphere on stage. It is not surprising that Grooms sees his work as part of a tradition from rural tent theaters, country spectacles involving scroll paintings and dioramas: "People would come in to see a big picture which was . . . extra magical

because it had these lighting effects and [3D] stuff. . . . It was big and people would come to see it. And that's the area I like to think about."[21]

Grooms intercuts these stage pyrotechnics with a lively animated sequence (another of the workmen's dreams?) involving square-dancing feet hammered and nailed to the floor and a wooden hog dancing to a fiddle tune. Grandmother's house then becomes the site of a nightmare fairy tale. Interior action takes place in an old lady's parlor set, and exterior views involve the house and its wooded setting, but Grooms moves fluidly from one medium to another, sometimes animating, sometimes using live action. Like *Shoot the Moon*'s moon men and *Fat Feet*'s bag lady, the grandmother is a magician/witch (she levitates a feather duster and sends it flying) who invites the workers into the house they built only to cook one in the oven. In this scene's grand finale, an overstuffed robin played by Mimi Gross "flies" to the grandmother's house, hanging in space in an elaborate costume before a huge revolve of painted clouds. Other spectacular stage feats include a shooting star riding a bicycle and a cow jumping over the moon.

Hippodrome Hardware rivals *Tappy Toes* in its spatial disorientation of the viewer by constructing its performance space out of a number of tableaux. Grooms calls on cinema's "creative geography" to incorporate an actual stage space (carved out of Grooms's studio loft and packed with an actual audience) with an ornate, Grooms-constructed theater box containing two costumed couples (including Grooms), the bird's "sky" revolve, the workers' homes, and all the animated spaces. This conjoining of disparate spaces for an ostensibly single-set film bears witness to Grooms's mastery of mixed media, this time in a specifically cinematic blend.

Ruckus Manhattan, 1976, is a delightful, fast-paced, feature-length film that documents the construction of Grooms's most ambitious work—the enormous sculptural environment *Ruckus Manhattan*. Carefully structured by collaborator David Saunders,[22] each section of the film focuses on a particular area of the installation: the Woolworth Building, the Statue of Liberty, Wall Street, the Staten Island Ferry, Chinatown, the Brooklyn Bridge, etc. In each scene we are shown the actual location, the process

of construction, and the finished product (from a variety of perspectives). Wildly eclectic music on the soundtrack links the disparate elements. "I Can't Give You Anything But Love" accompanies the Woolworth Building, "Sea Cruise" the Staten Island Ferry, "Blue Suede Shoes" the pornography shop.

A major strategy in the film is pixillation: jerky, stop-motion photography that not only speeds action but lends it a frantic, Keystone Kops quality. Though the sculpture is presented in detailed close-ups, the artists/workers are usually filmed from a distance, an army of wind-up toys working in a frenetic, carnival atmosphere. What ultimately emerges, however, is a sense of the enormity of the task, the exhaustive detail of the work, and the exhilaration that accompanies its creation.

The collaborative nature of building *Ruckus Manhattan* is made apparent in the film. As we become aware of the different kinds of materials involved in this huge environmental sculpture, groups of artists emerge as experts in wood, metallurgy, fabric, plastic, and paint. The process of creating art, not simply the finished product, is important here. As in *Hippodrome Hardware*, construction is linked to performance, the evolving work being on view for passers-by, the first step in a process that allows an audience to view, then enter a piece that celebrates urban life.

Inspired by and starring Grooms's daughter, Saskia, *Little Red Riding Hood*, 1978, is an unpretentious, home-movie version of the fairy tale that encompasses the lyrical, pastoral, and violent, nightmarish qualities of the original. Filmed "on location" and in a full-size Grandmother's House set built in the Maine woods, *Little Red Riding Hood* is the last word on a familiar Grooms theme, the violent disruption of an idyllic situation. Red Riding Hood's innocent frolicking in the woods recalls *Shoot the Moon*'s explorers leaping on the moon's surface before being menaced by monsters. She too embarks on a joyful, expansive mission, only to be accosted by a creature who threatens her life. Indeed, Grooms's version of the classic story has Grandmother and Red Riding Hood devoured by the wolf, though they return for an encore when the wolf is finally captured.

The soundtrack of the film is one of its most compelling

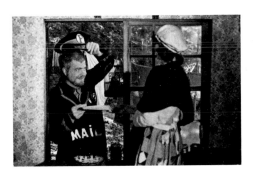

Red Grooms and Yvonne Jacquette in
Little Red Riding Hood, 1978

features. The leering, sexual, pop tune that begins the film—"Hey there, Little Red Riding Hood, you sure are looking good; you're everything a big, bad wolf could want"—is all the more loaded since it is sung by children. Some of Grooms's most inventive sound effects are employed, such as corks popped from bottles to suggest the plucking of posies. As in *Tappy Toes* there is little attempt at synchronous dialogue, another of the homemade qualities of Grooms's films.

This film mixes materials—Red Riding Hood's home has a frenetic stuffed canary and real chickens, while the wolf is clearly a man in a wolf suit. And it combines live action with animated inserts—Grandmother's face appears as a drawn, animated image superimposed on the page of her letter; a bat leaps toward the viewer in a 3D effect; the wolf's ZZZZ'd snores slide across the screen; hand-drawn sheep circle his head; and the cartooned "soul" of the wolf slips from his body and rises to heaven on flapping wings, signalling his death. Fast-motion cinematography is used to add a comic touch to scenes in which the wolf chases Red Riding Hood and is chased by the woodsmen; pixillation is employed to convey the moment when a papier-maché Red Riding Hood is eaten by the wolf; and a succession of slow-motion freeze frames makes unforgettable the moment when the wolf is slit open and live chickens, Grandmother, and Red Riding Hood are lifted out of his body into the sunlight.

Although *Little Red Riding Hood* is Grooms's last major film,[23] he has throughout his career made a number of short films, including paper-roll films, live-action shorts, and cartoon animations, that point to a number of consistent issues of his work. "Spin-offs" of his artwork, the paper-roll films resemble hand-drawn comic strips, but are transformed when filmed, as are Grooms's static sculptural environments and stagebound performances. Ideas about how to alter Grooms's static images are as varied in the short films as in the longer works: collaborator Rudy Burckhardt's camera[24] does not simply pan across the drawings, but enters into a choreographed relationship with them, sometimes moving in to emphasize a detail or pulling back to reveal an image's surprising context.

In *Umbrellas, Bah!* or *The Unexpected Voyage*, 1965,[25] a man buys a "special, wind resistant" umbrella and is carried by the storm to outer space. As in *Shoot the Moon*, a turn-of-the-century figure is transported from a Manhattan-like metropolis to another planet; surprisingly, its natives dance to rock 'n' roll music and (as we learn when the camera pulls back) place him on a throne and worship him. Here, Grooms's ironic humor is based on juxtapositions inherent in the clash of cultures and reversals of expectation (the creatures have umbrella-shaped heads). Other familiar Grooms elements include the use of saturated, vivid colors and a propensity for scenes of spectacle and chaos (an innocent tossed about by wind and rain). This is a film in which an accidental, surprising, violent eruption in everyday life leads to something extraordinary, an adventure that is dangerous, fantastic, exhilarating.

The Big Sneeze, 1962, and *Man Waking Up*, 1984, are both paper-roll films that employ inventive camera movements and sound effects. In *The Big Sneeze* a man walks into a beanery and orders two poached eggs. When the cook is heavy-handed with the pepper shaker, the camera shakes to mimic the motion. Among the comic sound effects is a "whooshing" vacuum cleaner noise used to convey the wind from the man's sneeze that blows the diner skyward. Grooms's emphasis on the single event—the extraordinary, explosive sneeze—recalls Thomas Edison's primitive kinetoscope film *Fred Ott's Sneeze*, 1889, in which that action constitutes the entire plot,[26] and is another depiction of an unexpected act explosively disrupting everyday life.

Man Waking Up presents much more extended examples of ways to animate still images. A catalogue of all the things people do first thing in the morning,[27] *Man Waking Up* gives each drawing an equivalent camera movement:[28] an alarm clock rings and the camera shakes; a man pulls up his pants and the camera rocks back and forth; he brushes his teeth and the camera moves from side to side, then up and down. Comic sound effects accompany these brief actions, as when hair tonic noisily squirts from a bottle. At the end of the film, there is a dissolve from the drawing of the man's blue-striped jacket to the actual blue-striped jacket worn by Grooms; accompanied by the rock song "Concrete Jungle," Grooms takes on The City, frenetically crossing and recrossing a busy intersection.

Violent slapstick moments characterize certain of the paper films.[29] In *Man or Mouse?*, 1962,[30] a man dies of fright, his face becoming more and more vividly, expressionistically colored, as we hear the rubber toy "squeek squeek" of a tiny mouse. *Fat Food* or *In Bad Taste*, 1968, a proto-splatter film made in the same year as George Romero's *Night of the Living Dead*, employs macabre humor on a much more grisly scale. This paper film's restaurant patron wanders "backstage" to glimpse a horrifying kitchen full of ghoulish cooks with purple and green faces who busily hack up dead horses and rats. Cornered in the restroom, the man is dismembered and served as dinner to his friends. As his legs and feet are eaten, the diners turn into green-faced monsters; they faint, however, when the man's disembodied head is served with an apple in his mouth. (*Spaghetti Trouble*, 1965, a prototype for *Fat Food*, is a much simpler, line drawing film in which a restaurant meal is disrupted when strands from a mop are confused with spaghetti. Both films incorporate cheery Italian music, which funcitons ironically, making the events seem more horrible.)

In a parody of the American success myth, *Meow Meow*, 1968, a longer Grooms paper animation, collapses the two 1930s film genres—musicals and gangster films—that depict a dramatic rise to fame and fortune. It chronicles the adventures of a man and the kitten he rescues from the city streets. The kitten grows into a lion, saves his master during a robbery, stars in a hit Broadway musical, is kidnapped by gangsters, and finally escapes. This film makes especially strong use of color, employing it to underscore the grotesque characters (the demonic, green-faced gangster leader) and to convey the lion's rage as it turns on and devours its captors. Two central images that recur throughout Grooms's work, the city and the theater, are richly articulated in this genre film spoof. Beginning with city images, like *Shoot the Moon* and *Fat Feet*, *Meow Meow* goes on to catalogue smoke-puffing billboards, feisty newsboys, dives like the "Black Cat Cafe," limousines, huge crowds flocking to cheer *Catnapped on Broadway*, and even a movie poster advertising the early Burckhardt/Grooms horror film *Lurk*.

In the *Conquest of Libya by Italy*, 1912–13, 1972–73,

Grooms mines yet another film genre, the 1930s and 40s newsreel.[31] A black-and-white graphics animation that brings together steel-cut engravings and hand-drawn images, *Conquest of Libya* is a film with epic sweep that manages to cover an entire war by adopting the three-minute newsreel format. The chaos and commotion of battle present an apt subject for Grooms: battleships, a cast of thousands, heads being sliced in two with sabers, soldiers falling into water, and camels flying through the air. The wartime situation involves the juxtaposition of radically different things—a clash of cultures, including alternating Italian and Libyan music, and conflicting moods—all providing an opportunity to mix materials and methods.

Grow Great, 1974, a live-action short that takes on tv ads,[32] explores a number of Grooms's themes. Filmed in violently clashing colors, *Grow Great* presents Mimi Gross, the ad's typical consumer, in a bathroom full of oversize, two-dimensional toothbrushes, reading a "Hi Fashion" magazine that illustrates the "Godiva Look." The adman's soothing voice accompanied by mindless music urges her/us to try a hair tonic that will instantly lengthen her short tresses. Employing the fantasy principle of ads, Grooms "brings to life" the bottle's trademark, an Indian woman with flowing sari and hair to match. Once again Grooms relies on comic juxtapositions inherent in a clash of cultures—Muzak is replaced by an Indian raga as the housewife leaps through a forest, trailing abundant locks. Parodying advertising techniques throughout, Grooms drops fragments of ad copy over Mimi's head ("Don't Be," "Upset," "Try") to reinforce the sales pitch, sets tinfoil arrows flashing around "the product," and magically switches locations to drive home the promise of "a new, outdoor you."

Before an' After, 1964, a comedy with a sadomasochistic edge, is Grooms's nod to the cartoon. Mimi Gross plays the terrifying Dr. Finkelheimer (part dominatrix, part health club operator) who whips and abuses a hunched, pathetic customer played by Grooms before forcing him to enter a body-building machine. In an ironic conjoining of the wild claims of health clubs and the miraculous transformations of cartoons, Red emerges as a menacing giant. The tables turned, the doctor is chased into her diabolic

machine, where she is reduced to a tiny, cut-out figure. A live-action film, *Before an' After* is nonetheless in the Popeye mode: its characters operate on the level of flat caricature; its revenge plot centers on the hero becoming suddenly more muscular than his tormentor; and its soundtrack is a nonstop stream of cartoon music, grunts and groans, and Olive Oylian patter.

The films of Red Grooms constitute an important if largely unknown part of his career. For the past twenty-three years, Grooms has looked to film to convey ideas that could not be expressed in any other medium. Film affords him the opportunity to move freely from live action to animation, to mix three- and two-dimensional objects in a special way ("flattening" even live actors to the level of comic strip or painted flat), to create confusion about scale (blending life size with miniaturization), and to extend and exploit the narrative dimensions of his work. Grooms likes to put himself in the filmmaking environment, although he acknowledges that some of the excitement and fun of creating spectacle before the camera does not show up on film. Nor is he interested in "all that black and gray,"[33] the film technology, the post-production work. What is important in Grooms's film work is the ideas. Working alone or with others, he employs whatever form or forms best express those ideas: "It's not clear in my mind at all sometimes what a thing is or what it might end up as. At this point, I'm even starting to do stuff that might be like a sculpture, but it might also be part of a movie."[34] Grooms's films, simultaneously about film and more personal than his work in other media, are often several things at once, displaying an active imagination that leaps from form to form. As Grooms adds to this Ruckus body of work, each new film celebrates spectacle on the level of artist-made home production.

Notes

1. Like a number of artists, Grooms makes films that are not distributed commercially. Ten of the works discussed in this essay are available from the American Federation of Arts Film Program (41 E. 65th Street, New York, NY 10021); the rest are part of Grooms's private collection and were seen through the courtesy of the artist, who also generously granted interview time and annotated this piece.
2. Extending his work in other media to film, Red Grooms has acted in the roles of producer, designer, performer, animator, and writer; yet the films are collaborative ventures. All of the films made during Red Grooms's marriage to Mimi Gross (up to *Little Red Riding Hood*) should be considered productions of Ruckus Studios, a cooperative venture of Mimi Gross and Red Grooms. Grooms himself considers *Target Discount Store* Al Kraning's film, while *Lurk* reflects more of director Rudy Burckhardt's sensibility than his own.
3. From an interview with Red Grooms conducted by Janet Cutler, October 17, 1984.
4. The credits on *Indian Scout* list its creator as "Red D. W. Grooms."
5. Cutler interview.
6. From the transcript of an interview conducted for the Archives of American Art, Smithsonian Institution, by Paul Cummings, March 4, 1974, p. 80.
7. Cutler interview.
8. Cummings interview, p. 27.
9. "Seymour Barab is also an accomplished cellist. Rudy Burckhardt knew of his work and got him involved in the film." From Red Grooms's notes to the author on this article.
10. Cummings interview, p. 16.
11. "Lyrics for the song are by Edwin Denby." Grooms's notes.
12. "This charming ballet between the rocket and the comet was entirely conceived and animated by Rudy Burckhardt, who baked the papier-maché comet in his own oven." Grooms's notes.
13. Cummings interview, p. 79.
14. "Edwin [Denby] besides playing the mayor often brought coffee to us on the set and cheered us up with his encouragement." Grooms's notes.
15. "Rudy [Burckhardt] edited *Shoot the Moon*, and I think it is his restraint and sense of properness that keeps my expressionism in the right balletic balance." Grooms's notes.

16. "Mimi and I went to live with the Falcones. They had rented a dance studio next to the Arlington High School on Massachusetts Avenue. We built the set and props in the studio and filmed all the live action in about a month. Then Mimi, Yvonne, and I worked on the animation for another month at Yellow Ball Workshop, Andersen and Falcone's animation facility in their home in Lexington, Massachusetts. Dominic, Yvonne, and I did the soundtrack, which consists entirely of sound effects. Yvonne edited the film and did all the post-production work. The four of us pooled our resources to produce the film." Grooms's notes.

17. "The animation in *Tappy Toes* as well as in almost all my others is cut-out or puppet animation: flat, hinged-together figures that play against a painted background. If the figure recedes or comes forward in space, that requires multiple sizes in a telescopic series. If the puppet stays on one plane, then it can be articulated by manipulating the hinged body, head, and limbs. If it turns from right to left, several figures must be interchanged and so forth. The movement is generally shot at two frames per second." Grooms's notes.

18. Cummings interview, p. 81.

19. Cutler interview.

20. Cummings interview, p. 29.

21. Cummings interview, p. 82.

22. "The construction and shape of the film belong entirely to David Saunders, who was responsible for its editing and sound; David put the movie together while I was out of the country. I acted as producer along with Mimi Gross, who also wrote the film's poems." Grooms's notes.

23. "Before this article comes out, I will have released a new film: *Small Fry Gangster,* 1982–84, made in collaboration with David Saunders." Grooms's notes.

24. "All the filming, soundtrack, and post-production work of the paper films has been done by Rudy Burckhardt with only two exceptions: *Spaghetti Trouble* and *Meow Meow* are by Yvonne Andersen. Rudy started the tradition back about '62 or '63 and has kept it up until as recently as last year [1983] with *Man Waking Up.*" Grooms's notes.

25. *"Umbrellas, Bah!* was commissioned by Edwin Denby as a present for George Balanchine. Edwin just quietly left it off for Mr. Balanchine, who didn't know what to make of it. After a while, Edwin just took it back. One of the voices on the soundtrack is Edwin's, the other is mine." Grooms's notes.

26. Grooms had an opportunity to screen turn-of-the-century films from Joseph Cornell's private collection a number of times and traces references to "primitive cinema" in his own films to those viewings. Cutler interview.

27. Another short film, *Apollinaire Unexpected,* 1966, also catalogues both the activities of waking up and cleaning the house while a visitor waits to be admitted. A domestic comedy, the film is further evidence of the delight Grooms takes in inventorying objects and events in exhaustive detail, and his inclination to use a range of humor from slapstick to satire to provide cinematic commentary on the material of everyday life.

28. "The camera movement in *Man Waking Up* reflects Rudy [Burckhardt's] extraordinary command of the camera at this point in his career." Grooms's notes.

29. A Grooms live-action short, *Washington's Wig Whammed,* 1966, features Edwin Denby as the silver-faced bust of the president framed by a hand-drawn 5¢ postage stamp border. He mugs and mutters briefly before being "canceled" by a huge stamp; he then "dies," slipping out of the frame.

30. "I made *Man or Mouse* as a present for Rudy and Yvonne [Jacquette]." Grooms's notes.

31. *"Libya* was made with Mimi Gross and other members of the crew that worked on *Hippodrome Hardware.* It was originally intended to be inserted into the *Hippodrome Hardware* film." Grooms's notes.

32. *"Grow Great* was commissioned by New Jersey public television as a filler for a pilot project—a show directed at an audience of women." Grooms's notes.

33. Cutler interview.

34. Cummings interview, p. 57.

Red Grooms
The Early Years (1937-1960)

Judith E. Stein

For the last twenty-year period I've been working with ideas conceived as a child.[1]

The art of Red Grooms sprang to life within a specific historical context. An account of his activities in Provincetown and New York in the late 1950s brings more sharply into focus one of the most fascinating and historically significant periods of twentieth-century art, when the hegemony of Abstract Expressionism gave way to a variety of representational modes. Often inspired by the rich flow of ideas circulating around him, Red Grooms is best appreciated against the foil of his peers.

The details of his early years in Nashville also deepen an understanding of the breadth of his work. Grooms has always maintained that the experiences of his childhood were among his most potent influences. A perusal of the exhibition checklist will confirm that virtually every facet of Grooms's subsequent iconography can be found in his art at the onset of his career. But with the exception of his highly influential Happening *The Burning Building*, 1959, Grooms's early work is largely undocumented and infrequently exhibited.[2]

Motivated by Grooms's first major retrospective at age forty-eight, this investigation of his evolution as an artist should help eliminate the gap in public awareness between the brilliance and unexpected range of his early production and the large body of his best-known work.

Although his Tennessee origins and disarming receptivity have prompted some to liken him to Li'l Abner, Red Grooms was never a wide-eyed mountain boy. Born Charles Rogers Grooms in 1937, he grew up in suburban Nashville, a few miles from the city's center. His frequent walks into town occasioned as many insights as the actual visits: "One of the biggest influences in my life was going from home into town, making that trip. I liked the removal, the abstraction of leaving home, getting away, being by myself. I had this great love of downtown in the city. I loved the atmosphere . . . it was sort of neutral territory."[3]

Nashville was and is the country music capital of America. A cultured city that boasts the world's only full-scale replica of the Parthenon, it also sports a loud and bawdy honky-tonk district. Yet to Red it is the refined aspect of his hometown that he stresses in his reminiscences: "I saw Nashville as an urban place, 'the Athens of the South,' and that always made me happy. . . . I thought the country was anticultural, and Nashville a metropolis. I had lots of civic pride."[4] But it is unlikely that the impressionable young artist, attending shows at the nearby Grand Ole Opry, would not have been intrigued by the glitzy decor and raw sexuality of Broadway and Printer's Alley. Elements in his later work, such as his fondness for splashy theatrical effects, or his fascination with impolite realities, would suggest this worldly Nashville's early if unconscious influence.

His parents, Gerald and Wilhelmina Grooms, both came from families who had lived in Tennessee for generations. The Grooms clan were landowners in the western part of the state. Settling in Nashville in 1930, Gerald Grooms met and married Wilhelmina Rogers, whose forebears were longtime residents of the city. The oldest of three sons, Red grew up in a supportive family circle that upheld the religious traditions of southern fundamentalism. Red was "templated in the Baptist church," according to his lifelong friend, Nashville artist and critic Louise LeQuire.[5]

Because one of the abiding images in Red's early work is of a world in flames, it is tempting to probe for its source among the many vivid sermons and Sunday school lessons he must have heard on the fire and brimstone of Hell. Baptist preaching may be as likely an inspiration for his scenes of conflagrations as the deadpan explanation Red himself offered in 1965. Describing Nashville's Ryman Auditorium, original home of the Grand Ole Opry, Red cited the rickety structure as the place "where my interest in fire

might have been ignited by the threat of the whole wooden place burning down."[6]

Red started drawing as a young boy. Although no one around him had any practical knowledge of the art world, his father had supported the family during a break between engineering jobs by working at home as a coppersmith. His highly prized bowls and ashtrays were sold through craft fairs and specialty shops. Encouraging their son's enthusiasm and genuine talent, Mr. and Mrs. Grooms enrolled ten-year-old Red in art classes at the Nashville Children's Museum. Subsequently both Red and his father studied art with Juanita Green Williams, who took them on weekend trips to the Vanderbilt University campus and to the Cumberland River banks to draw from nature.

For two years, Red studied privately with Williams, an artist, who as a student at New York's Art Students League had worked with Robert Brackman. Williams's downtown studio classroom was located on West End Avenue, in the attic of a ramshackle three-story brownstone called the Watkins Institute. Red recalls that the building housed a collection of "dark and spooky" Victorian paintings on the other floors.[7] An eccentric and colorful personality, Williams instilled in her pupil a strong sense of professionalism and seriousness about art. Later, Red also took two years of Saturday classes with Joseph Van Sickle, a Nashville artist who did Cubist renditions of the Grand Ole Opry.

Hollywood films, the Ringling Brothers and Barnum and Bailey circuses, and the Tennessee State Fair's Cavalcade of Amusement were the major formative influences of his childhood. Red recalls that as a boy it was his great ambition to create acts or rides for the carnivals. The theatrical aspect of the circus greatly appealed to him, and he put on his own versions of circuses in his backyard. In eighth grade, the large tabletop model of a carnival Red made for a boy's hobby fair was awarded first prize in its category in a show at the Women's Building on the Tennessee State Fairgrounds. The "class artist" in grammar school, Red was often chosen to do work on the blackboards for the holidays and special occasions.

In high school, Red played football and was one of a group of boys who put on their own skits. "One bit I did was a character based on the Fisk tire kid who wore a nightshirt and carried a tire and a candlestick. I'd come out wearing the Fisk kid's getup and say 'Time to Retire.'"[8] Among the influences on the format and content of these youthful performances was the radio comedy team of Bob and Ray, whom Red regarded as "surreal" and "kind of subversive."[9] At the time of his graduation, Red was voted the wittiest fellow in his class at Hillsboro High.

The young Grooms enjoyed the newspaper funny pages, tickled more by Orphan Annie or Jiggs than by the Terry Ward type of adventure story.[10] One of his favorite comics was "Smokey Stover," which contained constant visual and word puns. This strip, based around the activities of a dopey-looking fireman, reflected the same near surrealist humor found in the Marx Brothers routines. Red "especially [liked] the guy . . . up in the frame with his arm coming out at you. I was intrigued by something that would come out to the spectator. I like the aggression of the things. It's sort of like the stage, where you feel you can go right into the audience."[11]

Helene Connell, his high school art teacher, was the sister of playwright William Inge. She broadened Red's interest in art history by introducing him to the small Abrams paperback series on European masters, such as Georges Rouault, Pieter Brueghel, and James Ensor. He was particularly impressed by the book on Pablo Picasso, which kindled an attraction both to the man and his art that has never waned. A Museum of Modern Art traveling show of drawings at Nashville's Parthenon further expanded Red's art education. In contrast to the Watkins Institute's fusty canvases, here on view were drawings he found to be vital and energizing. He particularly responded to the work of George Grosz and Ben Shahn, and to a portrait of Edna St. Vincent Millay by Joseph Stella.[12]

As a high school student, Grooms flirted with the idea of becoming a commercial artist. Introduced to the magazine American Artist, he had been impressed with the liveliness and contemporaneity of the techniques of commercial illustration. In tenth grade, he enrolled in the Famous Artist School correspondence course in commercial art. Although his interest in these mail-order lessons dwindled when he began to learn more about the history

of art, a few of their techniques remained with him; for example, the school's emphasis on observation and the accurate memorization of details. In response to a journalist's question in 1976, Grooms described his personal definition of art: "I never much separated the forms of art. Movies first turned me on. Then I saw commercial art and liked that. Then I saw fine art and liked that. But I kept up with the first things and the vulgarity. I think vulgarity is kind of charming."[13]

As a teenager, Red often worked with soft-toned watercolors on toothy paper, drawing circus people, animals, or lone individuals. Impressionable, his early style reflected nearly every visual source he came across; for example, the work of Rouault and Picasso. "I learned by looking at stuff and [later] by meeting other artists. Just about everybody influenced me."[14] For example, figures in stovepipe hats, a favored motif of this period that Red retained well into his career, were most likely inspired by seeing an intact print of George Méliès's 1902 film, A Trip to the Moon.[15] By the time he was seventeen, his friend Louise LeQuire saw to it that Red was a member of the Nashville Artist Guild, which signified a degree of professional commitment.

When they were seniors in high school, Red and his friend Walter Knestrick exhibited thirty-five paintings at Myron King's Lyzon Gallery and frame shop in Nashville. Red had spent the summers of 1953 and 1954 working at the Lyzon. An early supporter of Red, King bought his drawings and hung them up in the front of his shop, along with work by such gallery artists as Chaim Gross, Moses Soyer, and David Burliuk. Grooms recalls that at about age eighteen he had a revelation while sitting with Walter Knestrick in a doughnut shop, at which point he suddenly declared, "I'm going to be a painter."[16] Red had recently seen the work of Jackson Pollock in another traveling show, which intensified his desire to create art of significance.

Grooms was to attain his aesthetic majority in the wake of Abstract Expressionism. Although he was excited by the work of many Action painters, he never felt comfortable working nonrepresentationally: "I tried to do abstract stuff [but would] never know where to stop. . . . [It seemed] all arbitrary. . . . I was painting from the surface."[17] Rejecting abstraction in favor of a then highly un-

fashionable figurative mode, Red would retain the Expressionists' emphasis on the stroke or gesture, as well as their insistence on an unpremeditated art act. Leaving Nashville at the age of nineteen, Red had the good fortune to gravitate toward several locations where he taught himself all that was necessary to complete his art education.

Red enrolled at the Art Institute of Chicago in the fall of 1955 and moved into the downtown Chicago YMCA. By his own description "a restless and undisciplined student,"[18] Red was frustrated at the prospect of waiting three years just to get into the student show. "I wanted action not education," he recently commented. Red spent most of his time in the Art Institute's museum and library, studying the work of Bernard Buffet, Jean Dubuffet, and Francis Bacon, his particular favorites at that time. His stay at the Institute soon came to an abrupt end: "One day I walked out leaving everything in my locker. My parents drove up and took me back to Nashville around Thanksgiving."

In January of 1956, Red came to New York City to study weekly at the New School of Social Research with Gregorio Prestopino, a painterly social realist whose work he had seen in Nashville. Living by himself at the McBurney YMCA on Twenty-third Street, Red was isolated from any community of artists but went to see many exhibitions, including those of Willem de Kooning, Philip Guston, and Franz Kline. On his first night in New York he saw Orson Welles's Othello, which precipitated a series of "psychological" drawings of people, including many fantasy characters, who were isolated on the page.[19] Sovereign Balloonist (pl. 1) dates from this first period in New York.

Grooms returned to Nashville for the summer of 1956 and stayed to spend the fall and spring terms in teacher training at Peabody College. Undertaken as a sincere effort to satisfy his parents' desire that he acquire practical career skills, Red found the program rather dull. He was anxious to continue working as an artist and did not wish to spend any more time in academic pursuits. By chance, Mrs. Grooms saw an article in Time magazine about the Hans Hofmann summer school in Provincetown and sent her twenty-year-old son north again.

Red fared no better as a student of the legendary Hofmann than he had under the tutelage of his Chicago in-

Fig 1. Yvonne Andersen and Red Grooms with their collaborative painting *Celebration of the Death of the Sun,* 1957.

structors or Prestopino. Grooms's aesthetic bent had been formed by age eighteen, and Hofmann's academic teaching methods left no room for Red's preference for figuration. Red dropped out halfway through the five-week course: "I went intending to be serious. But I just kind of lost interest."[20] Supporting himself as a dishwasher at the Moors Restaurant, Red became friends with a fellow worker, the poet Dominic "Val" Falcone. Sensing that "Charles," Grooms's given name, ill-matched the young artist's exuberant personality, Val Falcone nicknamed his friend "Red" because of his hair color, and the name stuck. Val and his wife, painter Yvonne Andersen, were then in their third year of running the Sun Gallery and attracted to them many of the most innovative and open-minded artists working in the East.

Yvonne had studied with Peter Kahn at Louisiana State University and like Red had been unimpressed with Hofmann's doctrinaire classes. In the summer of 1955, she and Val had opened the Sun Gallery in a former jewelry shop on Commercial Street.[21] They lived in the back of the small gallery, whose variable proportions could be changed by adjusting a partition wall. Shows were up for a week, opening Monday night at nine o'clock and closing at midnight on Sunday. During their first two seasons they held many group and solo shows, including those of Jan Müller, Lester Johnson, and Yvonne Andersen. In 1957— the summer Val and Yvonne met Red—Mary Frank, Lester Johnson, and Allan Kaprow were among those given exhibitions. Lester Johnson's expressionist style would be a major influence on Red's early work.

The Sun Gallery proved to be the perfect catalyst for Grooms. "Magical stuff was going on [and because] it was the opposite of the abstract people, I blossomed under their influence."[22] At the quaint New England ritual of the Blessing of the Fleet, during his first season in Provincetown, Red briefly met Mimi Gross, daughter of sculptor Chaim and Renée Gross, who were part of the well-established summer art colony there. Not until four years later were Red and Mimi to fall in love and team up together.

That summer Red and Yvonne worked on an idea of Val's to do a collaborative painting. Called the *Celebration of the*

Death of the Sun (fig. 1), the painting was executed at midnight over a period of several nights by the two of them wearing paper sacks with eye, nose, and mouth holes punched out. Wordlessly, with a sacramental air, they worked on the same surface, painting separate human heads. Picking up on a notion implicit in Action Painting, that the finished canvas is a visual record of the artist's private performance, Yvonne and Red turned the idea on its ear. Creating a representational image, anonymously and in tandem, the two embodied the antithesis of the macho ego display of Abstract Expressionism. And if earlier critics had used near religious terminology to describe the sacred arena in which the encounter of artist and material was enacted, the two painters gently ridiculed that hype by working within a context of high ritual.

The artists in the Sun Gallery circle were continually cross-fertilizing each other's work. Several months after Yvonne and Red's summer painting performance, in the spring of 1958, Allan Kaprow staged the well-known picnic for members of the Hansa Gallery at George Segal's New Jersey farm. The day's activities included the collective painting of a picture.[23] Although there was no direct connection between the two collaborative events, the Hansa and Sun Galleries shared many aesthetic concerns. Red later recalled that Kaprow's picnic performing events "opened things up" for him and his subsequent Happenings.[24]

That fall Red returned to New York and lived communally with Yvonne and Val in a loft on Twenty-fourth Street and Sixth Avenue. Red was twenty; Yvonne, twenty-five; and Val, thirty. The three shared all expenses and household chores and took turns at employment so that the others could be free to stay home and work in their studios. *The Scholar, L. E. Pant,* and *Walking Man* (pls. 10, 11, 12) date from this period. During that winter they bought a small handpress and produced the *City* (fig. 2). This portfolio, designed by Yvonne, contained prints by Red and Lester Johnson and poems by Val. Through his Provincetown friends Red soon met Alex Katz, Rudy Burckhardt, and George Segal. For employment, Red worked as an usher at the Roxy Theater. Dressed in the natty uniform of short gray jacket with silver epaulets, high-waisted pants, and

Fig 2. *City*, 1958, a portfolio of text and images.

gloves, Grooms spent seven months working and viewing the kind of Hollywood spectaculars that had so impressed him as a child.

When they returned to Provincetown in the late spring of 1958, Val proposed to his friends an outdoor billboard project that would bring art to the public, without cost. At the back of Val's father's parking lot, which edged the amusement park in Salisbury, Massachusetts, Yvonne and Red gathered unused telephone poles and erected twelve-by-twelve-foot panels in front of the roller coasters. Joined by Lester Johnson, they each painted a separate billboard. The underlying idea of the artist as public performer appealed to all of them, even if the onlookers' most frequent question was "When are you going to put in the words?"[25] Red's painting was of two large, long-legged figures walking in front of the parking lot and roller coasters, "kind of a scene of a scene,"[26] in his description. The boards stayed up for several years until they eventually fell apart. It was Red's first experience working on a monumental scale, an experience he would build upon nearly a decade later when he and Mimi Gross conceived the idea of the environmental sculpture the *City of Chicago*.

During the time he was working on the billboard, Red began making sculpture from debris he picked up on the beach. Two and a half years before, in his Chicago YMCA room, Red had initially explored the medium, constructing a standing figure out of Lake Michigan driftwood. Red recalls that it resembled the style of Reg Butler and Kenneth Armitage, and "was not totally out of the family" of his subsequent art.[27] In comparison with his two-dimensional work, Red found sculpture direct and concrete.

> There is a great difference between painting and sawing at wood, and I think sculpture is very good work because you start and you get closer and closer to the thing. Painting is very elusive; you can paint all day and be worse off than when you started. I think mostly in sculpture that it is going progressively and workmanlike towards the finish of the conception, but painting is demonic. . . . It's always escaping.[28]

That summer of 1958, the Sun Gallery shows included those of Alex Katz and Anthony Vevers, and Red Grooms's first solo exhibition. Acting on an idea generated by Val, Red included as part of his show a painting executed in public. An elaboration on the art-making performance of the year before, Red began with no plans about what he was going to paint, an attitude that he regarded as his version of existentialism. "I just came out and made a painting in front of the audience for forty-five minutes."[29] The improvisational factor was enhanced when, about halfway through, several rowdy sailors came up to the gallery window and began heckling Red, unbeknownst to the majority of the audience inside. Because Red could not address his hostile critics verbally, he expressed his rage on the canvas, developing an image of firemen engulfed in flames (pl. 15). Meanwhile, Yvonne went outside and talked the noisy crew into leaving. "I locked all the color I had laid down with a flurry of black lines, and it kind of gave a finish to it."[30] Red's sources for this innovative event, which would later be called a Happening, ranged from his understanding of the meaning of the words "Action Painting," an awareness of the theatrically staged painting performances of the French artist Georges Mathieu,[31] and his boyhood enthusiasm for entertaining a live audience with his own skits and plays.

That summer the Sun mounted two important group exhibitions based on the theme of the city. The first, "The Duality of City Life and Life in the Sun," was made up of paintings, sculptures, and writing by various members of the Sun circle. The second, simply called "The City," was a collaborative, large-scale installation/environment.[32] Yvonne Andersen's raw, free-standing figures, surfaced with black roofing cement, and her large, demolished tenement buildings established the harsh tone of brutal urban realities. Photographs by Robert Frank, poems by Dominic Falcone, charcoal drawings by Lester Johnson, and drawings by Red Grooms comprised the rest of the exhibition.

At the end of the season, Red returned to New York alone, Yvonne and Val having elected to stay in Provincetown for the winter to await the birth of their first child. Red found a small second-floor loft on Sixth Avenue near Twenty-fourth Street, where he lived for a short while be-

fore moving to a more spacious third-floor loft in a nearby building. He frequented the Cedar Bar and often walked to Greenwich Village to visit the Tenth Street art galleries. At the Phoenix Gallery, where he was briefly a member,[33] he met painter Jay Milder. Inspired by Val and Yvonne's sponsorship of the Sun Gallery and by the New York artists' cooperative Hansa Gallery, Red and Jay opened the City Gallery in Red's loft, which may well have been the earliest alternative art space in New York City.[34]

Red and his friends saw themselves as rebelling against the Tenth Street scene, where the prevailing taste favored Abstract Expressionism. "We were reacting to Tenth Street. In '58 and '59, Tenth Street was sort of like SoHo [is now], and it was getting all the lively attention of everyone downtown. . . . We were all just kids in our early twenties . . . [and] had a flair for attracting people to our openings."[35] When the Phoenix wouldn't show the work of their friend Claes Oldenburg, Red and Jay dropped out of it and gave Oldenburg his first show in New York. Jim Dine, who also made his New York debut at the City Gallery, did a mural in the stairwell. So did Stephen Durkee. Mimi Gross, who was then seeing Milder, showed there, as did Bob Thompson, Lester Johnson, and Alex Katz. A two-person show of works by Red and Jay was reviewed in *Art News*.

A self-described "beatnik artist"[36] with a limited income, Red worked with inexpensive hardware store enamels and tinting colors. The paintings of 1958–59 are primarily black, gray, and white, or earth reds. In these works, the emotional tone is set more by brushwork than by color (pls. 14, 19, 20). Their gestural style and figural content were close to the work of Lester Johnson, whom Irving Sandler has described as "an action painter with content."[37] Johnson was concerned with symbolizing the human condition, a theme also evident in Red's portraits and figure studies. Articulating the humanistic philosophy behind his early interest in the figure, Red unselfconsciously told Nashville art critic Clara Hieronymus in 1960: "I want to make some kind of strong statement about man in my paintings, such as a man standing up against the sky, wrapped in atmosphere and blowing his breath against the universe."[38]

Although he was never an abstractionist, Red fervently believed in the basic tenet of Action painting: "If you went out with *no* idea at all and you started struggling with your medium, you would come [back] with something new."[39] Like other Action painters Red tended to do his painting in one shot: "If [a painting] wasn't done in a frenzy it wasn't real. . . . The painting represented a pure emotion from beginning to end and was found in that emotion."

The summer of 1959 was the last season Yvonne and Val were in charge of the Sun Gallery. Among those given solo shows that year were Alex Katz, Anthony Vevers, and Lester Johnson. Around Labor Day, Lucas Samaras, Robert Whitman, and Allan Kaprow came up for a short visit. That summer Red began to move away from pure painting, adding collaged elements to his surfaces. *Three Bathers* (pl. 18), for example, done in the basement of the Sun, has corrugated cardboard augmenting and extending the canvas. *Letter from Home* (pl. 16) incorporates a handwritten note from his mother.

In the late fifties and early sixties, before the critical formulation of Pop art imposed sharper boundaries between them, Grooms, Dine, and Oldenburg shared a similar iconography. While rejecting Abstract Expressionism, they did not all take up figuration. Instead, they mined the subject, form, and associative content of clothing, using images of garments to imply human presence and behavior. One of Grooms's small but important works, *Shirt Collage*, 1959, present whereabouts unknown, formerly in the collection of Lincoln Kirstein, was made in part from a denim work shirt, complete with a cigarette pack in the pocket. Later Oldenburg fabricated numerous dresses, shirts, and shoes in a loose expressionist style, for his *Store*, 1961, and Dine would soon choose an uninhabited bathrobe as a metaphoric self-portrait.

Red's main production of the summer of 1959, staged late in the season, was a nonnarrative "play" entitled *Walking Man*. Its innovative format was derived in part from his high school skits and from the catalytic energies of the Sun Gallery circle. Through it, Red explored the fresh territory of the Happenings: "I had the sense that I knew it was something. I knew it was something because I didn't know what it was. I think that's when you're at your best point.

Fig. 3. Bill Barrell, Yvonne Andersen, Sylvia Small, Red Grooms, cast for *Walking Man*, 1959.

When you're really doing something, you're doing it all out, but you don't know what it is."[40] A curtain of bed sheets covered the set, which was fabricated from assorted metal and wood objects scavenged from the Provincetown dump. Yvonne and Val recall that it began with sounds of preparation, such as sawing, which underscored an implicit theme of construction *qua* performance.[41]

In response to a recent request to describe the action of *Walking Man* (fig. 3), which he had not considered since its presentation, Grooms recalled the following:

Possibly after some shadow play, the curtain was pulled back to reveal a vertical wooden box. It contained a few sparse parts with a hole cut in the back illuminated by a candle. Yvonne's lips, painted bright red and defined by white face paint, filled the hole like a movie close-up. Maybe she spoke the words "the walking man" very clearly and slowly and then blew out the candle.

The curtains were opened by me, playing a fireman wearing a simple costume of white pants and T-shirt with a poncholike cloak and a Smokey Stoverish fireman's helmet. Bill Barrell, the "star" in a tall hat and black overcoat, walked back and forth across the stage with great wooden gestures. Yvonne sat on the floor by a suspended fire engine. She was a blind woman with tinfoil-covered glasses and cup. During the premiere performance Val read some words of his own, but afterwards this was dropped. Sylvia Small, my girlfriend, played a radio and pulled on hanging junk. For the finale, I hid behind a false door and shouted pop code words. Then the cast did a wild run around and it ended.[42]

When Red returned to New York in the fall of 1959, he rented a loft at 148 Delancey Street, near the entrance to the Williamsburg Bridge. It had formerly been a boxing gym, and the back room was still full of lockers. Red slept there in a tiny cupola, which was also a skylight. The front facing Delancey was his studio area, the large central space being designated as a gallery, to which he gave the mock-grand name of the Delancey Street Museum. Here he presented a variety of exhibitions and two Happenings (pl. 22). One of these was Marcia Marcus's "unheralded ballet,"[43] *A Garden*. For this Happening leftover boxing posters were cut up into flower forms. Bob Thompson played

the bongos; Grooms depicted "the excitement of daytime"[44] and Richard Bellamy, then Director of the Hansa Gallery, wore a long flowing gown. "It was quite ceremonial—a lot of candle lighting. . . . [Dick's] robe caught fire and someone jumped out of the audience and put it out."[45]

The other performance Red presented in the Delancey Street Museum was *The Burning Building*, his own most successful and influential Happening. While the script was more developed than the script for its predecessor, *Walking Man*, it still left some things to chance: "It was not a literary idea but a kind of collage idea."[46] On opening night no one in the cast had a necessary match, and the event thus began with Bob Thompson soliciting the edgy audience for a light. This piece of spontaneous theater was included in all subsequent performances.[47] For his set Red had utilized many pieces of what he had assumed were abandoned furniture left by the former owners of the boxing gym. Shortly before the performance was set to open, four gangster types visited him to reclaim the items. Somehow Red managed to talk them out of tearing the set apart and they agreed to return later for their possessions. In all, *The Burning Building* was presented nine times. On one evening the audience consisted solely of Jim Dine.[48]

The Burning Building centered around the character of the Pasty Man, that "good-natured pyromaniac" of Judd Tully's description.[49] This anarchic alter ego appears in one form or another in all of Red's Happenings, and likely drew inspiration from the candle-carrying Fisk tire kid of his teenage skits. Images of firemen appear in Red's early paintings and populate the live performances. Cavorting around with their phallic helmets and pointy tools, those rambunctious "Groucho Marxist" fire fighters of Red's creation convey a host of associations, not the least of which is the energetic display of male sexuality.

Red traces his first awareness of fire's awesome potential to overhearing his mother questioning his father to determine if he smelled smoke in the house. He also recalls entertaining himself during long church services by daydreaming about the theatrical aspects of conflagrations.[50] Yvonne Andersen and Val Falcone remember Red's interest in witnessing fires in the late 1950s:

We would be walking along the street in New York, a fire engine would come by, and suddenly Red would disappear. We felt that he went to watch the color and excitement and get ideas for his paintings. We also thought he liked the idea of a team of people working together to solve a problem in a dramatic way.[51]

The dual threat and attraction of fire was elemental to the artist, whether he lived in the suburban South or a city tenement. In 1962, Allan Kaprow referred to Red as "a Charlie Chaplin forever dreaming about fire."[52]

The Magic Train Ride (originally titled *Fireman's Dream*), Red's third and final Happening of this period, was put on at the Reuben Gallery on Fourth Avenue. Bob Thompson, who understudied Terry Barrell in his role as Fireman in *The Burning Building*, was its star actor. Media and audience interest in Happenings was rapidly growing, and an opening night reviewer for the *Village Voice* spotted such "conspirators of the upper beat as Dr. Meyer Schapiro, Robert Frank, Howard Hart and Bernard Scott in the jammed audience".[53] As did his two earlier events, *The Magic Train Ride* unfolded before a set of Red's construction and featured several costumed actors, who emitted howls and soughings from backstage and "burst out from behind the scrim to stampede back and forth like buffalo children through the aisles."[54]

Red Grooms had his first solo show in New York in January 1960, at the legendary Reuben Gallery. Viewed by its founder, Anita Reuben, as "an outpost for human image art in a sea of Abstract Expressionism,"[55] it helped launch the careers of many important artists during its short life from October 1959 to April 1961. Among those who showed at the Reuben were: George Brecht, Jim Dine, Rosalyn Drexler, Martha Edelheit, Lester Johnson, Nicholas Krushenick, Claes Oldenburg, Robert Whitman, Lucas Samaras, George Segal, Richard Stankiewicz, and Robert Whitman. Referring both to the Happenings and the gallery exhibitions as the Reuben, Lawrence Alloway has observed that: "The city and its inhabitants was not only the *subject* of much of this art, it was also, literally, the *substance*, providing the texture and bulk of the material itself."[56]

The iconography of the city galvanized Grooms and his circle of friends in Provincetown and lower Manhattan. Their early Happenings, described as "animated collages" by Susan Sontag, utilized found materials. According to Sontag, Happenings resembled the involuntary collage principle of the modern city: "the brutal disharmony of buildings in size and style, the wild juxtaposition of store signs, the clamorous layout of the modern newspaper."[57] Derived in part from the chance encounters favored by the Surrealists, Happenings offered a radical mix of the found and the created, intelligible words (if not content), and undecipherable collisions which had the aggressive intent of unsettling the audience.

Although Red Grooms was only briefly involved in the world of Happenings, they were an enormously fertile influence on his subsequent career. The city and its dwellers were to become two of the major themes of his work; the collaborative process, which incorporated the element of chance occasioned by the numerous participants with their varying personal styles and points of view, continued in his films and such joint productions as *Ruckus Manhattan*. The Happening's "shock" effect on the audience, developed in part from Antonin Artaud's idea of a "theater of cruelty," remained a consistent undercurrent in Red's work, even when (or especially when) he was being most beguiling. The "curious dualism of optimism and anarchy," which Max Kozloff had found inherent in the Happenings genre,[58] was to be an abiding characteristic of Red's aesthetics.

The first six months of 1960 brought Red an expanded audience, as his reputation began to grow beyond the avant-garde circles of lower Manhattan. Word of the influential *Burning Building* was brought to uptown dealer John Bernard Myers by both Robert Rauschenberg and Fairfield Porter.[59] Porter, an early and enthusiastic supporter, had singled Grooms out of a February group show at the Reuben to praise his vitality in *The Nation*. The 1960–61 season at the Reuben was the height of public attention to Happenings, but Red did not participate. Reflecting on the reasons he dropped away, Red later commented that he had become self-conscious and had lost the thread of what he was doing: "I started to think about writing a little bit. And I got on very shaky ground."[60]

The watershed exhibition "New Media—New Forms I" at the Martha Jackson Gallery in June 1960, which formally introduced such new movements in art as assemblage and proto-Pop to a wider, uptown audience, included one relief sculpture by Grooms—*Policewoman*, 1959 (pl. 21). With sgraffitoed features and bedspring curls, this one-legged, scrapwood crossing guard was positioned against an oval tabletop. Unlike Picasso's well-known Cubist work, *Still Life with Chair-caning*, 1912, which cunningly used braided rope to mimic the look of gadroon molding, the ornamental border of Red's oval table read literally. In *Policewoman* Grooms engineered the wholesale transformation of his street-found materials into art. In reviewing "New Media—New Forms," the perspicacious Thomas B. Hess seemed to foretell the coming public acclaim of both Pop art and Grooms's work:

> There is a kind of protest in many of these works, but it is not against the values of middle-class society as were the Dada manifestations. Rather the new protest is in favor of society—or for People in general—and against the invisible, crystal-hard barriers that an oil-on-canvas or sculptured-sculpture place between the witness and the finished object. It is as if many of these artists were trying to reach out from their works to give the spectator's hand a good shake or nudge him in the ribs.[61]

An avant-garde celebrity with a growing uptown reputation, Grooms was at the threshold of a new phase of his career when he precipitously left New York in June 1960 to spend the next eighteen months abroad. Changed by his travels, he was to return to a changed art world. Grooms's former colleagues, Jim Dine and Claes Oldenburg, were enjoying the rush of public attention to Pop art, a newly formulated critical category. Although he shared many of their concerns with popular imagery, Grooms would never fit within the profile of Pop, his art being more engaged and accessible than that of his peers. In the interim, Grooms's painting style had shifted, strongly influenced by the high-key colors, bold compositions, and everyday subjects of the Italian Macchiaioli group. Once back in New York, he immersed himself in a yearlong project, creating his first feature film, *Shoot the Moon*.

Many years later, in a conversation with Grace Glueck, Grooms commented: "My work is about exits and entrances,"[62] referring to the subway turnstile section of *Ruckus Manhattan*. But Grooms's career also concerns exits and entrances, for more than once he was to redirect his art by leaving the familiar for the unknown. It is a sign of his genius as an artist that when he returns, refreshed and strengthened, he invariably picks up in a different place from where he left off.

Notes

1. Red Grooms, interview with the author, April 1982.

2. Cf. Barbara Haskell, *Blam!, The Explosion of Pop, Minimalism and Performance 1958–1964*, exhibition catalogue (New York: Whitney Museum of American Art, 1984); *The Early Sixties: Red Grooms and Peter Saul*, exhibition catalogue (New York: Allan Frumkin Gallery, 1983).

3. From the transcript of an interview conducted for the Archives of American Art, Smithsonian Institution, by Paul Cummings, March 4, 1974, p. 4. Grooms also mentioned the trip to Jerry Tallmer: "That [three-mile] walk was a big influence on my life . . . a movement into the heart of the city." "A Little City With a Big Art," *New York Post*, June 19, 1976, p. 36.

4. Quoted in Paul Richard, "Red Grooms: An Appreciation," *Red Grooms: A Catalogue Raisonné of his Graphic Work 1957–1981* (Nashville: The Fine Arts Center, Cheekwood, 1981), p. 10.

5. Interview with the author, December 1984.

6. Red Grooms, "A Statement," Michael Kirby, ed., *Happenings—An Illustrated Anthology* (New York: E. P. Dutton & Co., 1965), p. 118.

7. Cummings interview, p. 10.

8. Notes to the author, December 1984.

9. Cummings interview, p. 78.

10. Cummings interview, p. 147. Grooms was here contrasting his taste with the prevailing style of comics favored by the Pop artists.

11. Quoted in Michaela Williams, "Son of Smokey Stover," *Chicago Daily News*, Dec. 30, 1967, p. 5. From time to time Red has used Smokey Stover as an alter ego. A poem he wrote to accompany the entry on his work *The Patriots' Parade*, 1967, for the exhibition catalogue *New York Collection for Stockholm* (Stockholm: Moderna Museet, 1973), is titled "Smokey Stover Visits The Holocaust."

12. From the transcript of an interview by an unknown interviewer with Red Grooms and Marisol, on deposit in the Archives of American Art, Smithsonian Institution, 1965, p. 15.

13. Amei Wallach, "Making New York a Fun City," *Newsday*, Part II (May 9, 1976), p. 5.

14. Quoted in Todd Strasser, "Interview: Red Grooms," *Ocular*, 4 (Winter 1979), p. 53.

15. Notes to the author, December 1984.

16. Cummings interview, p. 24.

17. Cummings interview, p. 28.

18. This and the following two quotes are from notes to the author, December 1984.

19. Cummings interview, p. 31.

20. Notes to the author, December 1984.

21. Cf. *The Sun Gallery*, exhibition catalogue (Provincetown: Provincetown Art Association and Museum, 1981); Dorothy Gees Seckler, *Provincetown Painters* (Syracuse, NY: Everson Museum, 1977), pp. 256–57.

22. Cummings interview, p. 37.

23. Calvin Tomkins, *Off the Wall* (Garden City, NY: Doubleday & Co., 1980), pp. 151–52.

24. Quoted in Barbara Haskell, *Blam!*, p. 35.

25. *The Sun Gallery*, p. 20.

26. Cummings interview, p. 38.

27. Notes to the author, December 1984.

28. Grooms and Marisol interview, p. 30.

29. Cummings interview, p. 49.

30. Notes to the author, December 1984.

31. Cummings interview, p. 52.

32. *The Sun Gallery*, pp. 20–21.

33. Cf. Faye Hammel, "Protest on Tenth Street," *Cue* (March 28, 1959), pp. 18, 39. Although he is not named in the text, Grooms is pictured in a group portrait of Phoenix Gallery members, second from the right in the top row, p. 18.

34. Barbara Haskell, *Blam!*, pp. 19–20.

35. Quoted in Dave Rettig, "Kind of Controlled Chaos," *Artlines*, 4 (May 1983), p. 6.

36. Cummings interview, p. 36.

37. Irving Sandler, *The New York School: The Painters and Sculptors of the Fifties* (New York: Harper & Row, 1978), p. 126.

38. Clara Hieronymous, "Nashville Artist Now in Europe," *The Tennessean* (July 24, 1960).

39. This and the following quote are from Cummings interview, pp. 47–48.

40. *Ibid.*, p. 29.

41. Conversation with the author, February 1984.

42. Notes to the author, December 1984.

43. Cummings interview, p. 63.

44. Fred McDarrah, *The Artist's World in Pictures* (New York: E.P. Dutton & Co., 1961), p. 184.

45. Cummings interview, p. 63.

46. *Ibid.*, p. 59.

47. Michael Kirby, "The Burning Building: The Production," in *Happenings* (New York: E. P. Dutton & Co., 1965), p. 125.

48. Cummings interview, p. 62.

49. Judd Tully, *Red Grooms and Ruckus Manhattan* (New York: George Braziller, 1977), p. 7.

50. Conversation with the author, December 1984.

51. Notes to the author, November 1984.

52. Quoted in Harriet Janis and Rudi Blesh, *Collage: Personalities, Concepts, Techniques* (Philadelphia: Chilton Co., 1962), p. 274.

53. Jerry Tallmer, "Theatre (?): Three New Happenings," *The Village Voice* (January 13, 1960), p. 9.

54. *Ibid.*

55. Quoted in Lawrence Alloway, "Introduction," *Eleven from the Reuben Gallery*, exhibition catalogue (New York: Solomon R. Guggenheim Museum, 1965), unpaged.

56. *Ibid.*

57. Susan Sontag, "Happenings: An Art of Radical Juxtaposition" (1962), in *Against Interpretation* (New York: Farrar, Straus & Giroux, 1966), p. 270.

58. Max Kozloff, "Art and the New York Avant-Garde," *Partisan Review*, 31 (Fall 1964), p. 550.

59. John Bernard Myers, *Tracking the Marvelous* (New York: Random House, 1983), p. 202.

60. Cummings interview, p. 54. Grooms did two subsequent Happenings, *Berkeley Eruption*, 1968, and *Hippodrome Hardware*, 1972.

61. Thomas B. Hess, "Mixed Mediums for a Soft Revolution," *Art News*, 59 (Summer 1960), p. 45.

62. Quoted in Grace Glueck, "The City's Biggest Gallery Show Twits the City," *New York Times*, June 13, 1976, sec. 2, p. 35.

Early Work: 1956-1960

"You paint for yourself first, then for your friends, and then for the people you would like to know."

Nashville Banner, 1961

1. **Sovereign Balloonist** 1956
 Pencil on paper
 16⅝ x 14"
 Collection Saskia Grooms, New York, NY

2. **Jack Johnson Fighting Jeffries** 1956
Ink on paper
11 1/16 x 8 5/8"
Collection Red Grooms, New York, NY

3. **Self-Portrait** 1957
 Wash on paper
 11 ½ x 8 ¹³⁄₁₆″
 Collection Saskia Grooms, New York, NY

4. **Carnival Crowd** 1957
Reed pen and ink on paper
8⅞ x 1¾"
Collection Dominic Falcone and Yvonne Andersen, Lexington, MA

5. **The Operation** 1957
 Reed pen and ink on paper
 12³⁄₈ x 9³⁄₈"
 Collection Dominic Falcone and Yvonne Andersen, Lexington, MA

6. **Black Man** 1957
 Reed pen and ink on paper
 12⅜ x 9⅜"
 Collection Dominic Falcone and Yvonne Andersen, Lexington, MA

7. **Camel Cigarettes** 1957
Reed pen and ink on paper
11 x 8½"
Collection Dominic Falcone and Yvonne Andersen, Lexington, MA

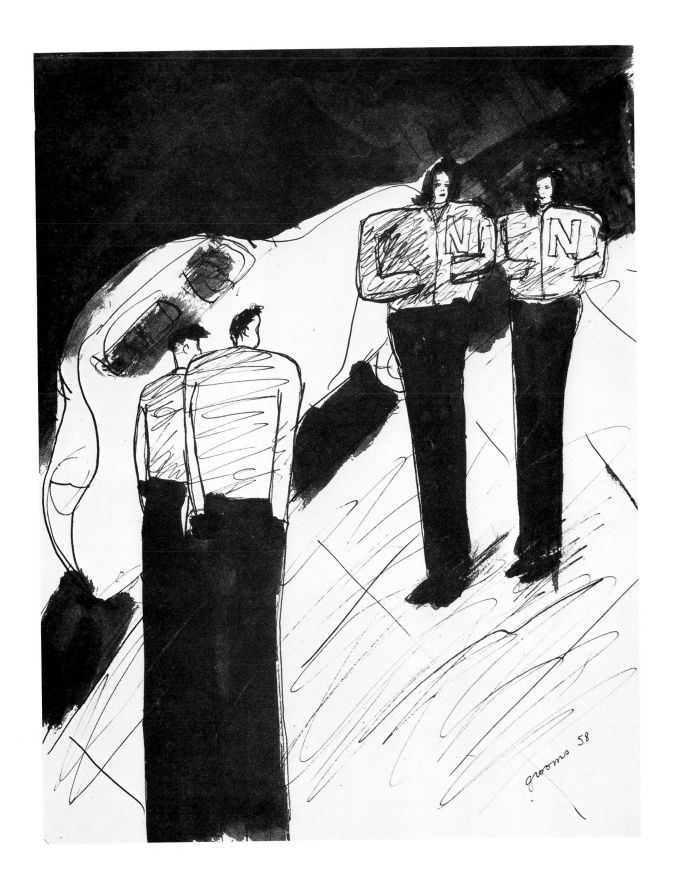

8. **Sidewalk with Teenagers** 1958
Reed pen and ink on paper
11½ x 9"
Collection Dominic Falcone and Yvonne Andersen, Lexington, MA

9. **City Boy** 1957
 Oil on canvas
 14⅛ x 20"
 Collection Mr. and Mrs. R.G. Grooms, Nashville, TN

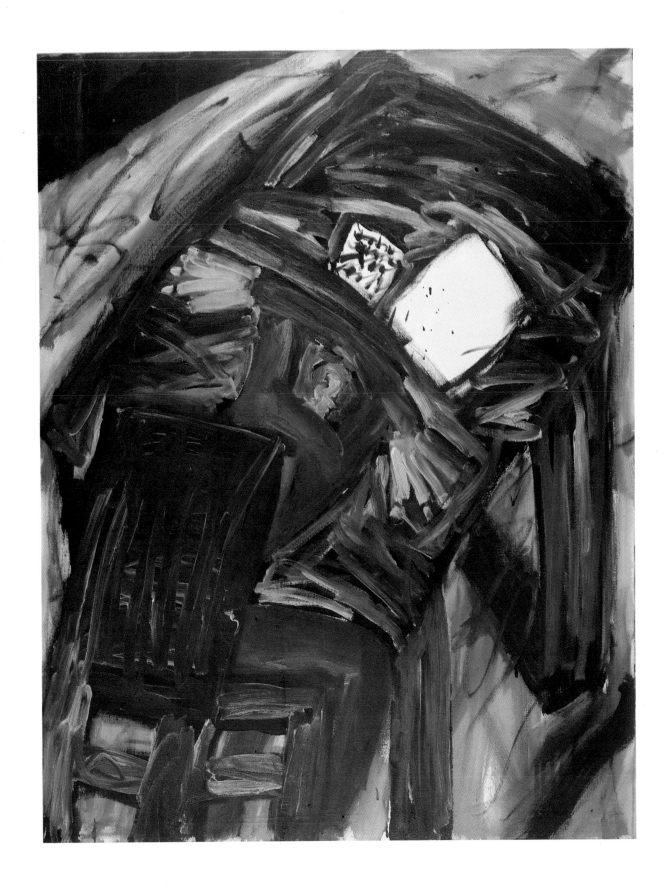

10. **The Scholar** 1957
 Oil on canvas
 49 x 38"
 Collection Red Grooms, New York, NY

11. **L. E. Pant** 1957
 Oil on canvas
 12 x 12"
 Collection Mimi Gross, New York, NY

12. **Walking Man** 1957
Oil on canvas
25¼ x 25¼"
Collection Dominic Falcone and Yvonne Andersen, Lexington, MA

13. **Fireman** 1958
Oil on canvas
50 x 50"
Private collection

14. **Winter Man** 1958
 Oil on canvas
 48 x 48″
 Collection Barry M. Cohen, Alexandria, VA

15. **Painting Done During Play Called Fire** 1958
Oil on canvas
54 x 91"
Collection Red Grooms, New York, NY

16. **Letter from Home** 1959
 Oil on canvas with collage
 12¼ x 14¼"
 Collection Patty Mucha, St. Johnsbury, VT

17. **The Kiss** 1959
 Oil on plastic tray and cardboard
 27½ x 21"
 Collection Alfonso A. Ossorio, East Hampton, NY

18. **Three Bathers** 1959
Oil and cardboard on canvas
35 x 66¼"
Collection Saskia Grooms, New York, NY

19. **Man Smoking** 1959
 Oil on canvas
 26 x 24"
 Collection Brooke Larsen, New York, NY

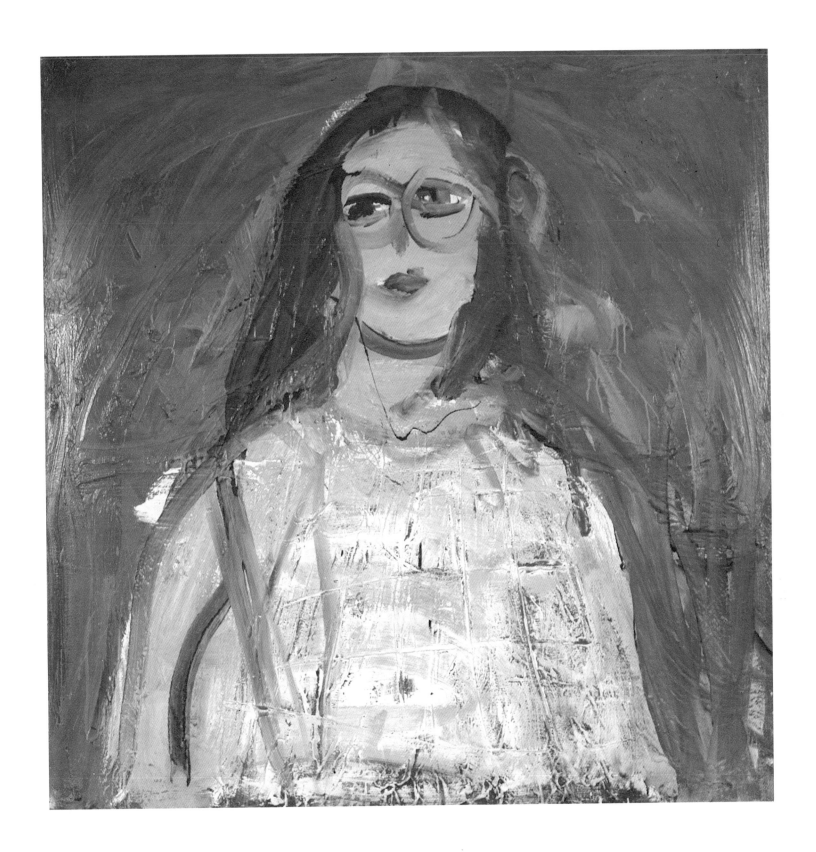

20. **Joan** 1959
Oil on canvas
48 x 48″
Collection Louise and Virgil LeQuire, Franklin, TN

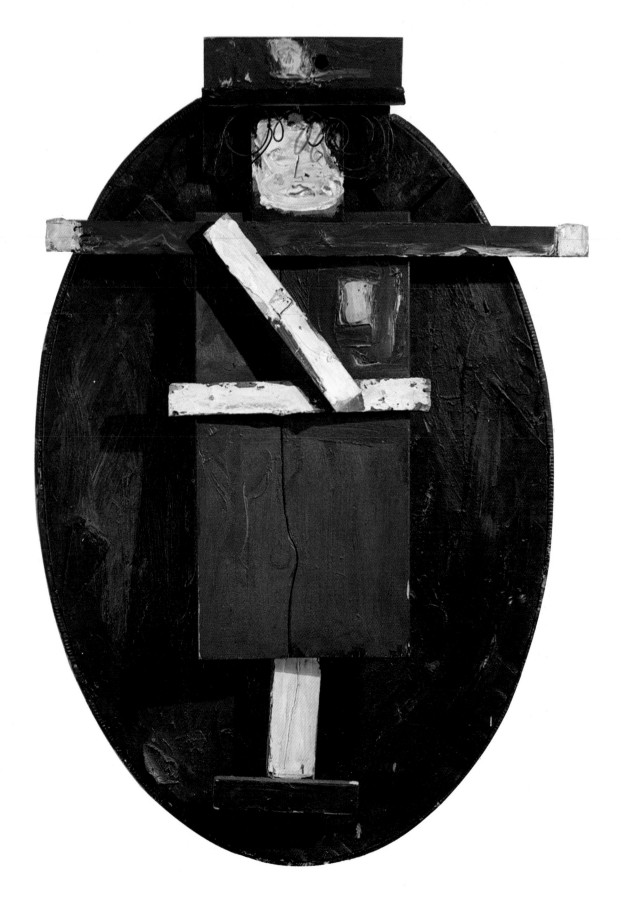

21. **Policewoman** 1959
 Object relief: tabletop and other street-found materials, wood, metal, paint
 45 x 29 x 10"
 Collection Mr. and Mrs. David Anderson, New York, NY

22. **Delancey Street Museum** 1960
 Reed pen and ink on paper
 13½ x 16¼"
 Collection Saskia Grooms, New York, NY

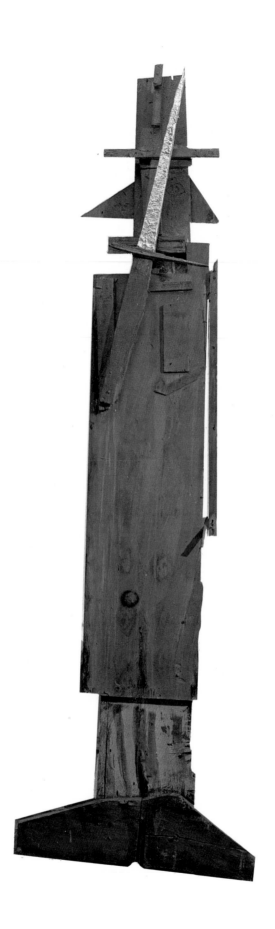

23. **Confederate Soldier** 1960
Painted wood, nails, metallic foil
75 x 12½ x 12″
Collection René Low, New York, NY

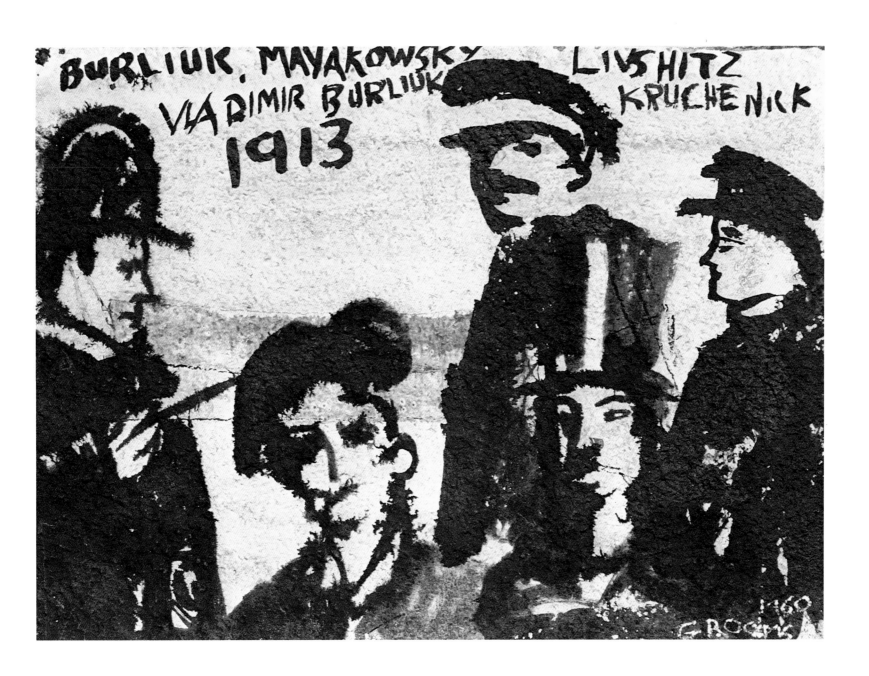

24. **The Russians** 1960
Ink and wash on paper
11 x 15"
Collection Gertrude and Benjamin H. Caldwell, Nashville, TN

25. **Bob Thompson** 1960
 Reed pen and ink on paper
 14 x 17"
 Collection Louise and Virgil LeQuire, Franklin, TN

26. **Portrait of Bill Woods** 1960
Wash on paper
17 x 14″
Collection Red Grooms, New York, NY

Circle of Family and Friends

"I like to make sort of documentaries. Something you can see as it happens—what people wear and do."

Time, 1965

27. **Portrait of the Artist's Father** 1961
 Ink on paper
 13¾ x 16⁹⁄₁₆″
 Collection Saskia Grooms, New York, NY

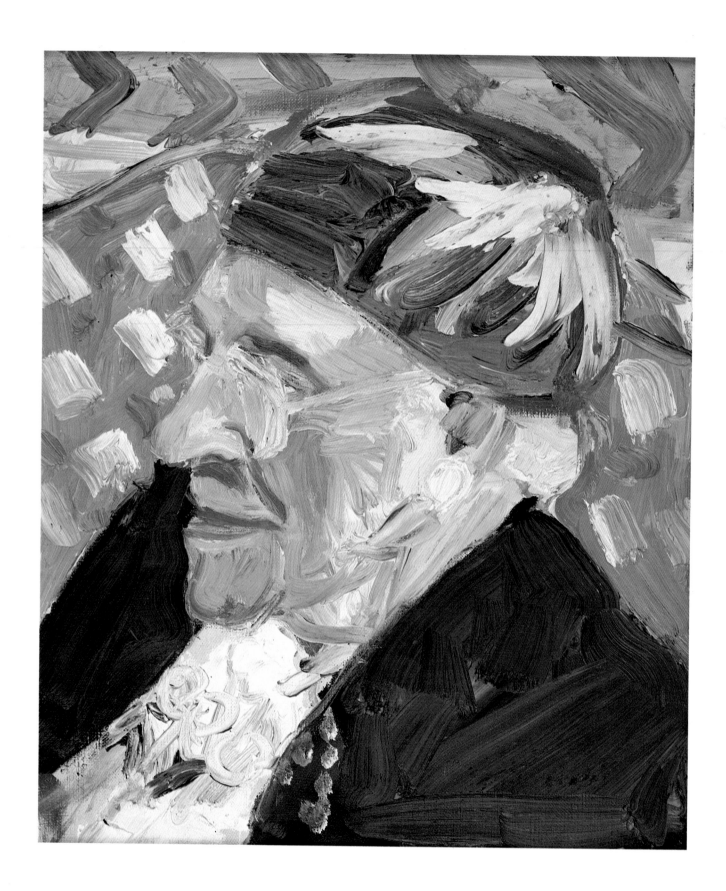

28. **Portrait of Annie Hillis Grooms** 1964
Oil on canvas
14⅛ x 12″
Collection Mr. and Mrs. R.G. Grooms, Nashville, TN

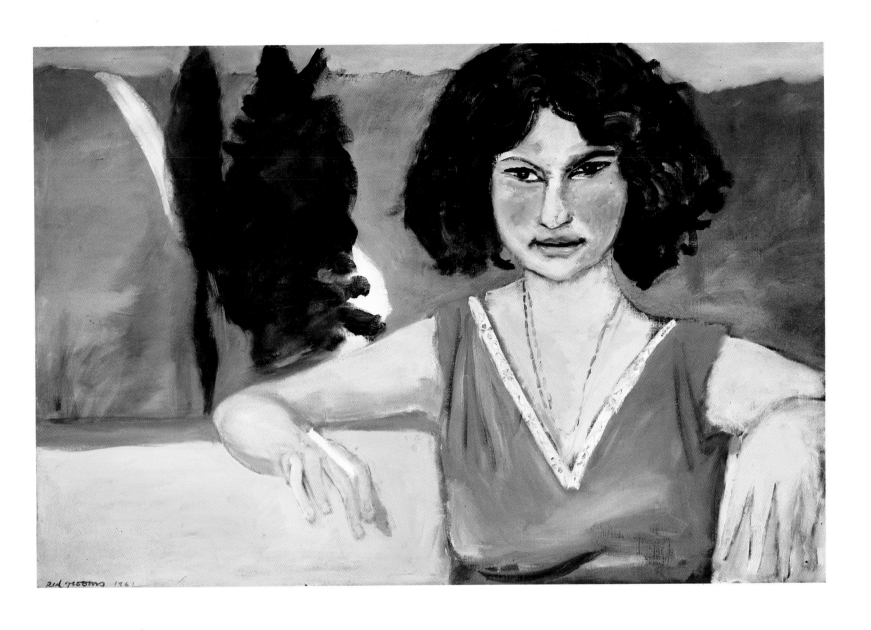

29. **Portrait of Mimi with Italian Landscape** 1961
Oil on canvas
39¼ x 58¾"
Collection Paul Suttman, Brooklyn, NY

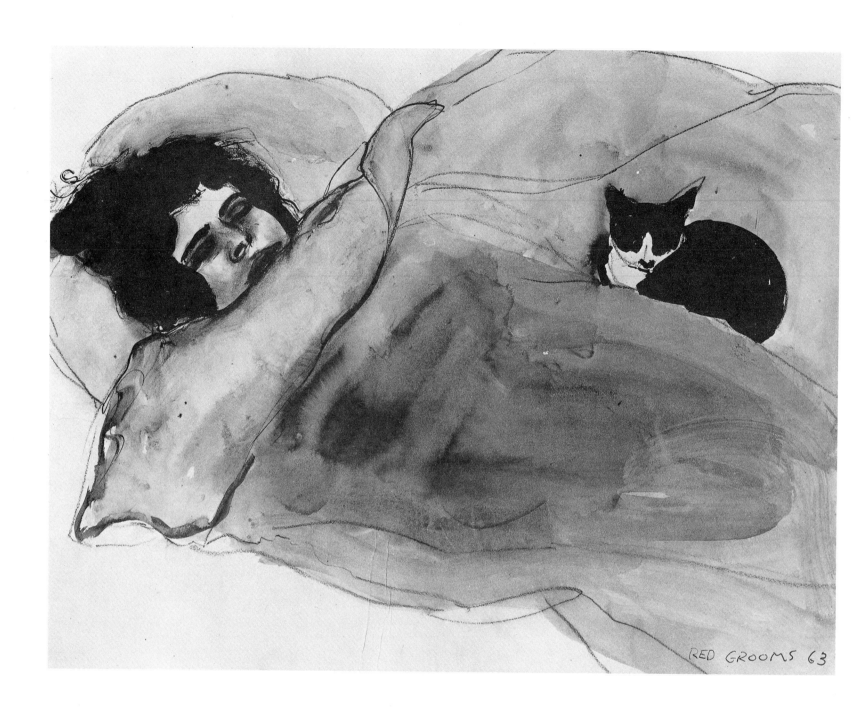

30. **Mimi Asleep with Cat** 1963
Wash on paper
18 x 23"
Collection Renee and Chaim Gross, New York, NY

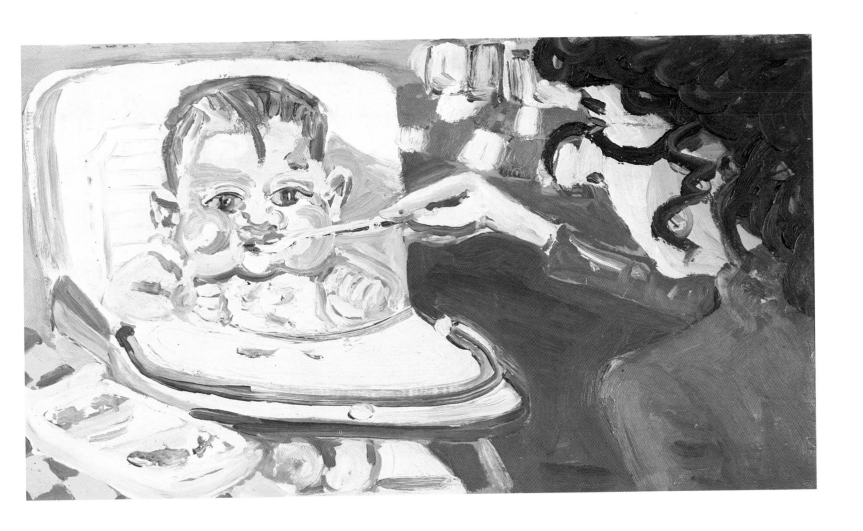

31. **Spoonfed** 1972
Oil on wood
9½ x 17"
Collection Saskia Grooms, New York, NY

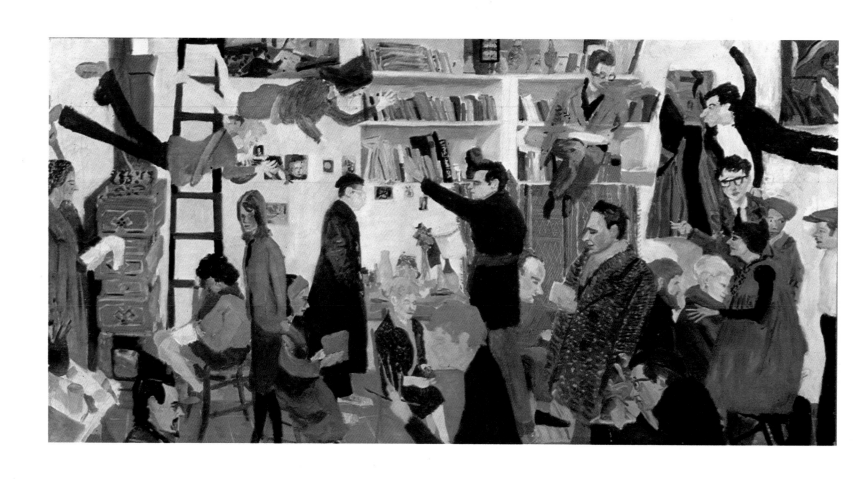

32. **Via Guelfa Studio** 1960-61
Oil on canvas
44½ x 86″
Collection Saskia Grooms, New York, NY

33. **Gwen** 1961
Oil on canvas
10 x 24″
Collection Mr. and Mrs. R.G. Grooms, Nashville, TN

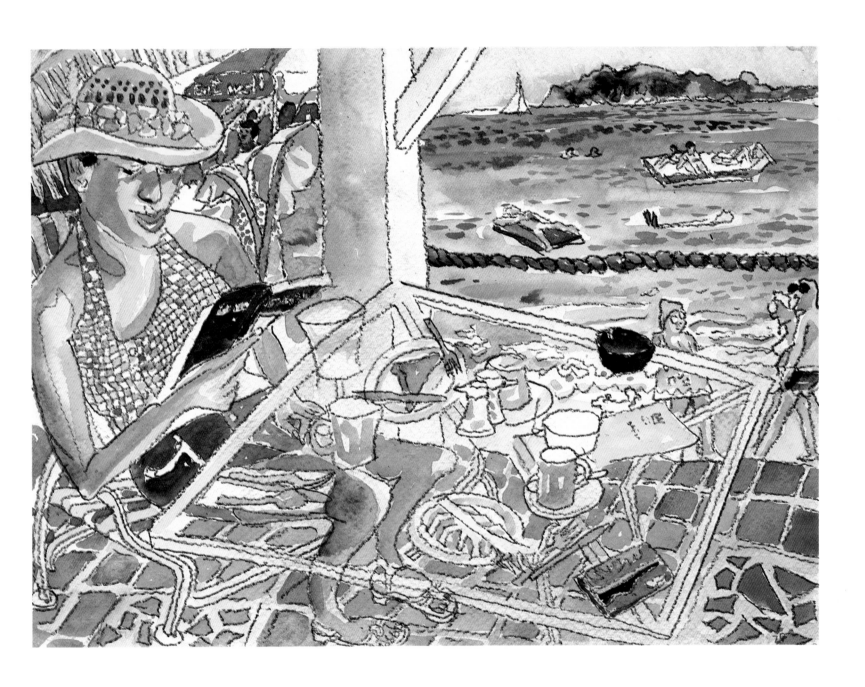

45. **Transparent Breakfast Table, St. Thomas** (Jill) 1978
Watercolor
11 x 15″
Collection Mr. and Mrs. Walter G. Knestrick, Nashville, TN

46. **Room 227** 1978
Gouache on watercolor board
30 x 45"
Collection Everson Museum of Art, Syracuse, NY
Gift of the Artist through Syracuse University

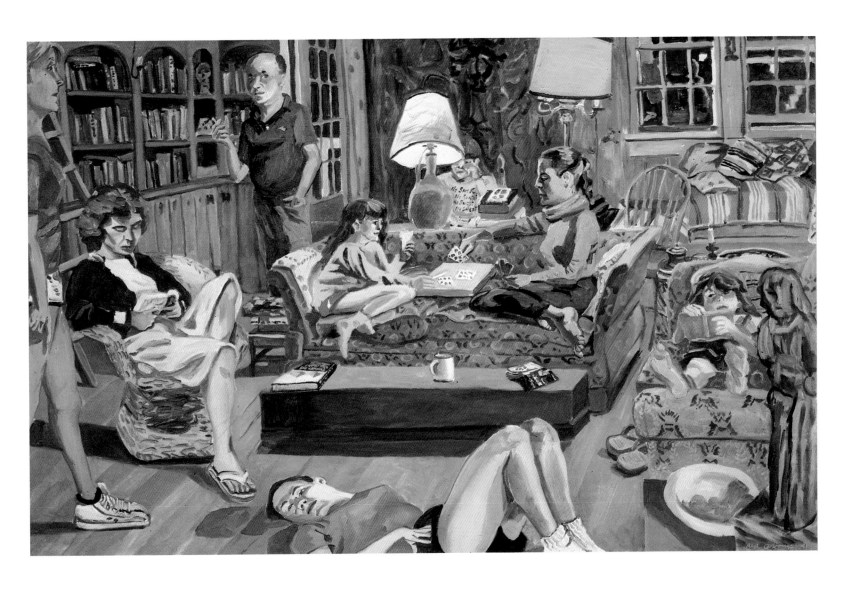

47. **The Living Room** 1981
Oil on canvas
28 x 44″
Collection Red Grooms, New York, NY

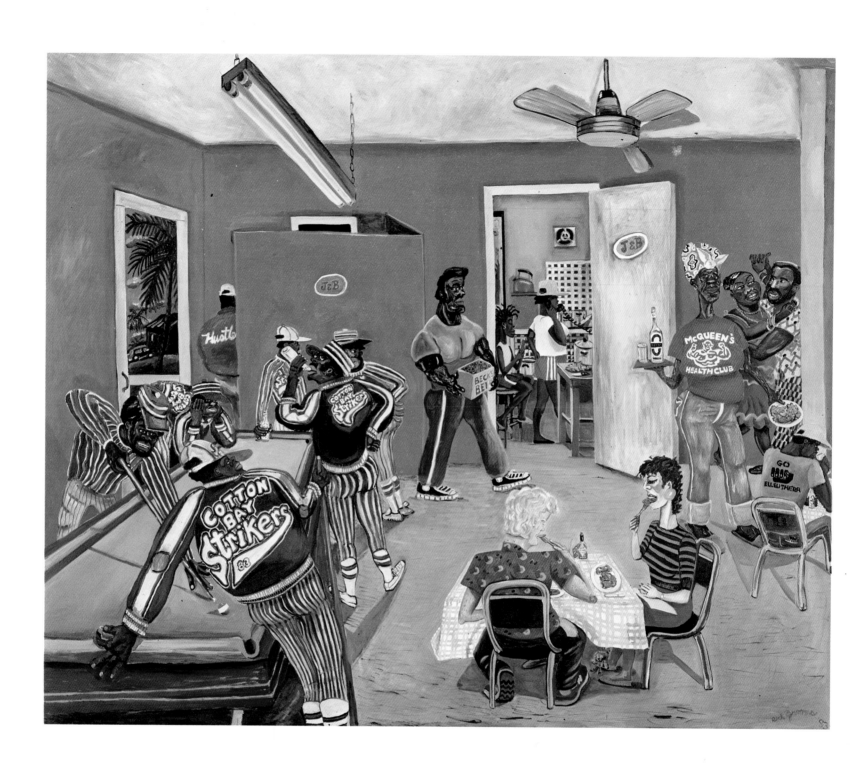

48. **Blue Restaurant** 1983
 Oil on canvas
 90 x 74"
 Collection Frederick R. Weisman Foundation of Art, Los Angeles, CA

The City

"The city is a gigantic room where you can hide. In the country you have nature. In the city you have other people to cover up your loneliness."

Newsweek, 1967

49. **The Builder** c. 1962
Ink on paper
11 x 8⅛"
Collection Mimi Gross, New York, NY

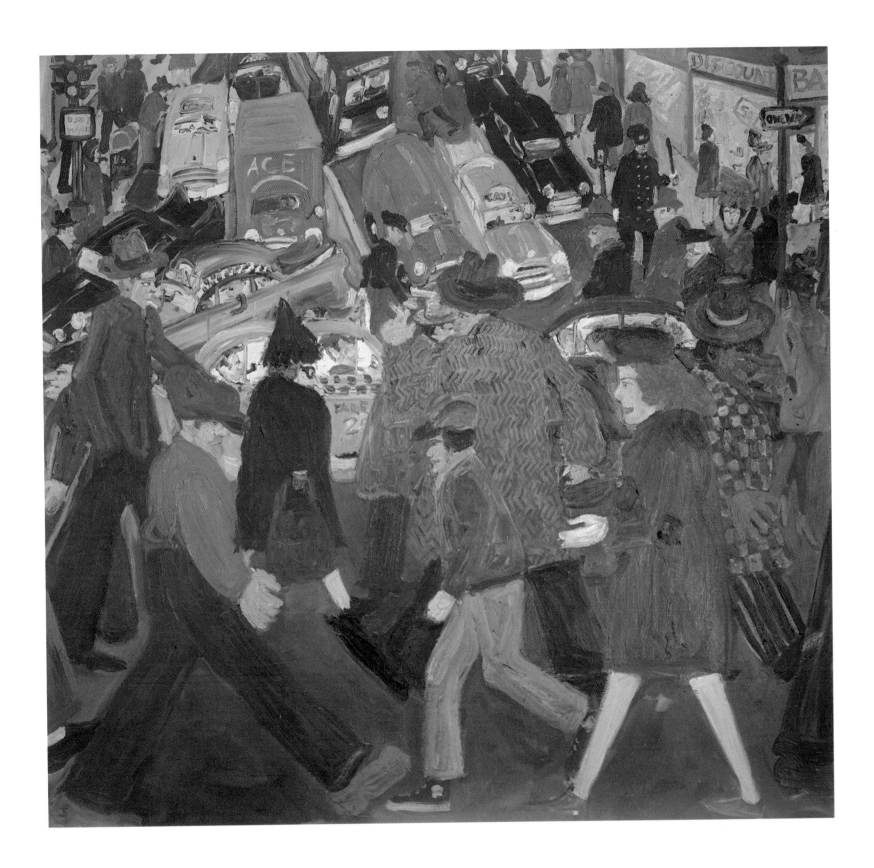

50. **Don't Walk** 1963
Oil on canvas
72 x 77"
Private collection

51. **Purple Umbrella** 1964
Oil on canvas
50¼ x 50¼"
Collection Hirshhorn Museum and Sculpture Garden,
Smithsonian Institution, Washington, DC

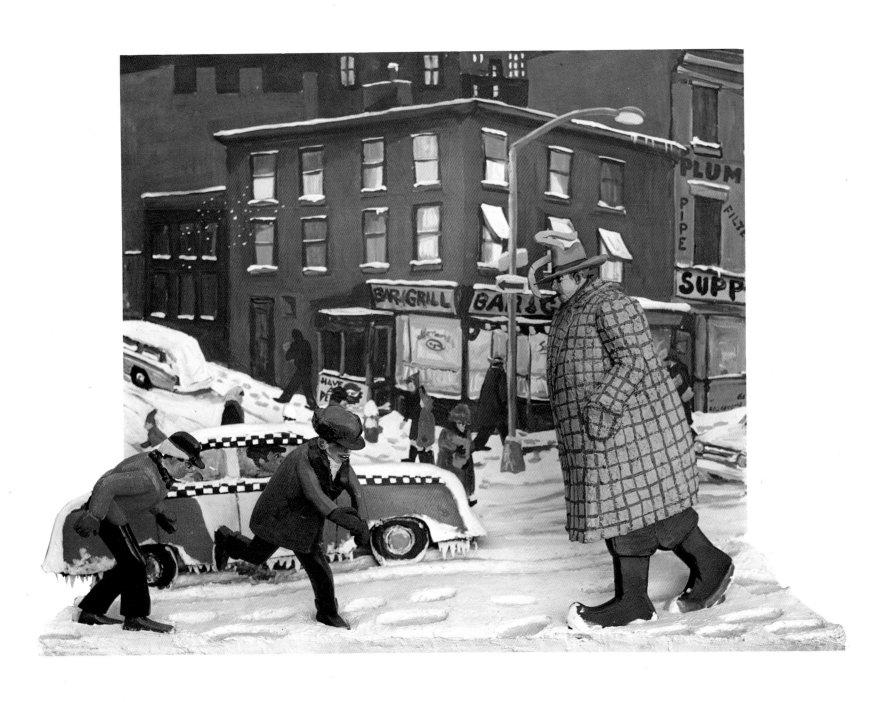

52. **Eighth Avenue Snow Scene** 1965
Acrylic on wood
37 x 49 x 10½"
Collection Kimiko and John Powers, New York, NY

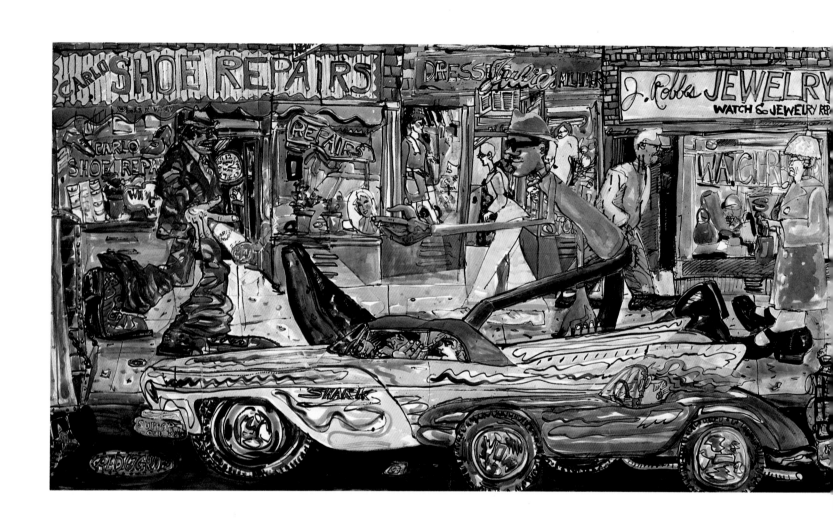

53. **Seventh Avenue Between 22nd and 21st Streets, New York City** 1967
Ink and mixed media on two panels
Each panel: 51 ½ x 91"
Collection Frederick and Jan Mayer, Englewood, CO

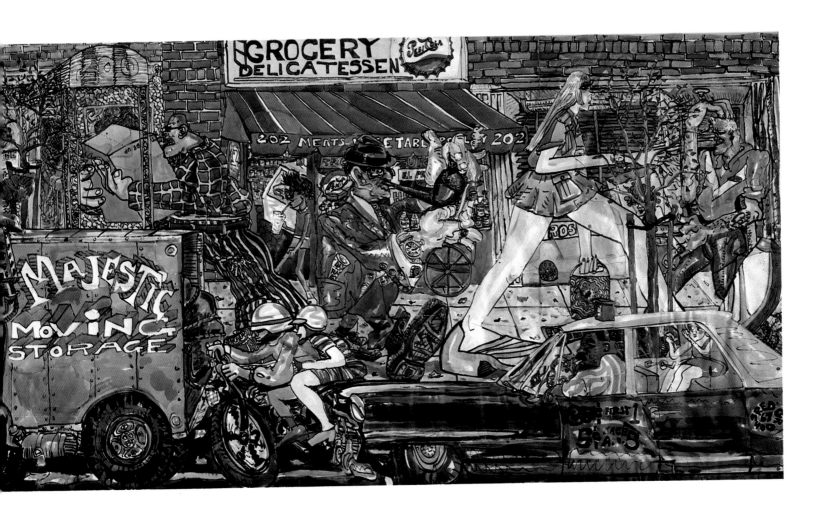

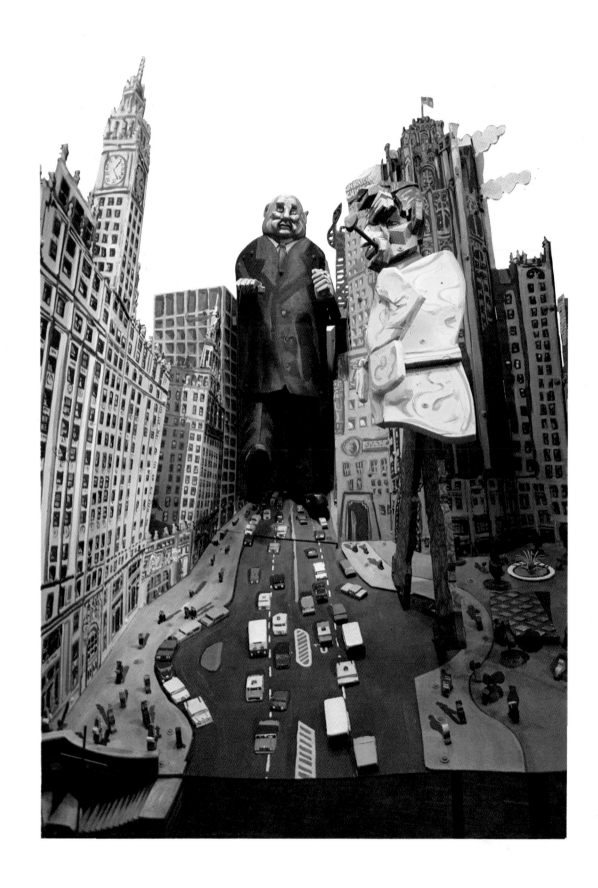

54. **City of Chicago** (Mimi Gross and Red Grooms.
Assisted by Rusty Morgan and Edward C. Flood) 1967 (*detail*)
Mixed media and mechanical parts
12 x 25 x 25'
Collection Art Institute of Chicago,
Gift of Maggie Magerstadt Rosner

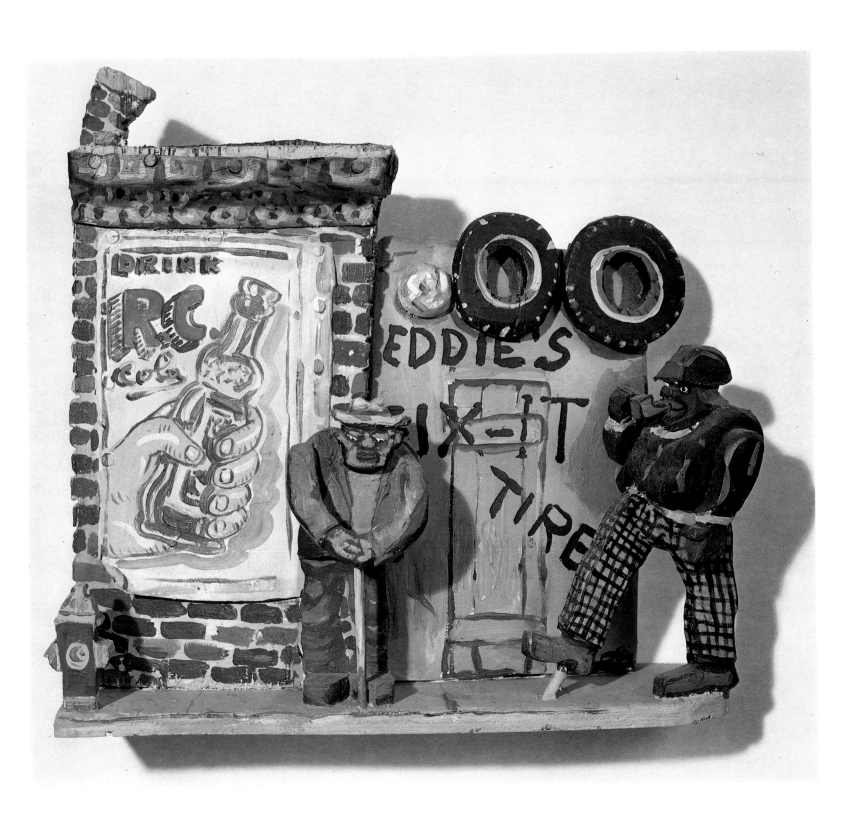

55. **Nashville Street Scene** 1970
Acrylic on wood and tin
14 x 15″
Collection Mimi Gross, New York, NY

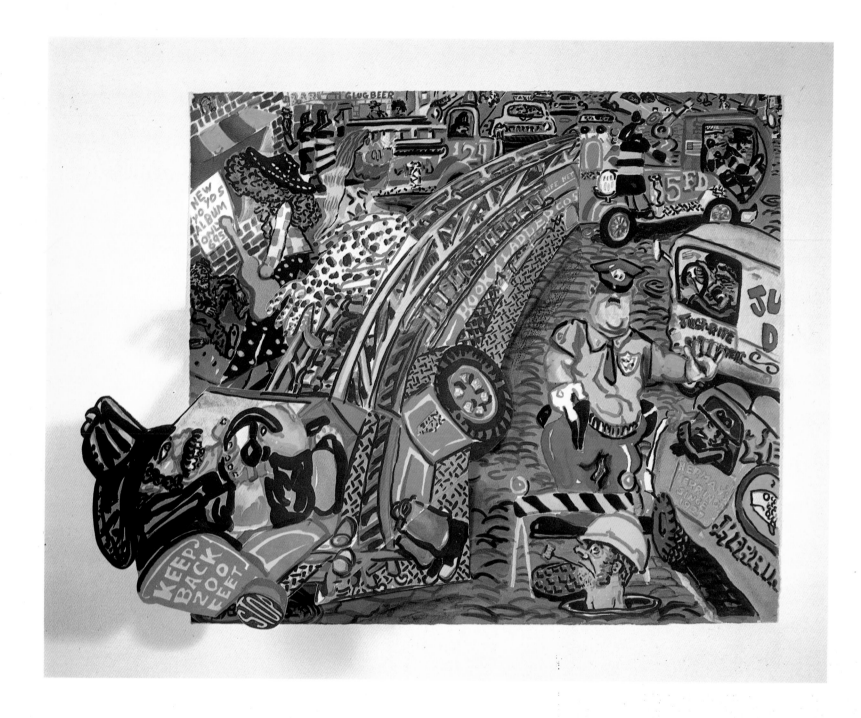

56. **AARRRRRRHH** 1971
 Color lithograph on Arches Cover
 22 x 28"
 Published by Harry N. Abrams, Inc.
 Chromatist: Jean Pierre Remond
 Collection Saskia Grooms, New York, NY

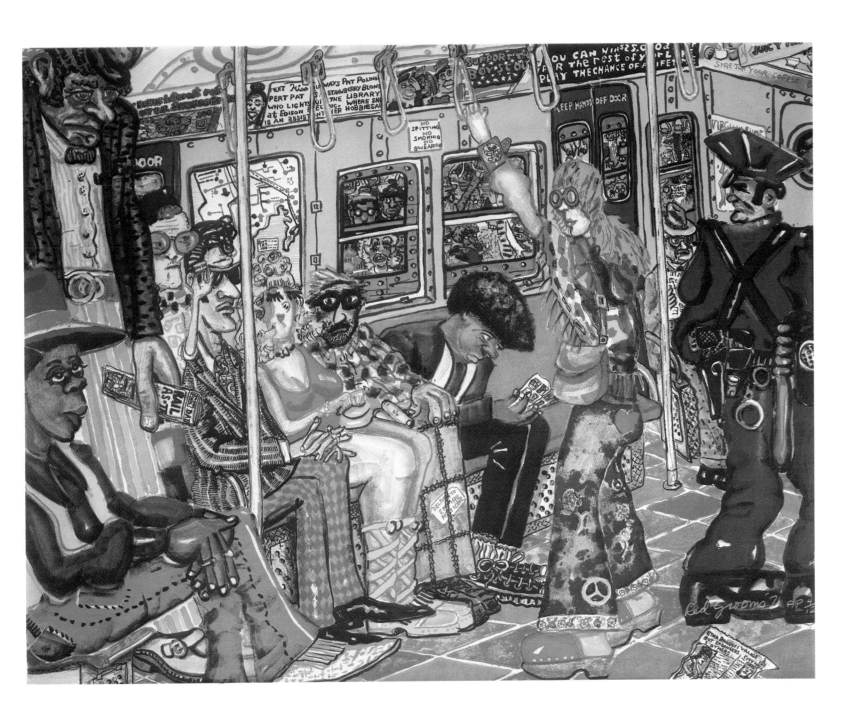

57. **Local** 1971
Color lithograph on Arches Cover
22 x 28″
Published by Harry N. Abrams, Inc.
Chromatist: Jean Pierre Remond
Collection Saskia Grooms, New York, NY

58. **Night Floater** 1974
Watercolor
25½ x 40″
Collection Mimi Gross, New York, NY

59. **O.T.B. Strut** 1974
 Gouache and crayon on paper
 22½ x 30½"
 Collection Mr. and Mrs. Walter G. Knestrick, Nashville, TN

60. **Harry Watley's Mad Dash up Walker Street** 1975
Gouache on paper
42 x 30"
Collection Dolores and Stanley Feldman, Lynchburg, VA

61. **Canal Street Molls** 1975
 Gouache on paper
 39¾ x 25¼"
 Collection Dr. Jack E. Chachkes, New York, NY

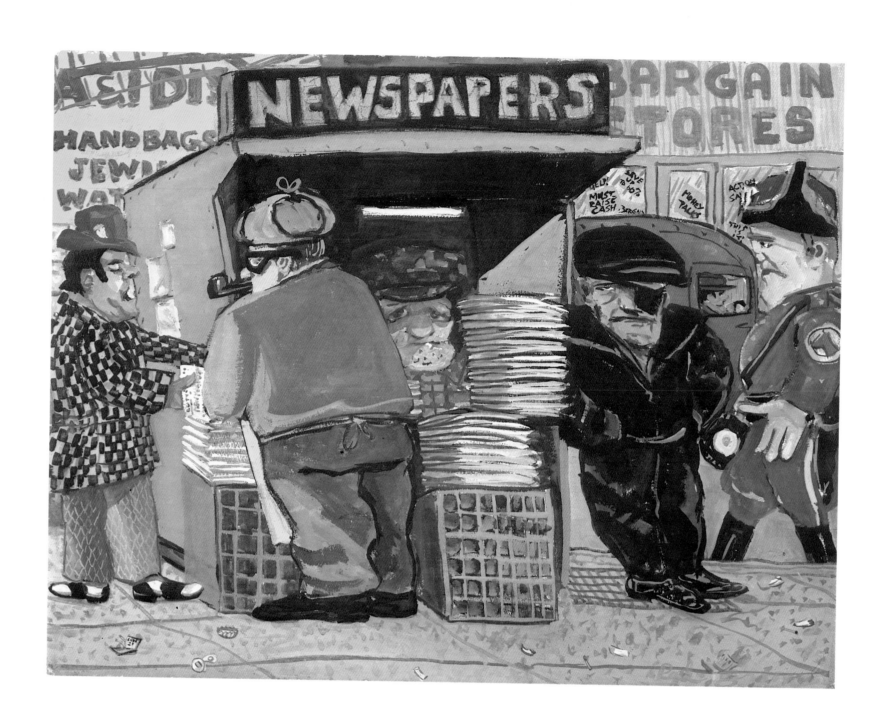

62. **Newsstand** 1975
Gouache on paper
25 x 30"
Collection Mr. and Mrs. Ervin Entrekin, Nashville, TN

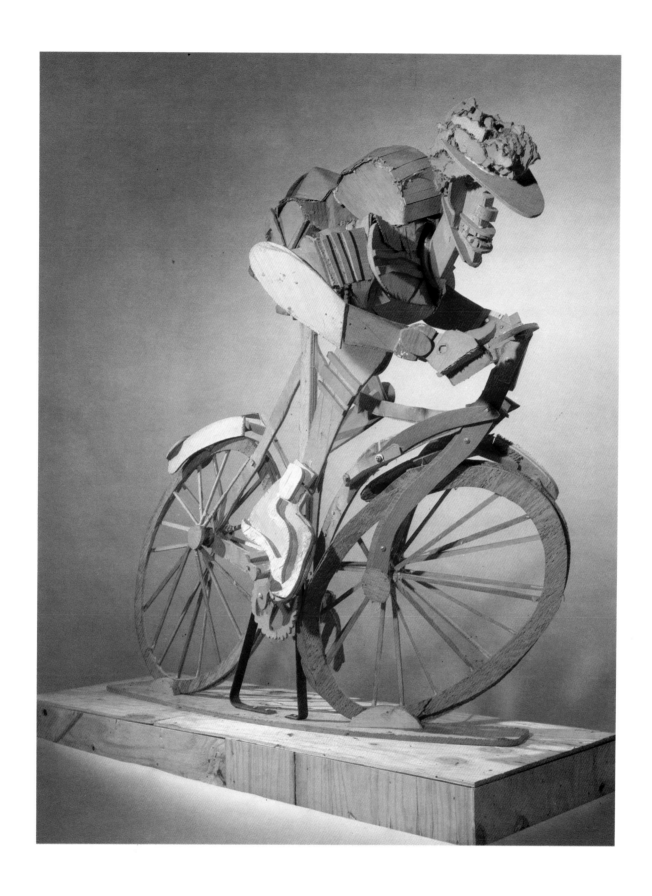

63. **Bicyclist** (maquette for figure on **Brooklyn Bridge, Ruckus Manhattan**) 1975
Wood construction
54 x 72 x 36"
Collection Red Grooms, New York, NY

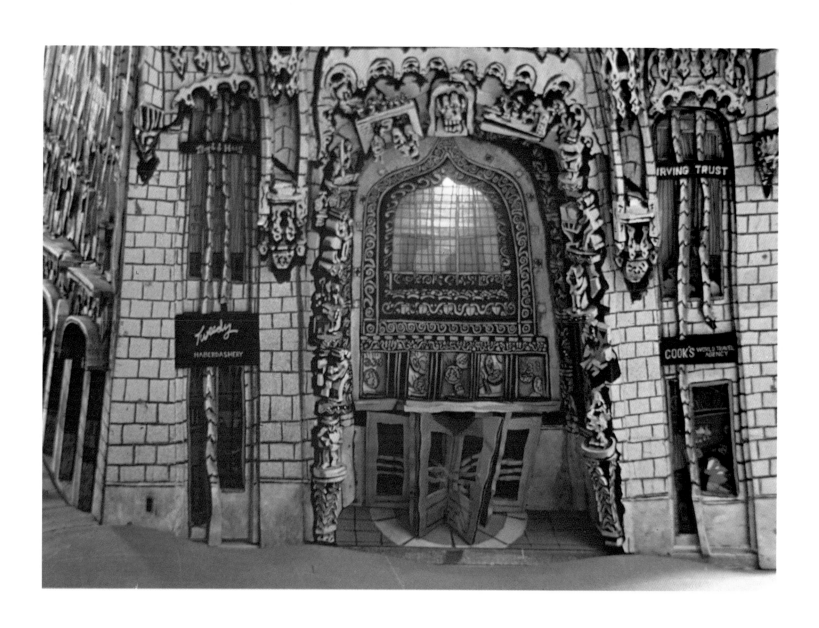

64. **Woolworth Building** (Archie Peltier and Red Grooms, with Ruckus Manhattan Construction
from Mimi Gross and Red Grooms, **Ruckus Manhattan**) 1975 (*detail*)
Mixed media
17 x 14 x 15′
Collection Marlborough Gallery, New York, NY

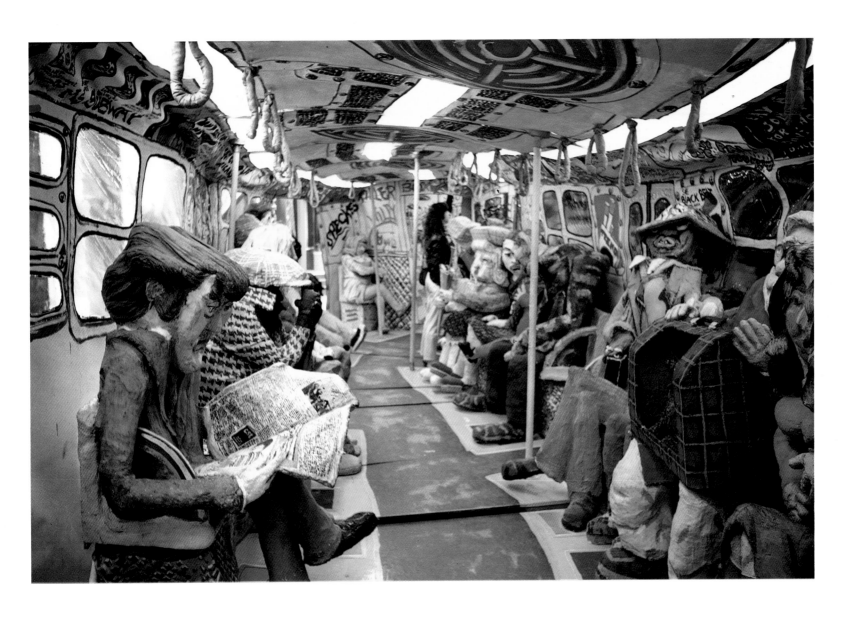

65. **Subway** (Mimi Gross and Red Grooms, from Mimi Gross and Red Grooms, **Ruckus Manhattan**) 1976 (*detail*)
Mixed media
9' x 18'7" x 37'2"
Collection Marlborough Gallery, New York, NY

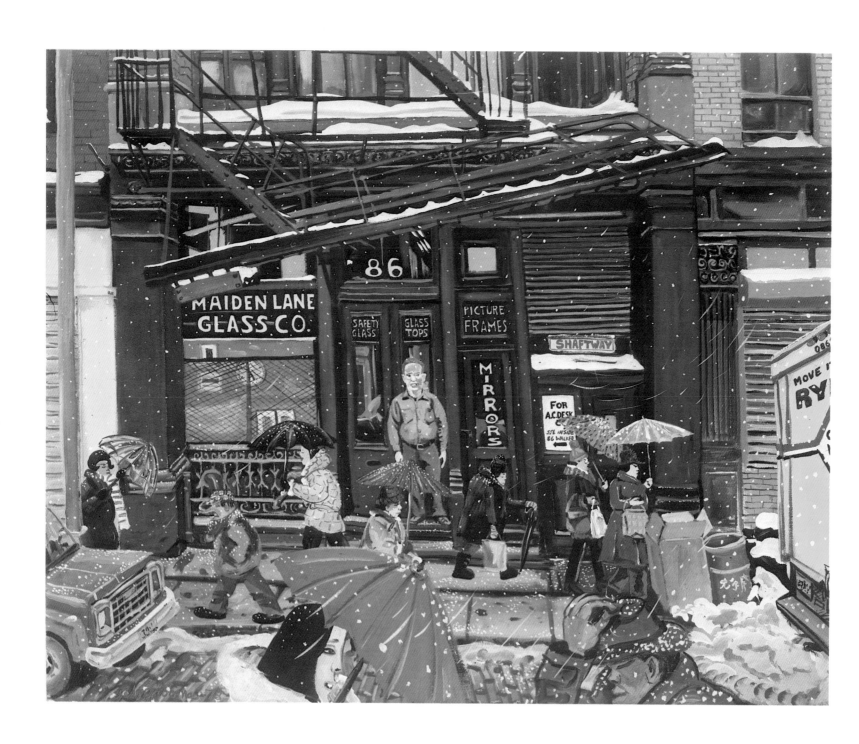

66. **Snowy Day on Walker Street** 1976
Acrylic on canvas
40 x 50"
Collection Red Grooms, New York, NY

67. **# 17** 1980
Gatorboard, wood, Celastic, Plexiglas, electric lights, alkyd aluminum
60 x 48 x 17"
Collection Ann and Walter Nathan, Glencoe, IL

68. **Hooks** 1980
 Gouache on paper
 30 x 41¾"
 Private collection

69. **Hotline** 1980
Gouache on paper
42 x 39¾"
Collection Alda and Bernard Harmon

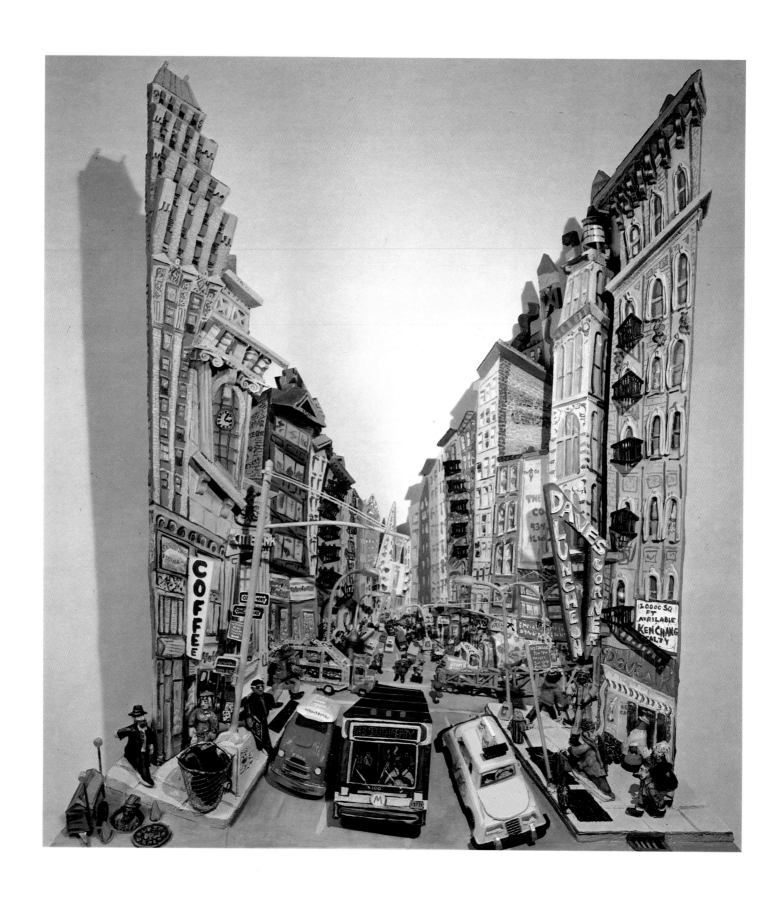

70. **Looking Along Broadway Towards Grace Church** 1981
Alkyd paint, Gatorboard, Celastic, wood, wax, Fome-cor
71 x 63¾ x 28¾"
Collection Agnes Gund, New York, NY

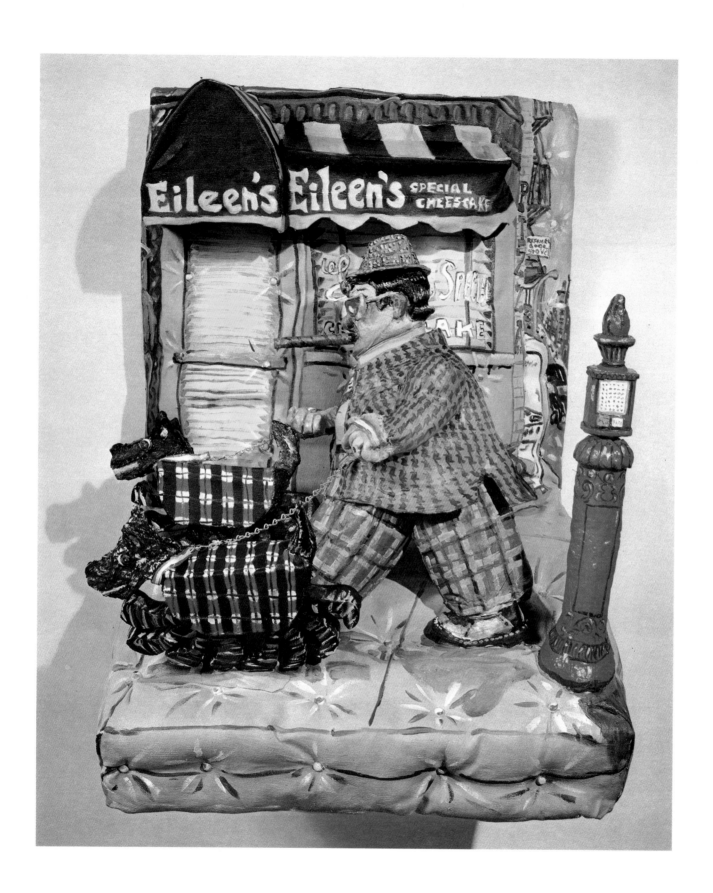

71. **Walking the Dogs** 1981
Gatorboard, canvas, wax, oil pigment
39 x 26 x 21"
Collection Douglas and Carol Cohen, Highland Park, IL

Art About Artists

"The romance of Picasso's life as an artist was very influential on me, and very mysterious."

<div align="right">

New York Times, June 22, 1980

</div>

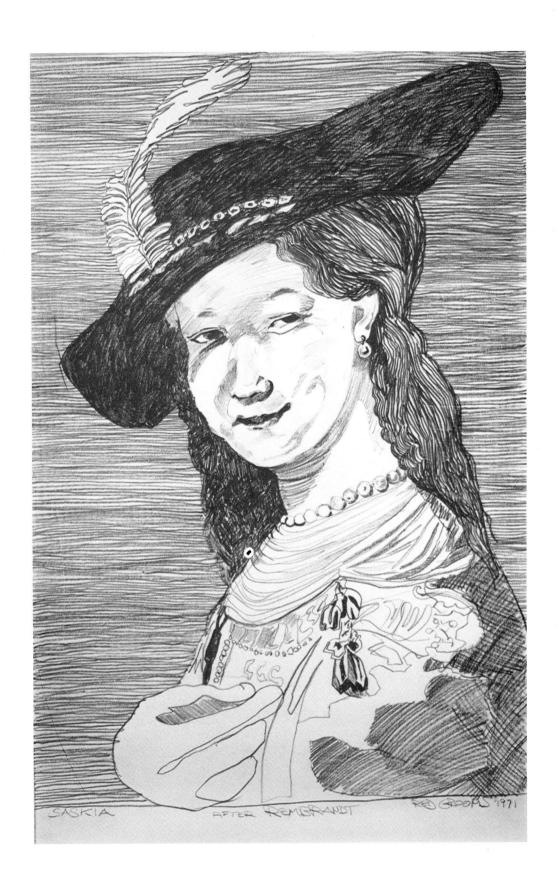

72. **Saskia After Rembrandt** 1971
 Pencil on paper
 39½ x 26"
 Collection Paul Richard, Washington, DC

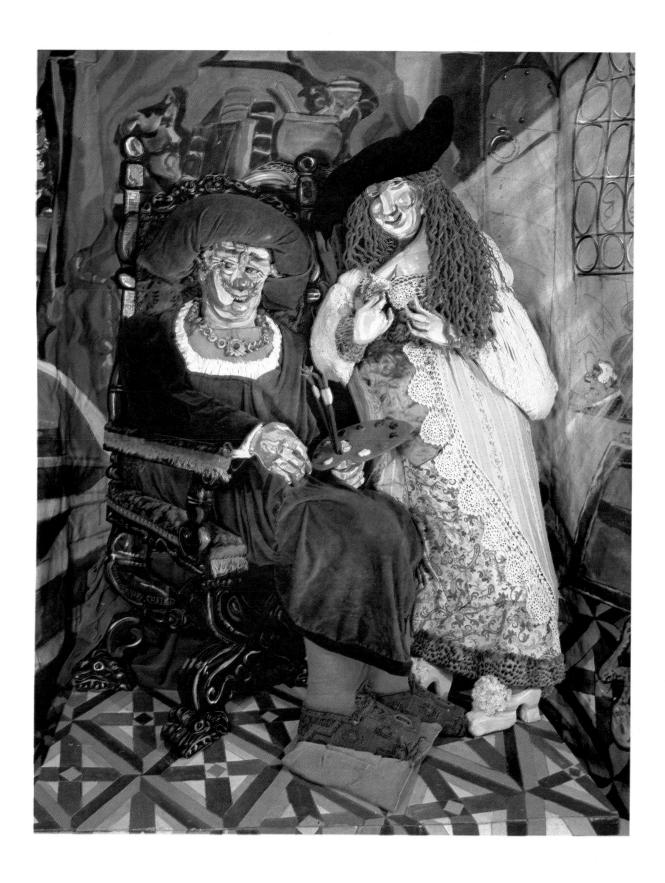

73. **Mr. and Mrs. Rembrandt** 1971 *(detail)*
Mixed media: construction of canvas, wood, fabric, found materials
108 x 118 x 42″
Collection The Fine Arts Center, Cheekwood, Nashville, TN
Gift of Mr. and Mrs. Ervin Entrekin and Mr. and Mrs. Walter Knestrick

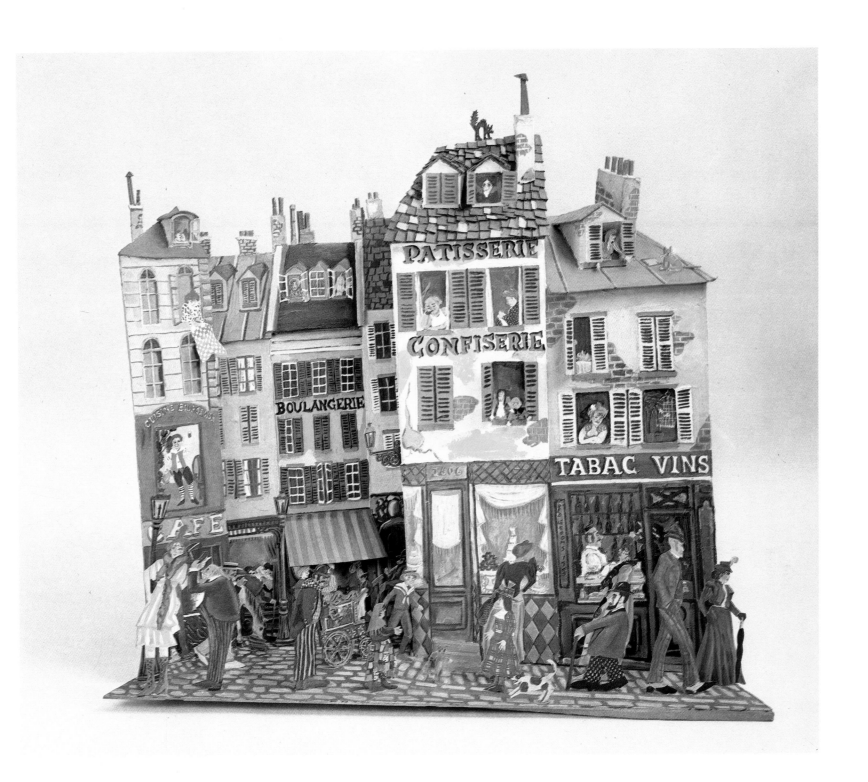

74. **Paris in the Springtime** 1963
Painted cardboard and wood
42 x 41 x 15″
Private collection
Exhibited in Philadelphia

75. **Apollinaire** 1963
Painted cardboard and wood
30 x 40"
Private collection

76. **Alfred Jarry** 1963
Painted cardboard and wood
18 x 9½ x 7½"
Private collection

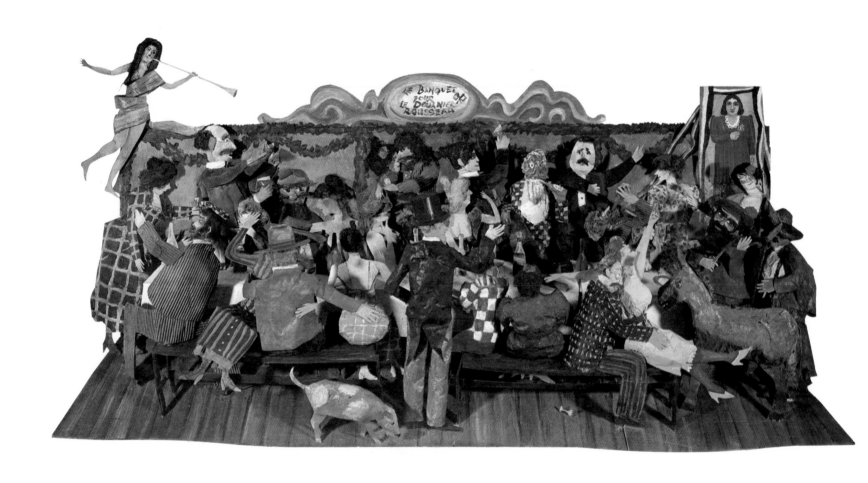

77. **Le Banquet pour le Douanier Rousseau** 1963
Mixed media
32 x 81 x 16″
Private collection

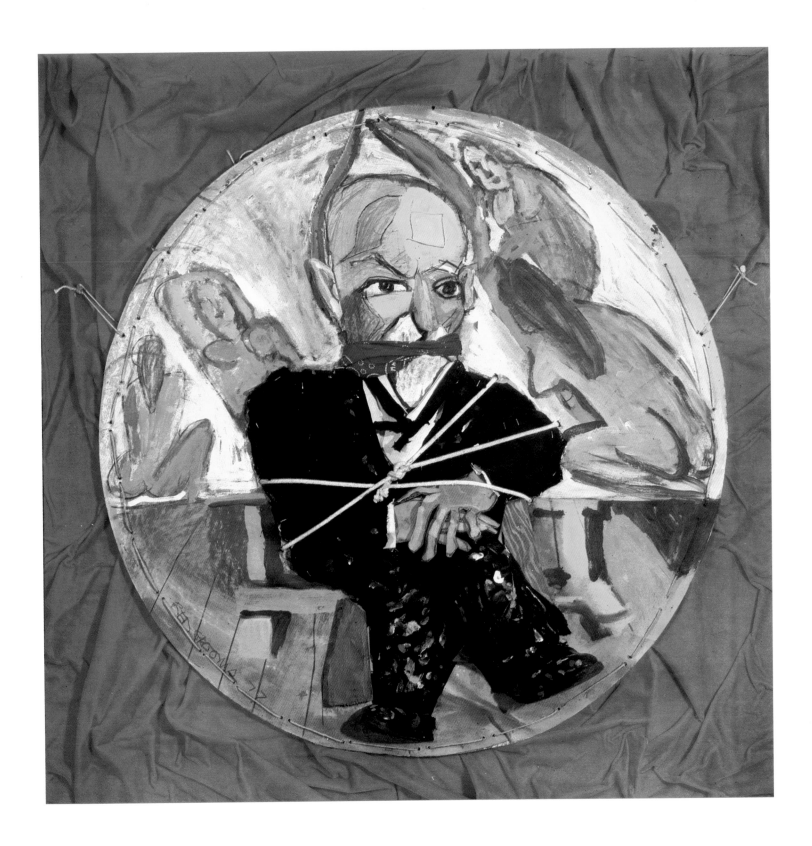

78. **Tie Cez** 1977
Mixed media
46 x 46 x 9"
Collection Nancy and Alan Saturn, Nashville, TN

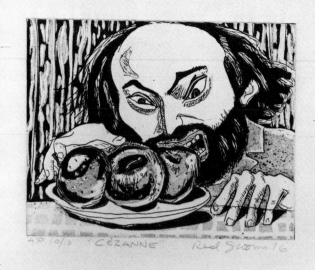

79. **Nineteenth Century Artists — Cézanne** 1976
Etching and aquatint in black on Rives BFK
Edition 40
15 x 11"
Co-published by Brooke Alexander, Inc., and Marlborough Graphics, Inc., NY
Printer: Jennifer Melby
Collection Brooke Alexander, Inc., New York, NY

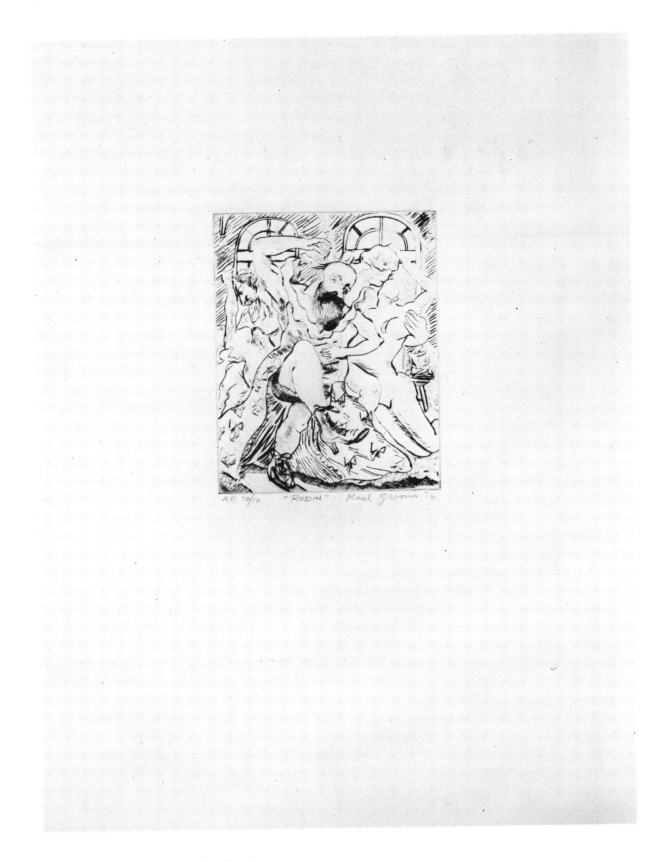

80. **Nineteenth Century Artists — Rodin** 1976
Etching and aquatint in black on Rives BFK
Edition 40
15 x 11″
Co-published by Brooke Alexander, Inc., and Marlborough Graphics, Inc., NY
Printer: Jennifer Melby
Collection Brooke Alexander, Inc., New York, NY

81. **Don't Draw in Bed** (Matisse) 1975
Pencil on paper
22¼ x 31"
Collection Ms. Jean Feiwel, New York, NY

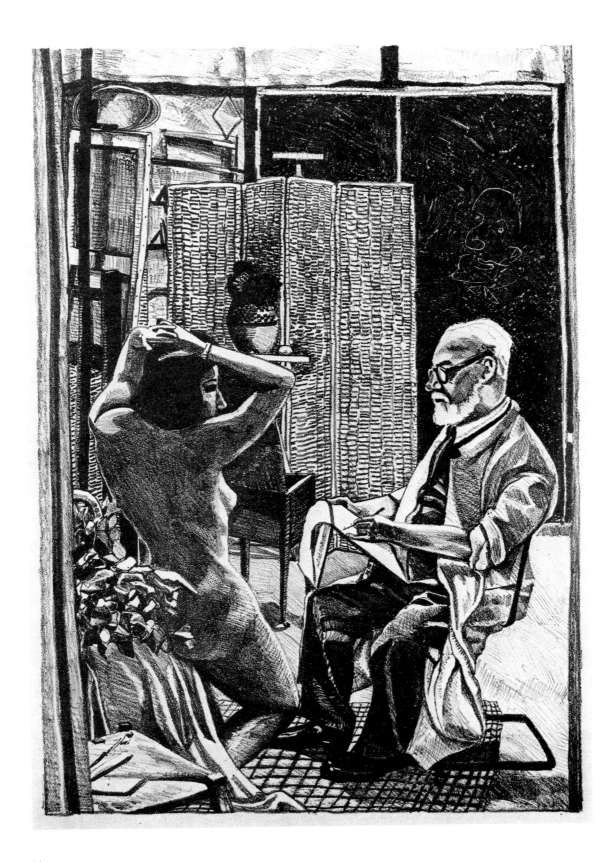

82. **Matisse** 1976
 Lithograph in black on Rives BFK
 Edition 75
 34½ x 25½"
 Co-published by Brooke Alexander, Inc., and Marlborough Graphics, Inc., NY
 Printed by Paul Markiewicz
 Collection Brooke Alexander, Inc., New York, NY

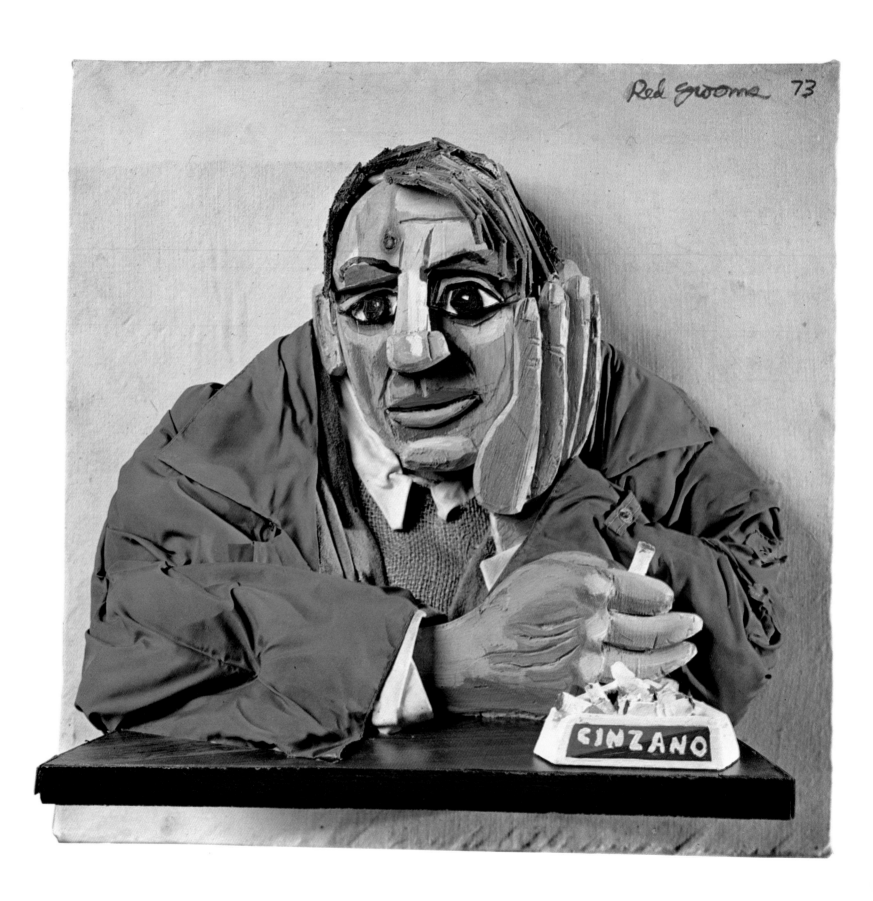

83. **Picasso in a Cafe** 1973
Wood, cloth with acrylic paint in Plexiglas case
24¾ x 24½ x 9⅞"
Collection Sydney and Frances Lewis, Richmond, VA

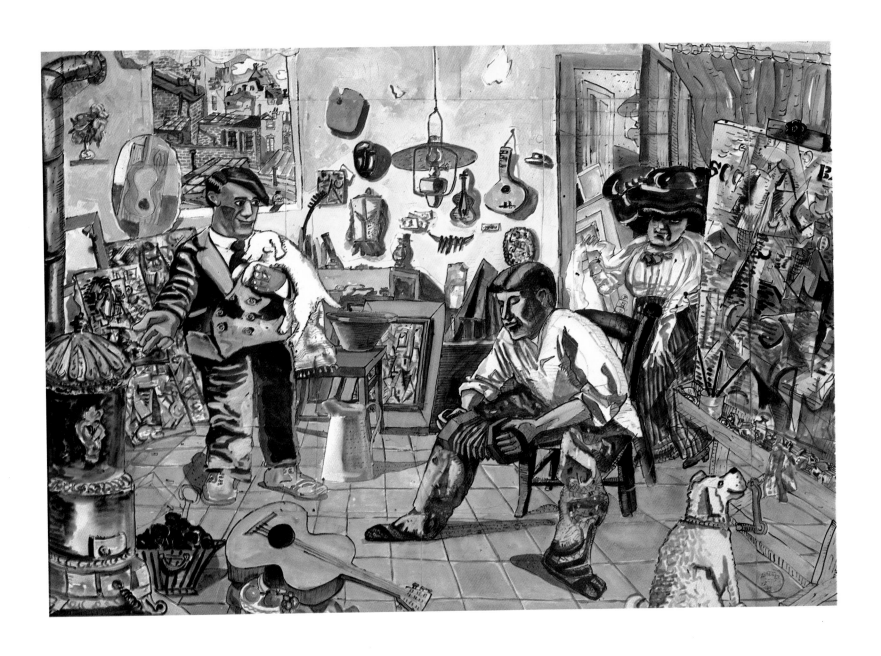

84. **Picasso in Braque's Studio** 1974
Colored inks on collaged paper
6 x 4′
Collection Mr. and Mrs. Morton J. Hornick, New York, NY
Exhibited in Philadelphia

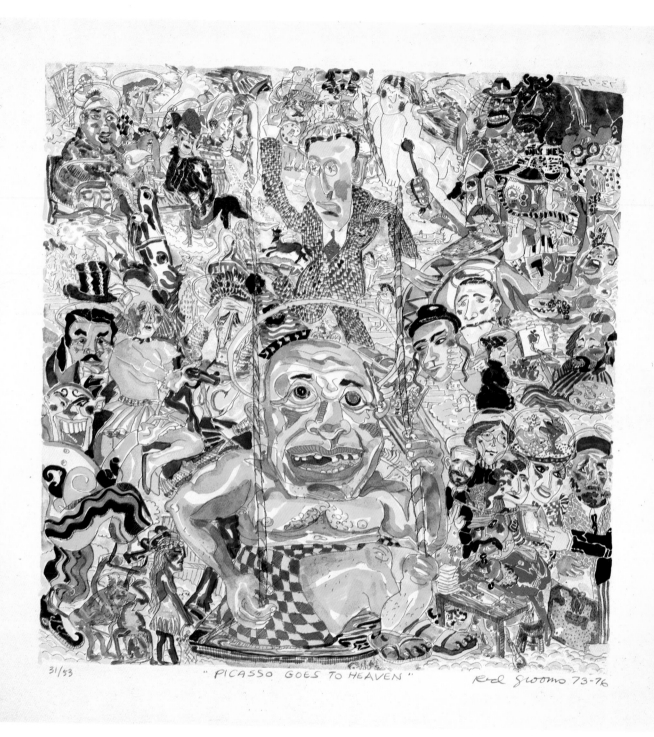

31/53 "PICASSO GOES TO HEAVEN" Red Grooms 73-76

85. **Picasso Goes to Heaven II** 1976
Hand-colored etching on Arches Cover
Edition 20
30³⁄₈ x 29"
Co-published by Brooke Alexander, Inc., and Marlborough Graphics, Inc., NY
Printer: Jennifer Melby; stencils cut by Chip Elwell
Collection Brooke Alexander, Inc., New York, NY

86. **Jackson Pollock** 1973
Oil and mixed media
32 x 26"
Collection Judy and Burton Resnick, Rye, NY

87. **Franz Kline** 1983
Gouache on carved telephone book
21 x 19 x 6″
Collection Red Grooms, New York, NY

88. **A Room in Connecticut** 1984
Oil on canvas and acrylic on Plexiglas with aluminum frame
72 x 96″
Collection Pennsylvania Academy of the Fine Arts, Philadelphia, PA

89. **Dali Salad** 1980-1981
Color lithograph and silkscreen on Arches Cover, Japanese paper and vinyl, cut-out, glued
and mounted on rag paper backing; framed and covered with a Plexiglas dome
26 ½ x 27½ x 12½"
Co-published by Brooke Alexander, Inc., and Marlborough Graphics, Inc., NY
Printer: Steven M. Andersen, Vermillion Press Ltd., MN
Collection Brooke Alexander, Inc., New York, NY

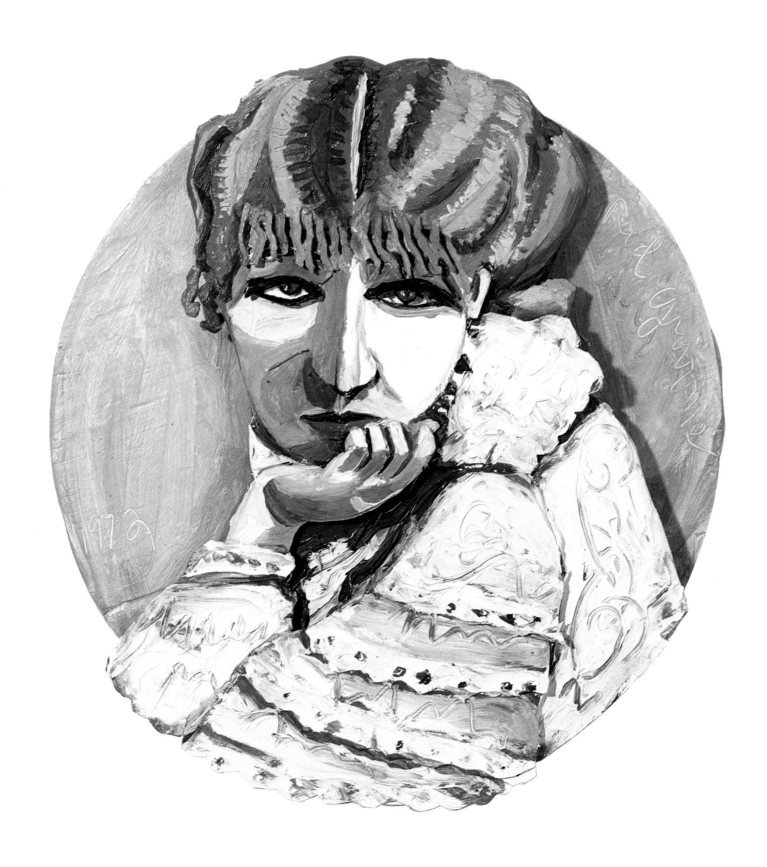

90. **Portrait of Sarah Bernhardt** 1972
Painted wood in Plexiglas case
13½ x 12 x 3″
Collection Jessica R. Weiss and Carl Teitelbaum, New York, NY

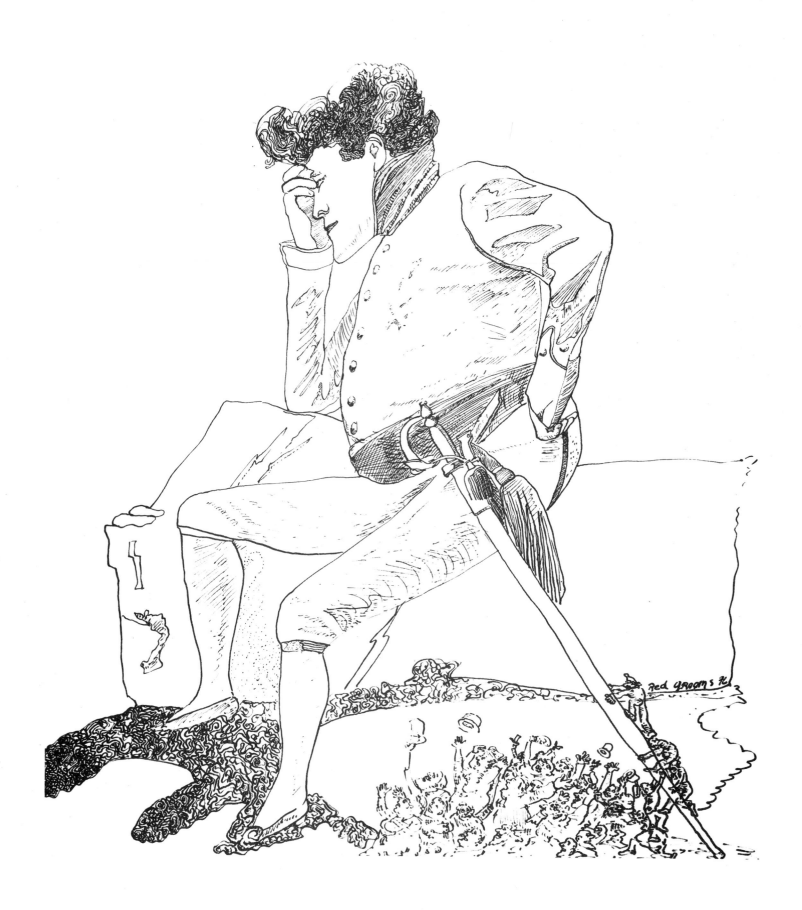

91 Sarah Bernhardt in the Role of L'Aiglon 1976
Pen and ink on paper
24 x 19¼"
Private collection, Paris, France

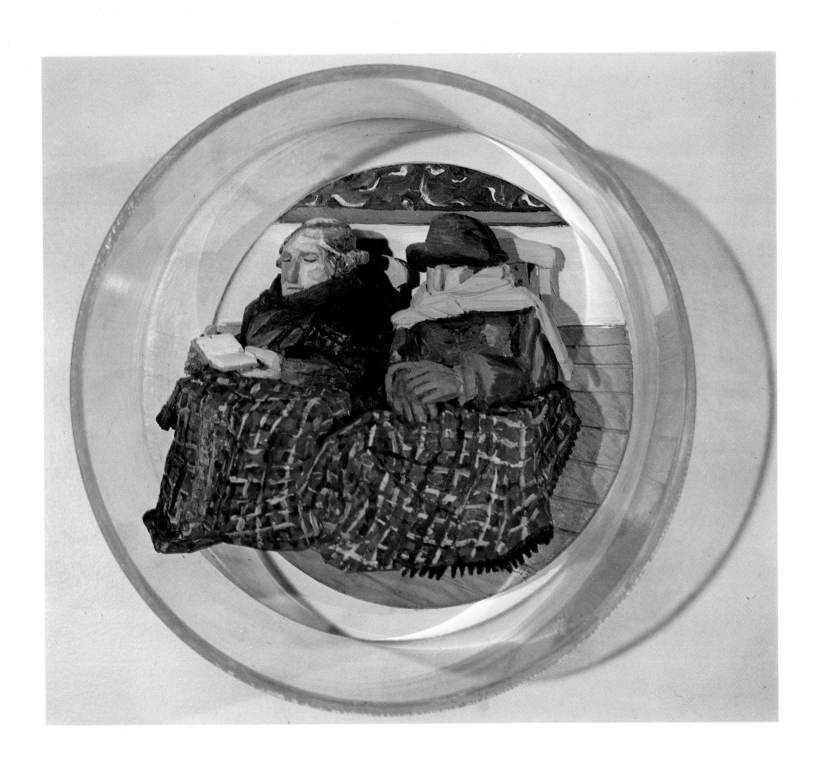

92. **Cone Sisters** 1973
Painted wood in Plexiglas case
12 x 12 x 5½″
Private collection
Exhibited in Philadelphia

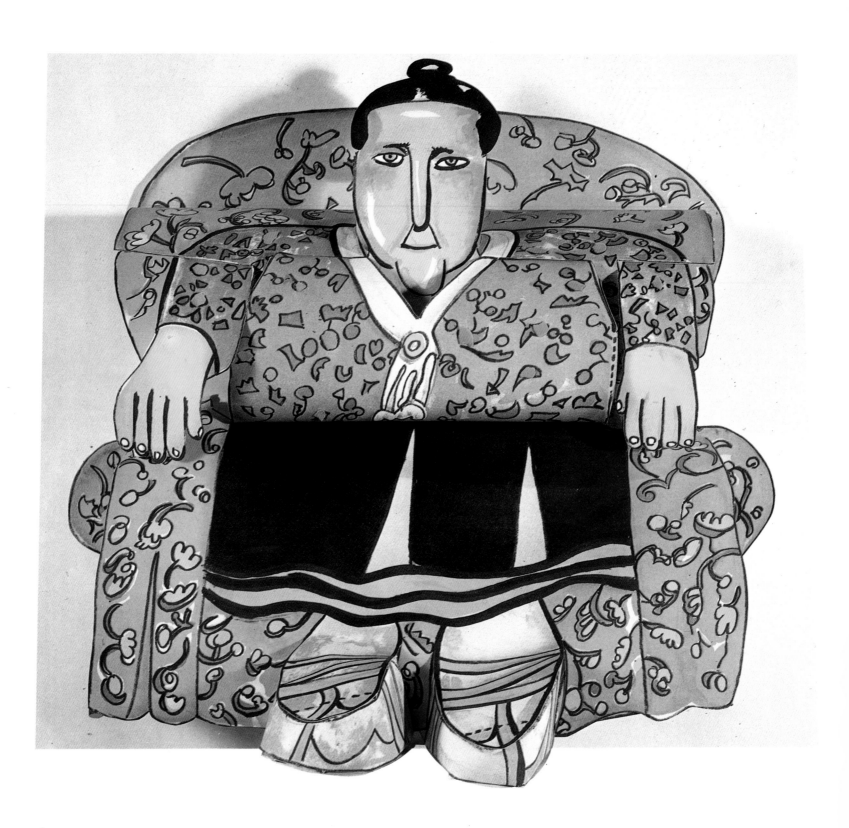

93. **Gertrude** 1975
Color lithograph on Arches-Cover, cut-out, glued and mounted in Plexiglas box
19¼ x 22 x 10"
Co-published by Brooke Alexander, Inc., and Marlborough Graphics, Inc., NY
Printer: Mauro Guiffreda, American Atelier, NY
Assembled by Chip Elwell
Collection Saskia Grooms, New York, NY

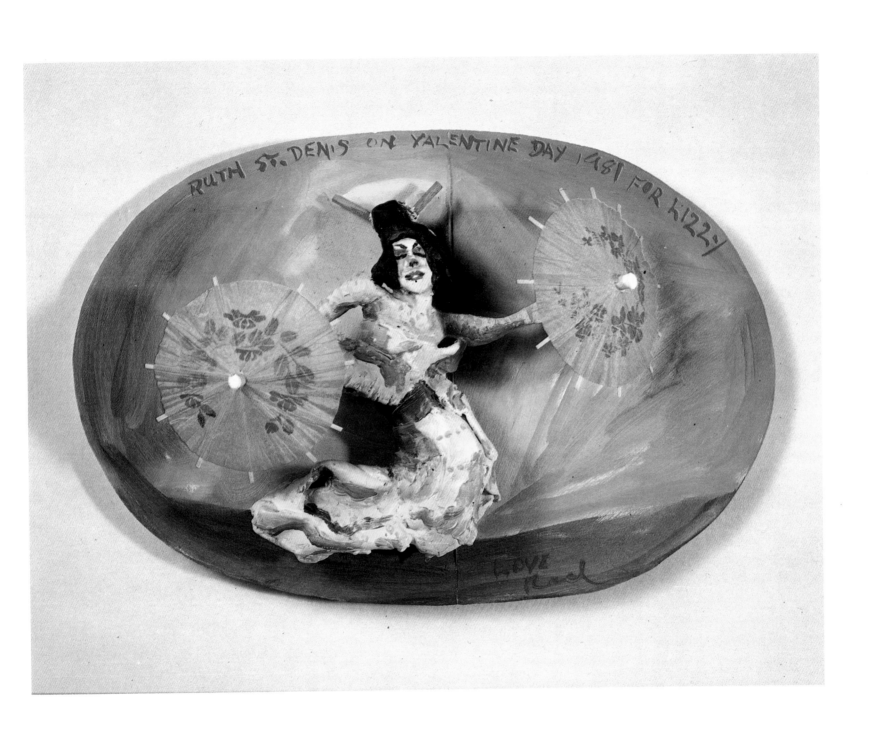

94. **Ruth St. Denis** 1981
Oil on wax and Masonite, paper umbrellas
8½ x 13½ x 4″
Collection Elisabeth Ross, New York, NY

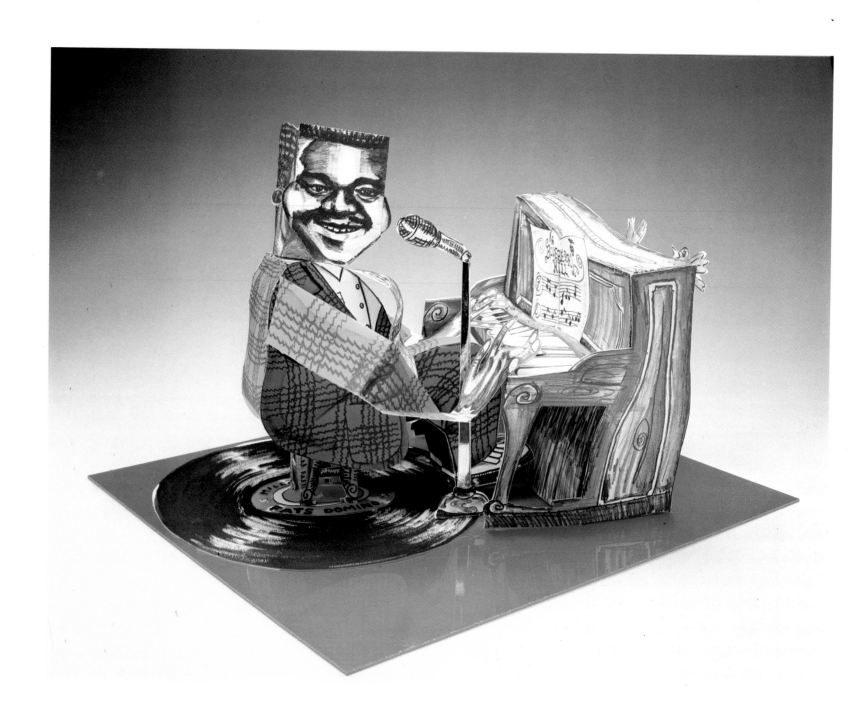

95. **Fats Domino** 1984
 Color lithograph, cut-out, in Plexiglas box
 15 x 20 x 20"
 Printer: Bud Shark
 Collection Bud Shark, Shark's Lithography, Ltd., Boulder, CO

Art About Art

"I just love history. I like [historical] periods of time and trying to get involved in those textures. . . ."

Cummings interview, 1974

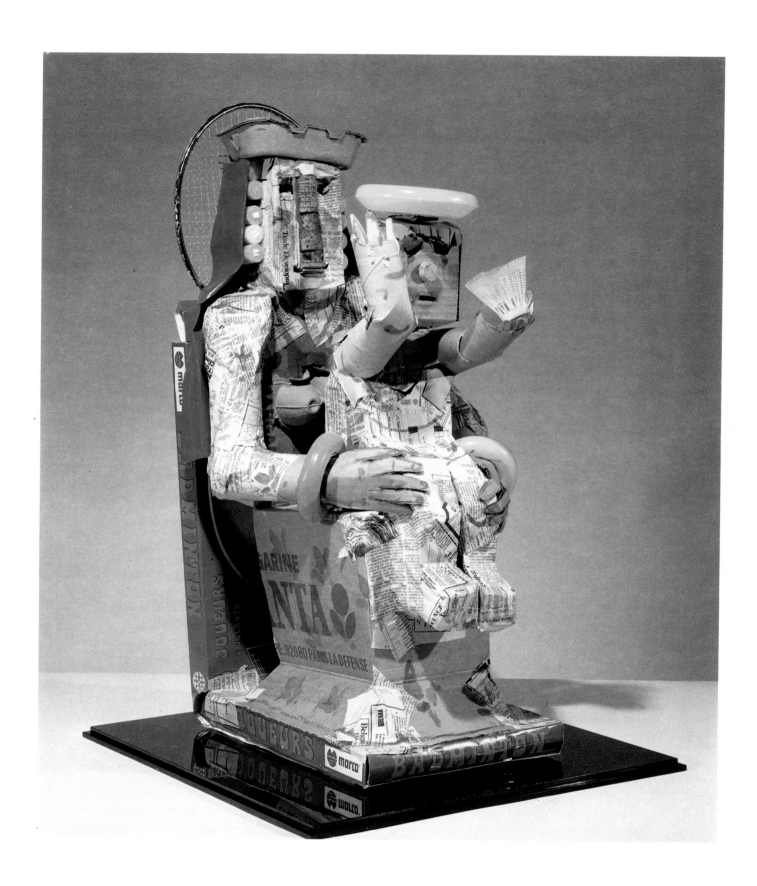

96. **Notre Dame de Badminton** 1980
Mixed-media construction
25½ x 10½"
Collection Bob Balaban and Lynn Grossman, New York, NY

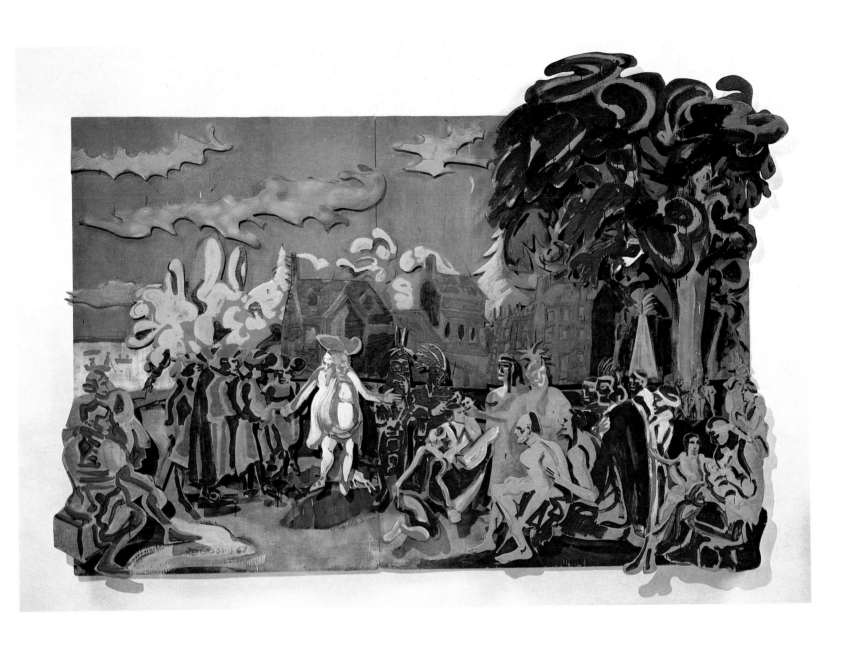

97. **William Penn Shaking Hands with the Indians** 1967
Enamel on plywood
75 x 108 x 10"
Collection Denver Art Museum — National Endowment for the Arts Museum Purchase Grant
and matching funds from Mr. William Copley, Mr. and Mrs. Edward Strauss and Anonymous

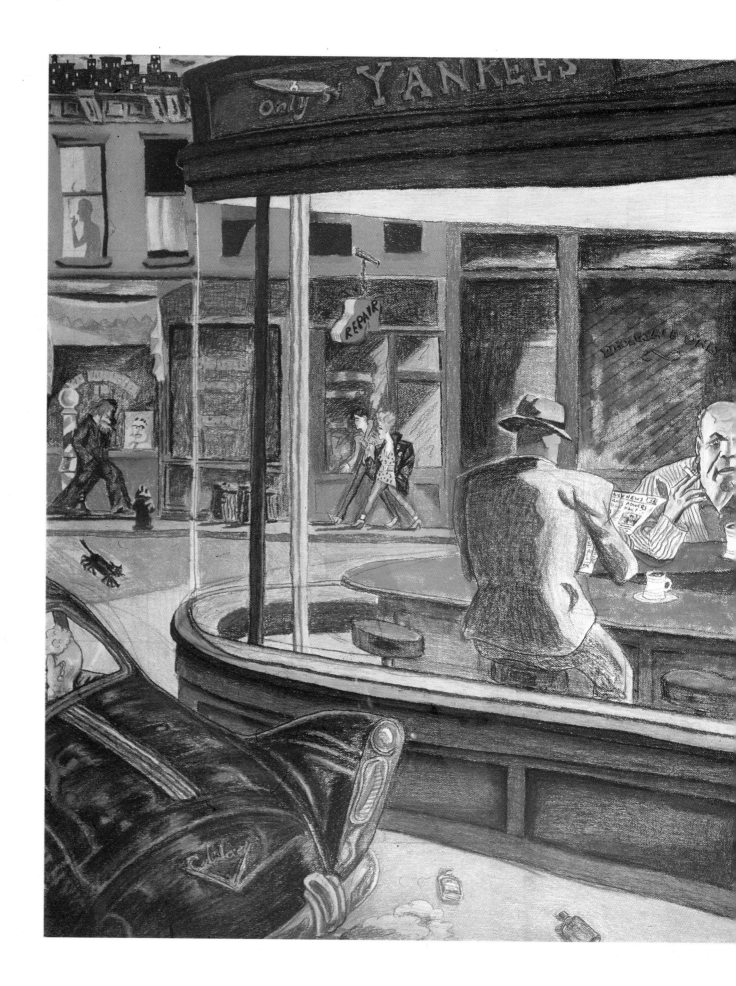

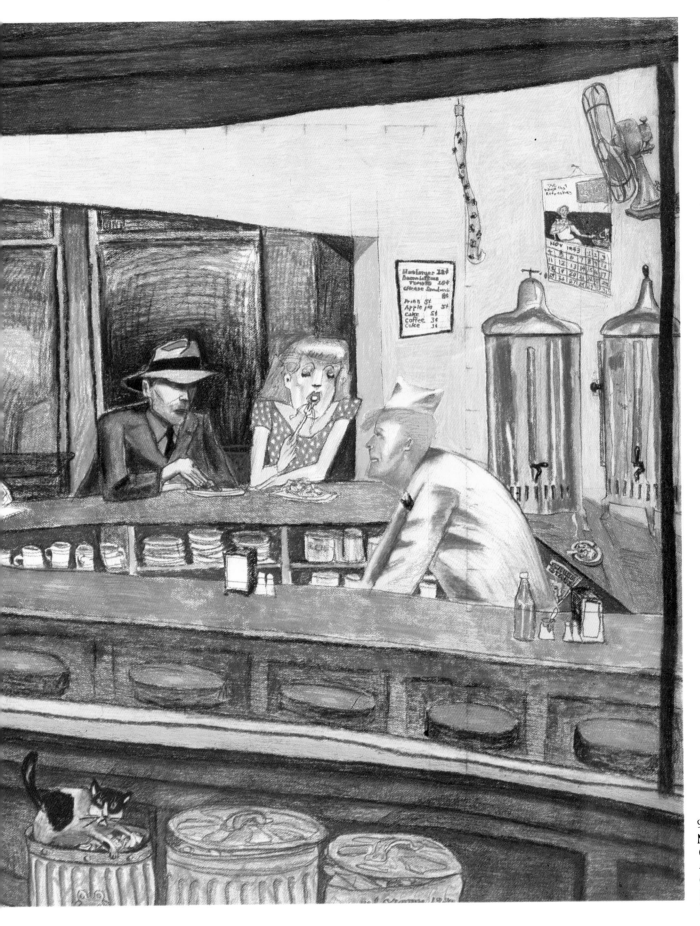

98.
Nighthawks Revisited 1980
Colored pencil on paper
44 x 74½"
Collection Red Grooms,
New York, NY

99. **Museum** 1978
 Color lithograph offset on F. J. Head handmade paper
 Edition 150
 10¼ x 23¾"
 Published by Brooke Alexander, Inc., NY
 Printer: Joe Petrocelli, Siena Studios, NY
 Collection Brooke Alexander, Inc., New York, NY

100. **Guggenheim** 1971
Color lithograph on Arches Cover
Edition 20
38½ x 26"
Published by George Goodstadt, NY
Printed at Bank Street Atelier
Chromatist: Jean Pierre Remond
Collection Brooke Alexander, Inc., New York, NY

Traditional Values:
Commissioned Portraits, Landscape, Still Life, Historic Themes

"It's almost subversive if I do something that isn't jokey. It would undermine my career, and also the expectations of the audience."

New York Times, March 29, 1981

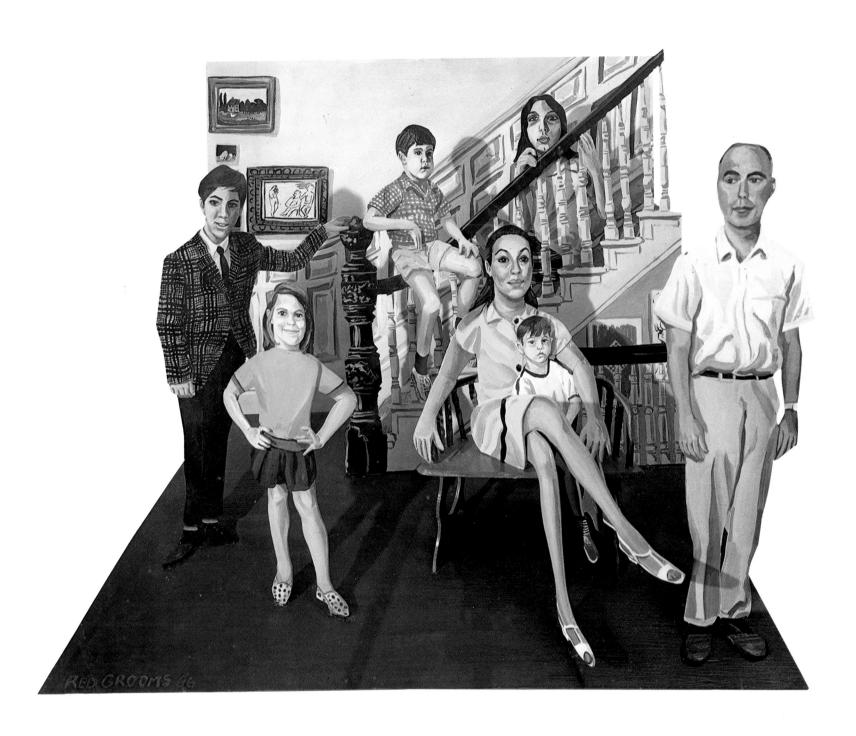

101. **The Levinson Family** 1966
Acrylic on cut-out Masonite, in Plexiglas box
28 x 33 x 15″
Private collection

102. **Kids Watching Me Paint** 1961
Oil on canvas
48 x 58"
Collection Margaret R. Rigg, St. Petersburg, FL

103. **Maine Pastorale** 1964
Oil on wood
7½ x 17"
Collection Mimi Gross, New York, NY

104. **Olive Tree – Bari, Italy** 1968
Reed pen and ink on paper
19½ x 14″
Collection Renee and Chaim Gross, New York, NY

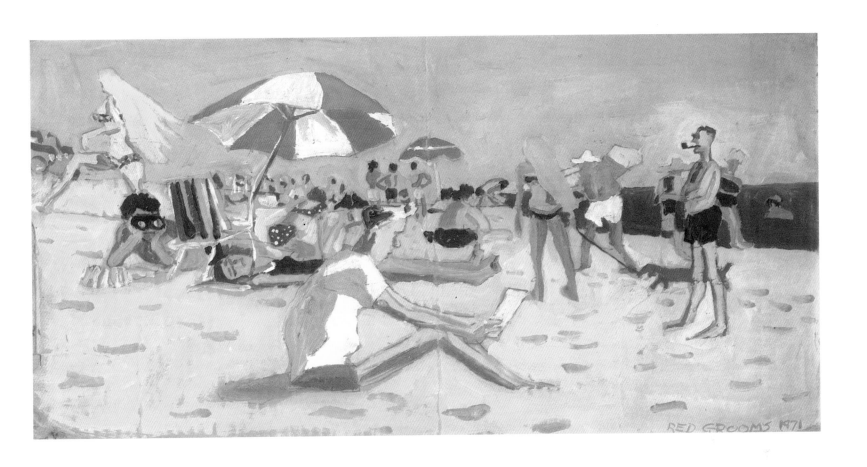

105. **Prancing Blonde on New Beach** 1971
Oil on cardboard
12 x 24"
Collection Red Grooms, New York, NY

106. **Nashville Fireflies** 1976
Watercolor and blue felt-tip pen on paper
11 x 14"
Collection Ann P. H. Austin, Cleveland, OH

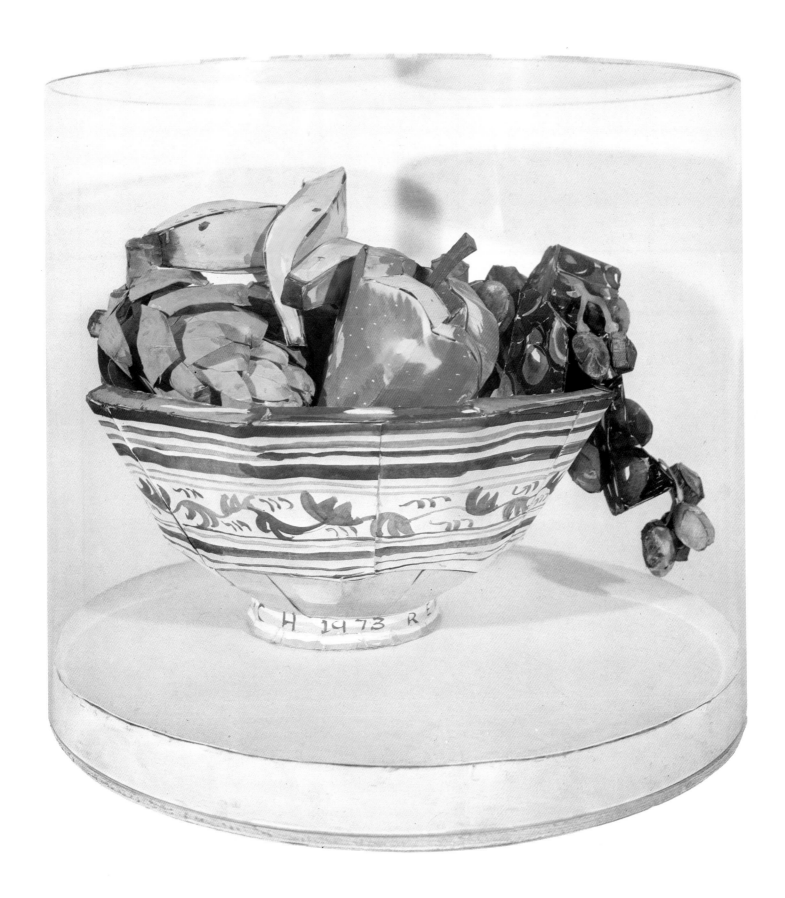

107. **Gretchen's Fruit** 1973
 Paper, glue and watercolor in Plexiglas case
 12 x 16 x 16″ on a 39″ base built by Red Grooms
 Collection Jessica R. Weiss and Carl Teitelbaum, New York, NY

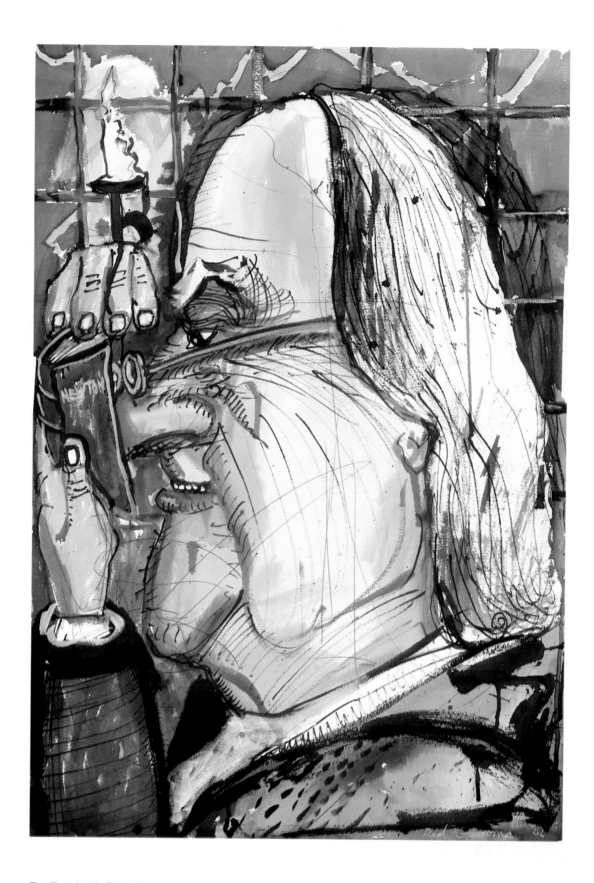

108. **Dr. Franklin's Profile** 1982
Watercolor, metallic paint, colored inks and gouache on paper
42 x 29½"
Collection Philadelphia Museum of Art
Purchased: Alice Newton Osborn Fund
Exhibited in Denver and Los Angeles

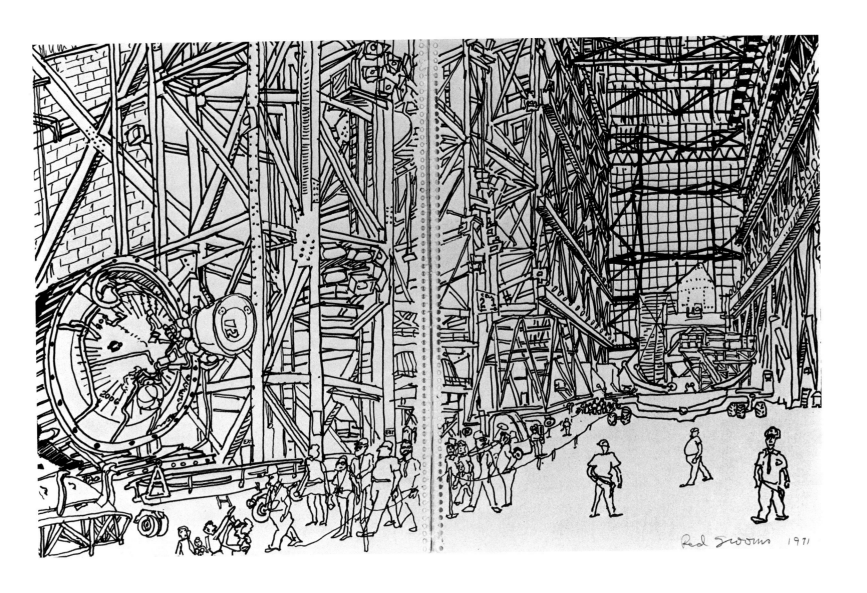

109. **Inside Launching Pad** 1971
Black pen on two sheets of white wove sketchbook paper mounted together
15¹⁵/₁₆ x 27⁵/₈″
Collection Allen Memorial Art Museum
Special Acquisitions Fund, Oberlin College, Oberlin, OH

The Movies and the Wild West

"I've always been knocked out by big scale . . . Battle scenes, Samson and Delilah stuff, sword-fighting. Not quality—quantity. No taste. As a kid I'd think about making movies overwhelmed by spectacle. For me, movies have always been more exciting than painting, but painting is somehow more my bag."

Art News, 1973

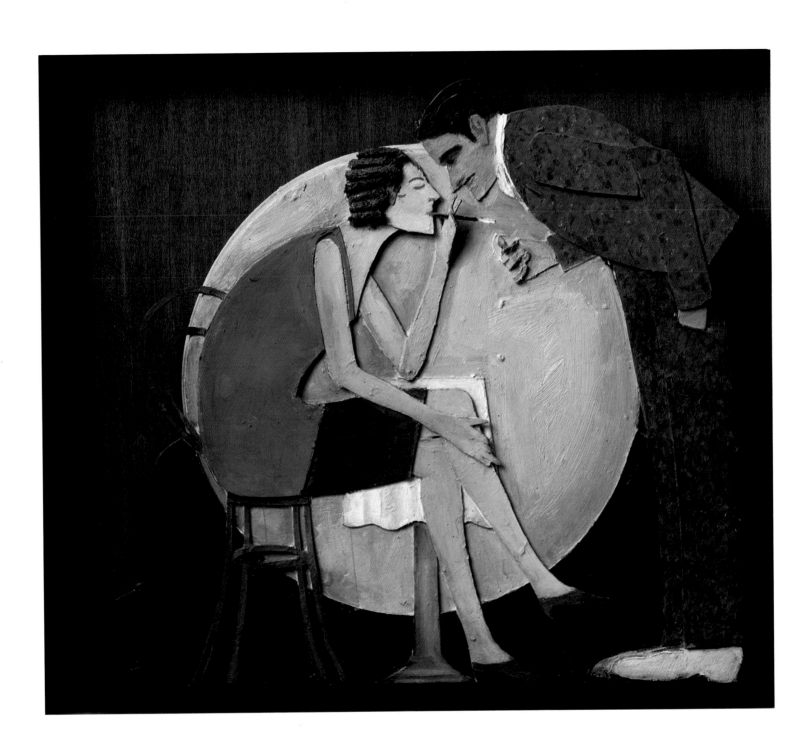

110. **A Light, Madam** 1962
Oil on cardboard and wood
19 x 25 x 4"
Collection Edward Plunkett, New York, NY

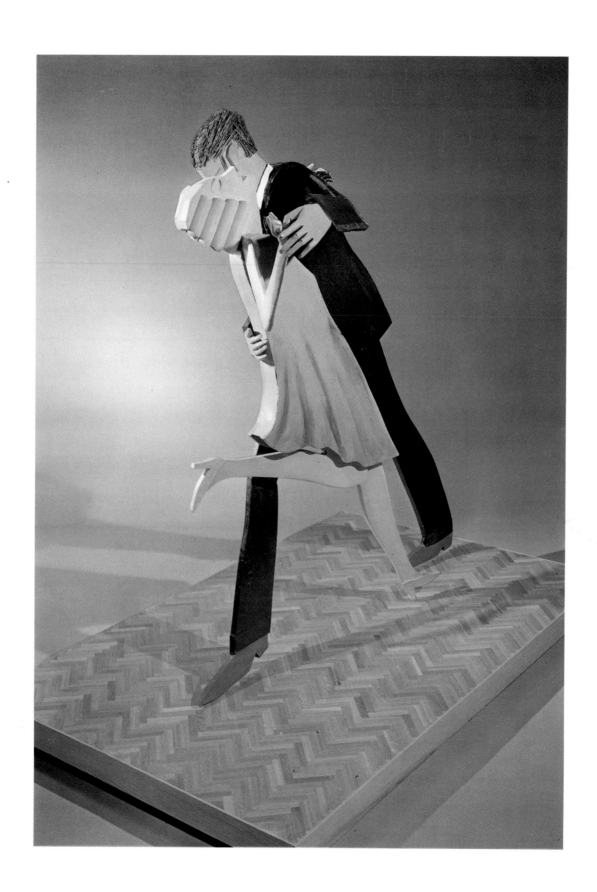

111. **Tango Dancers** 1963
Base 1984
Cut-out wood, parquet base
78 x 48"
Collection Carter Burden, New York, NY

112. **The Founders** 1966
Colored inks on collaged paper
40½ x 38″
Collection Mrs. Emil J. Arnold, New York, NY

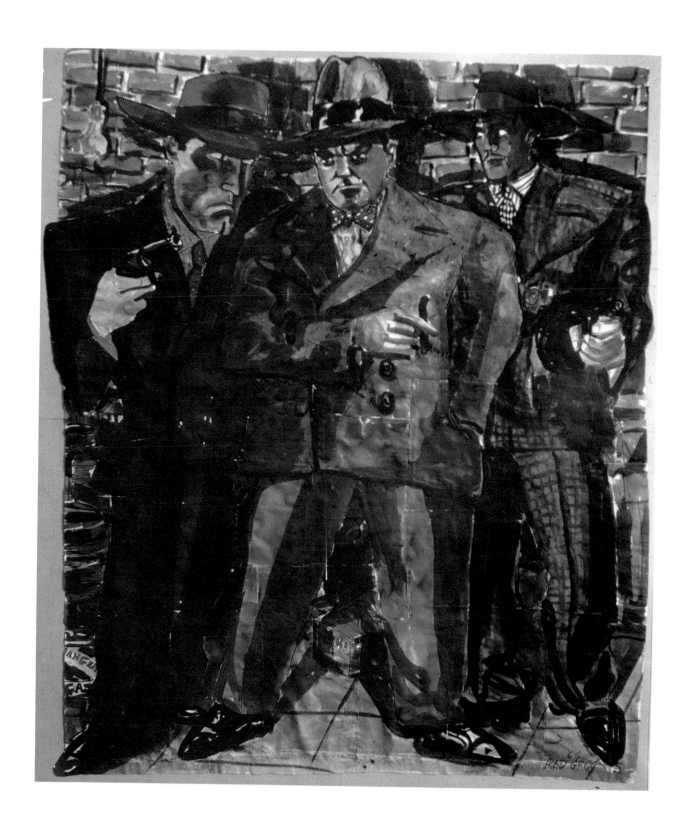

113. **Jimmy Cagney and Friends** 1966
Colored inks on collaged paper
82 x 71"
Collection Mr. and Mrs. Louis S. Cole, Chicago, IL

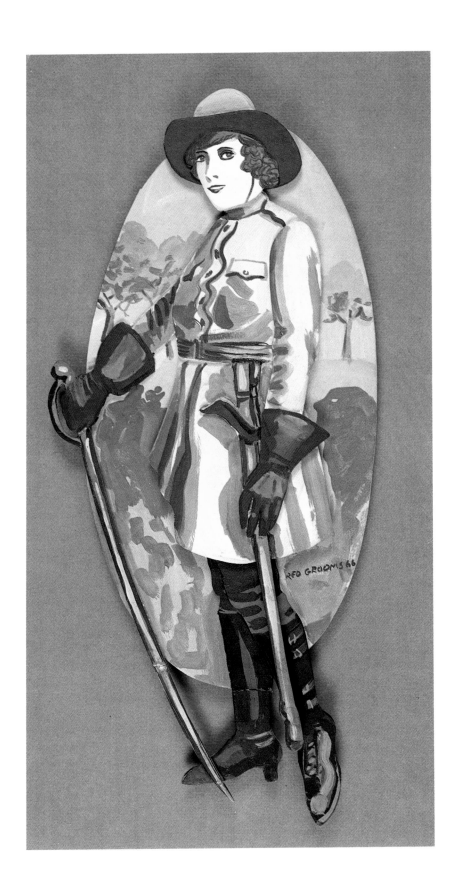

114. **Pearl White in a W.W.I Canteen Uniform** 1966
Acrylic paint on Masonite
9¼ x 20¼"
Collection Mr. and Mrs. R.G. Grooms, Nashville, TN

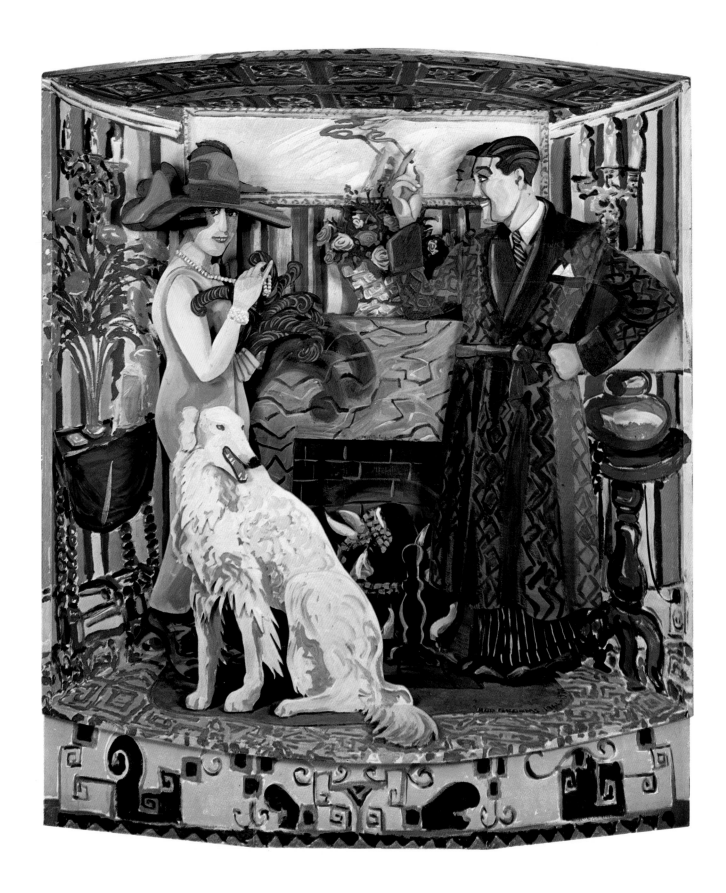

115. **Somewhere in Beverly Hills** 1966-1976
Stick-out construction of painted wood and Upson board
93 x 82¼ x 24½"
Private collection

116. **Tootsie** 1971
Painted wood, Plexiglas and electric light bulb
66¾ x 16⅞ x 12¼"
Collection Estate of Joseph H. Hirshhorn, Washington, DC

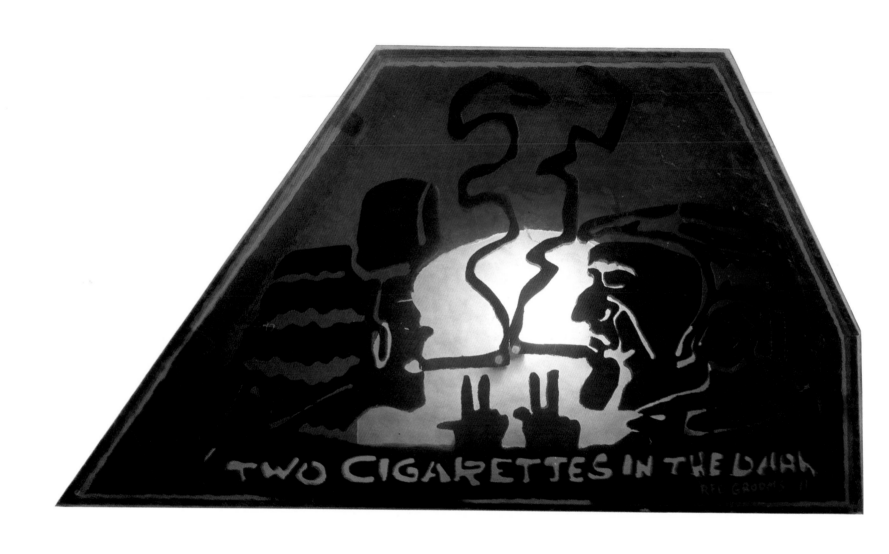

117. **Two Cigarettes in the Dark** 1971
Blue and red Plexiglas, light bulb
15 x 26 x 5½″
Collection Red Grooms, New York, NY

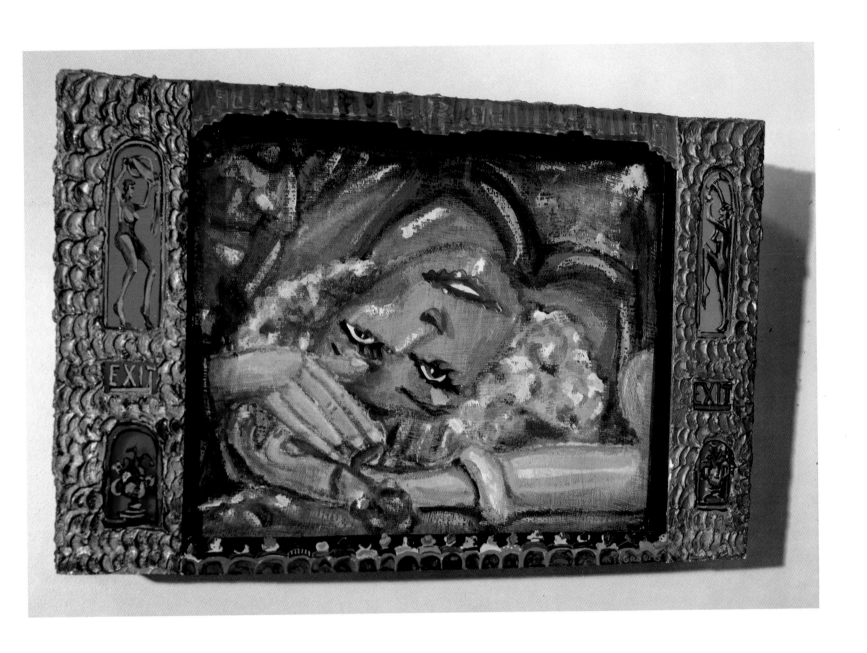

118. **The Kiss, Movie Screen** 1971
Mixed media
30 x 31¼ x 7″
Collection Suzanne Slesin, New York, NY

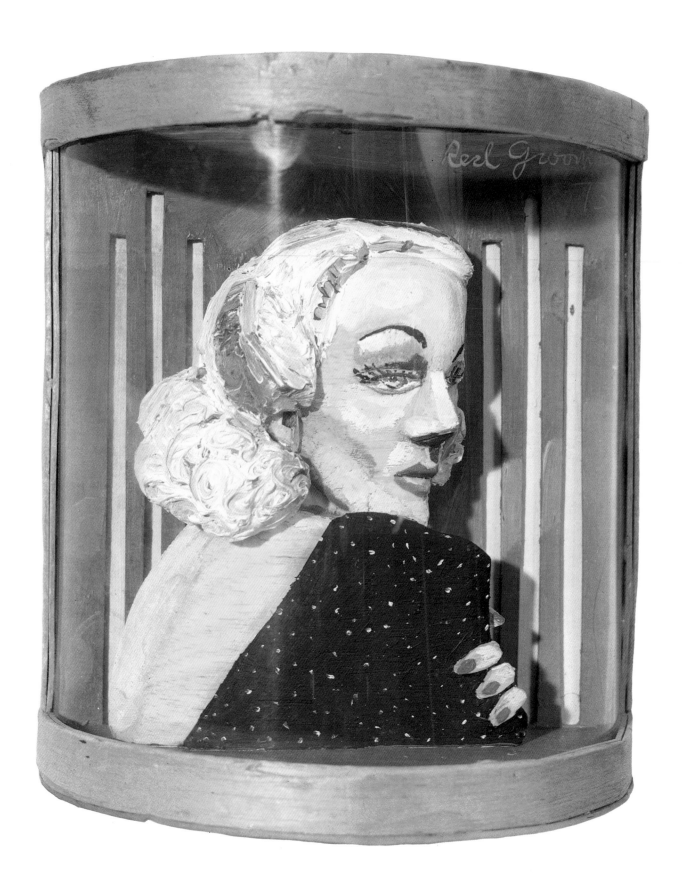

119. **Carole Lombard** 1973
Oil on balsa wood and cardboard
8 x 7½ x 4"
Collection Mimi Gross, New York, NY

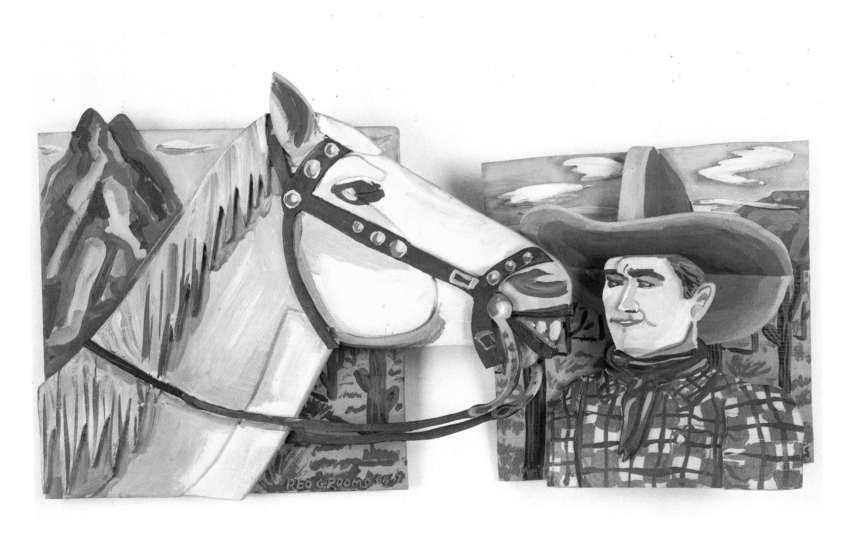

120. **Western Pals** 1966-1967
Acrylic on plywood construction relief in two parts
13½ x 13½"
17 x 22½"
Private collection

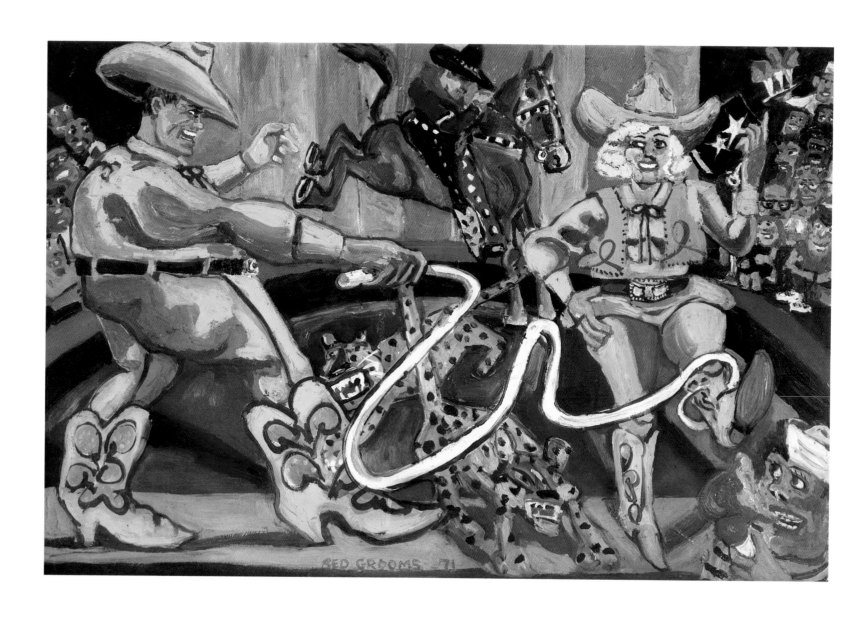

121. **Great Western Act** 1971
Oil on Masonite
23½ x 35"
Collection Red Grooms, New York, NY

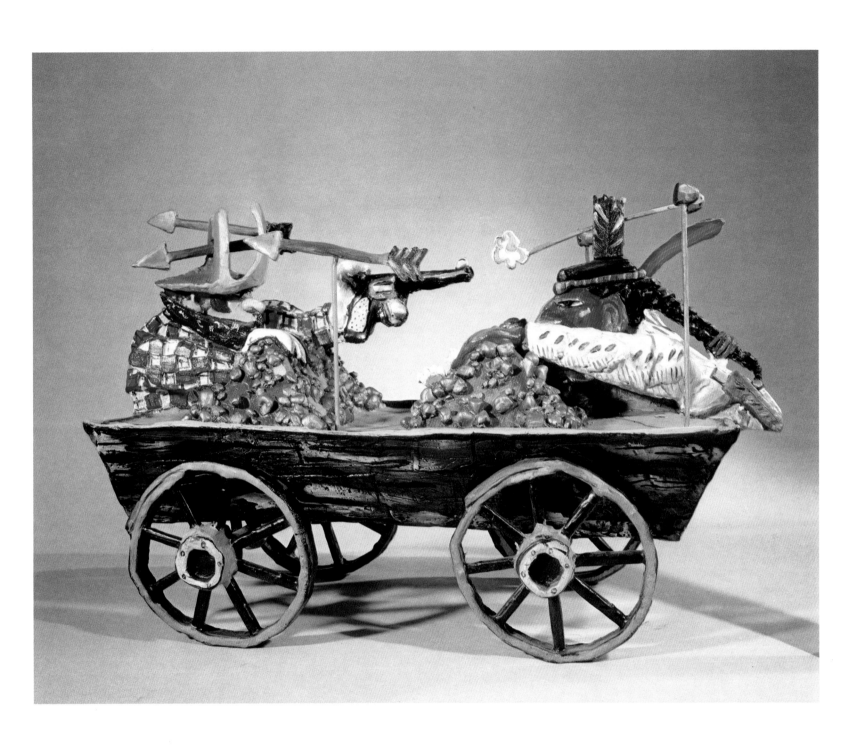

122. **Shoot-out** 1980
Painted bronze
11½ x 22 x 9¼"
Collection Red Grooms, New York, NY

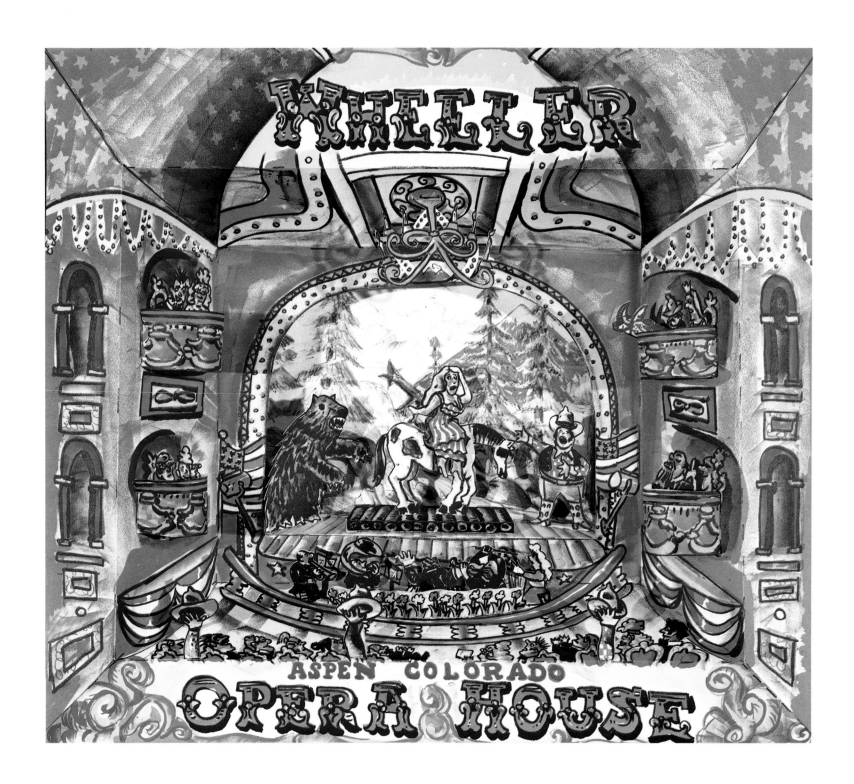

123. **Wheeler Opera House** 1984
Color lithograph, cut-out, in Plexiglas box
4½ x 20 x 17½"
Printer: Bud Shark
Collection Bud Shark, Shark's Lithography, Ltd., Boulder, CO

Film and Happening Props, Paper Movies and Poetry

"I'm for craziness, but also practicality. I do admire
Disney a lot; he's one of the few guys I can see as
a hero."

New York Times, March 29, 1981

124. **Big Moon Face** (used in **Shoot the Moon** 16-mm. film) 1962
Construction
42 x 52 x 18"
Collection Saskia Grooms, New York, NY

125. **Cityscape** (used in **Shoot the Moon** 16-mm. film) 1962
Construction
38¼ x 71 x 11"
Collection Saskia Grooms, New York, NY

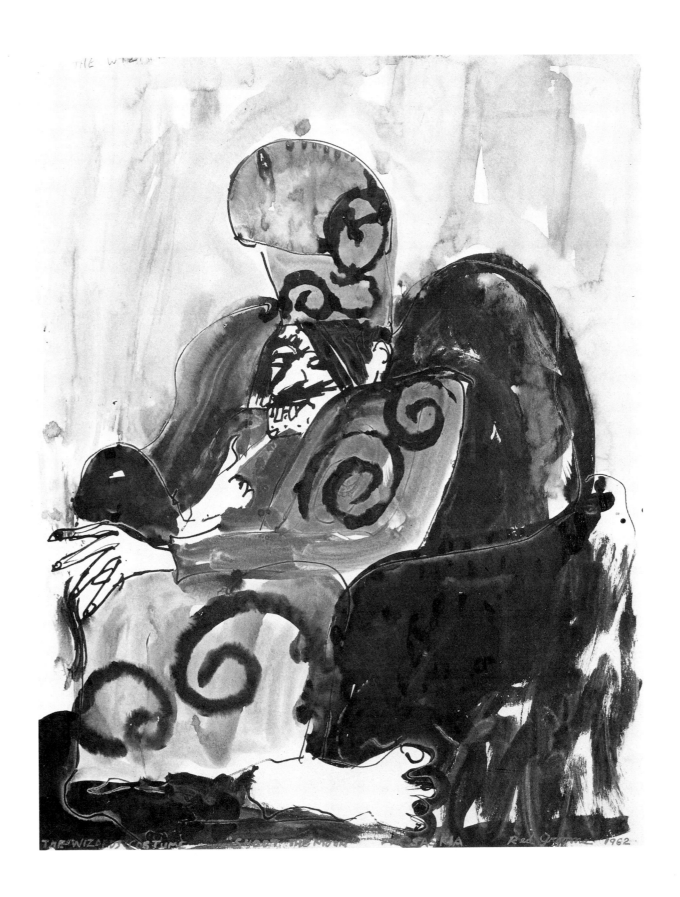

126. **The Wizard's Costume** (for **Shoot the Moon** 16-mm. film) 1962
India ink and gouache on paper
22 x 17″
Collection Saskia Grooms, New York, NY

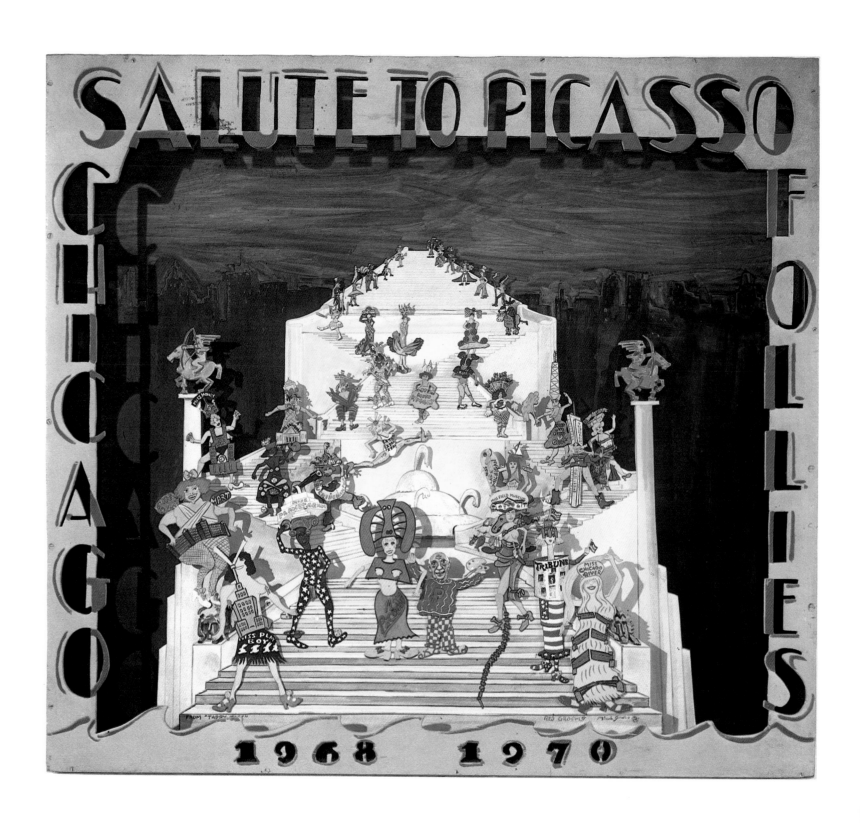

127. **Salute to Picasso — Chicago Follies** (animation used in **Tappy Toes**, a 16-mm. film by Mimi Gross and Red Grooms) 1968-70
Gouache and collage
5′ x 5′ x 4″
Private collection

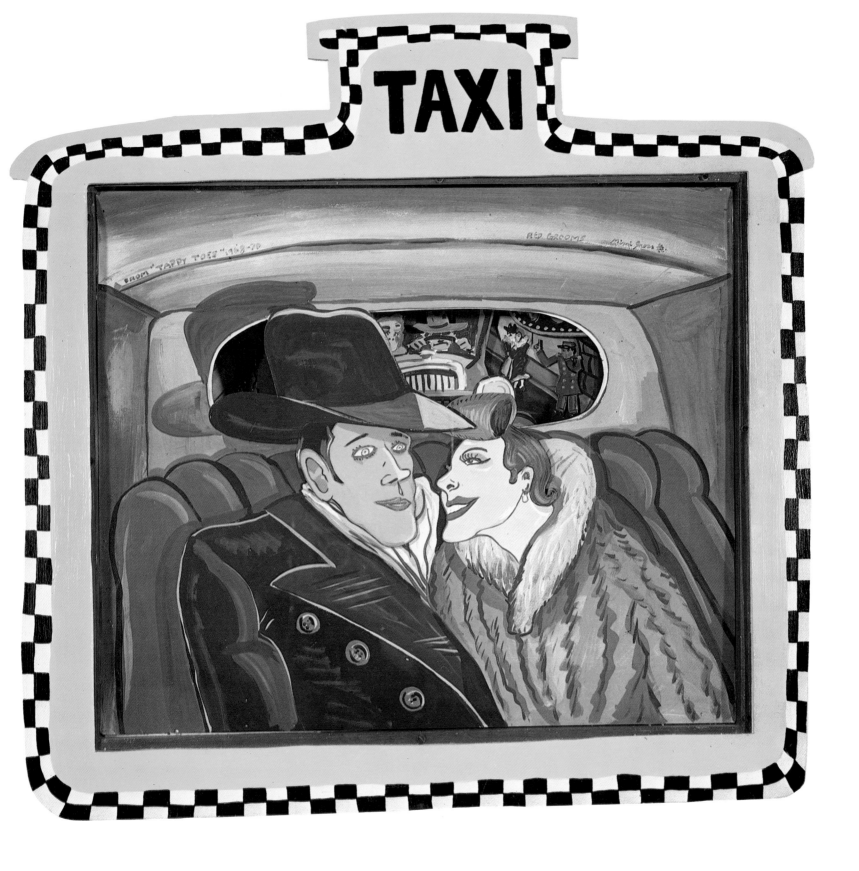

128. **Taxi** (animation used in **Tappy Toes**, a 16-mm. film by Mimi Gross and Red Grooms) 1968-1970
Gouache and collage
32 x 34″
Collection Ann and Walter Nathan, Glencoe, IL

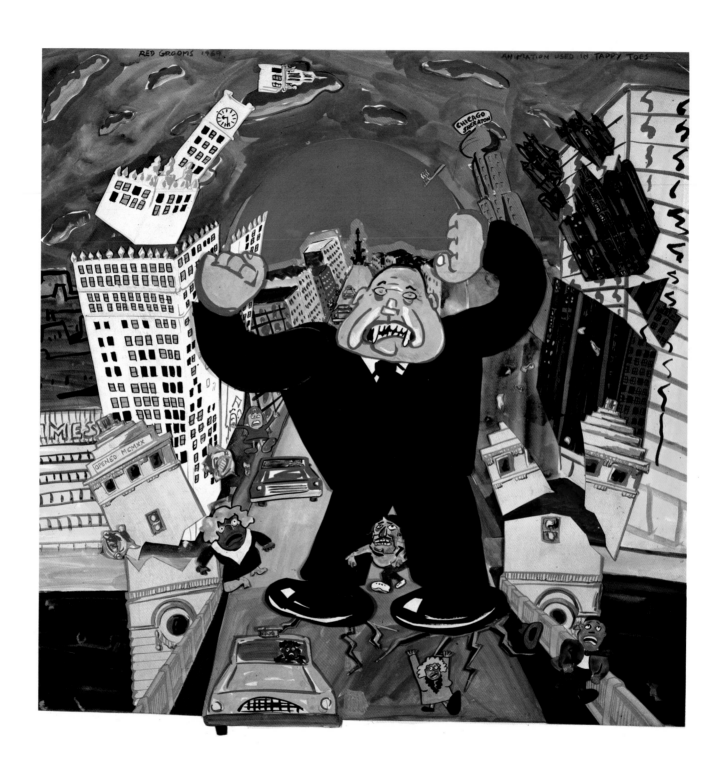

129. **Michigan Boulevard with Mayor Daley** (animation used in **Tappy Toes**, a 16-mm. film by Mimi Gross and Red Grooms) 1969
Gouache and collage
40½ x 40½"
Collection The Metropolitan Museum of Art, Purchase, Friends of the Department Gifts and matching funds from the National
Endowment for the Arts, 1978
Exhibited in Philadelphia

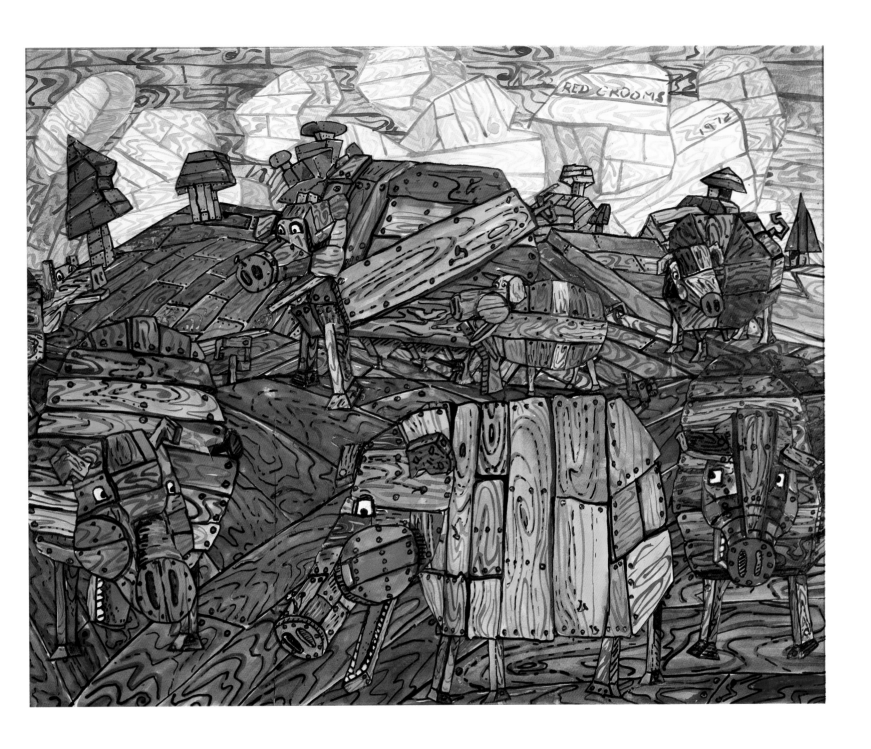

130. **I Nailed Wooden Pegs to Wooden Fields** (animation used in **Hippodrome Hardware**) 1972
Gouache on collaged paper
20½ x 25¾″
Private collection

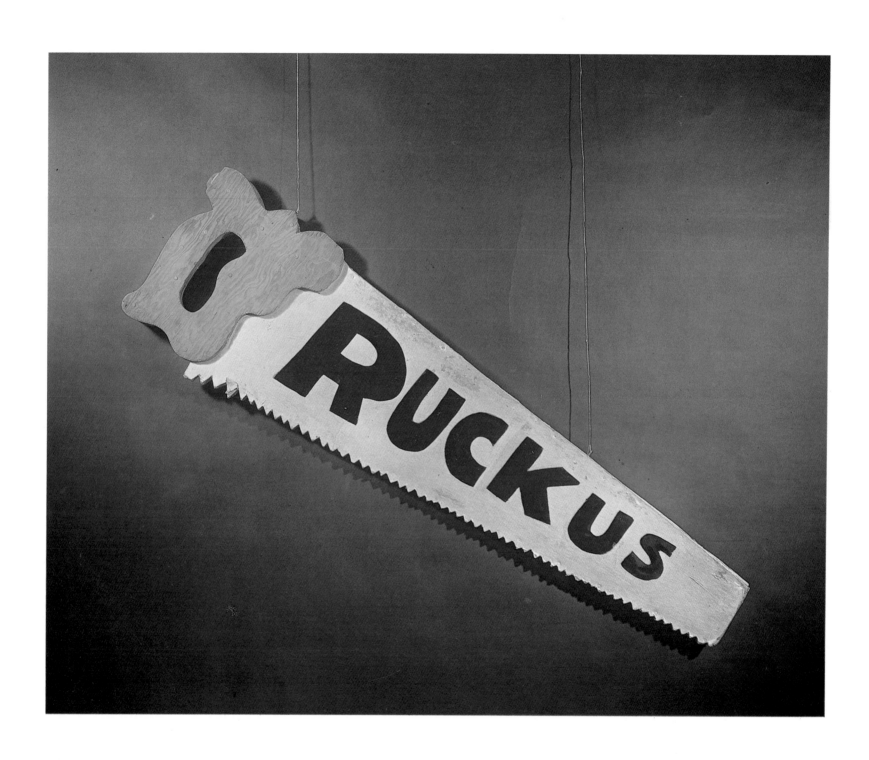

131. **Saw** (used in **Hippodrome Hardware**) 1972
Painted wood and Upson board
21 x 72"
Collection Red Grooms, New York, NY

132. **Catnipped** 1964
Paper movie in painted wood and cardboard frame, colored ink
Movie roll: 5½″ x 35′
Sculpture: 15 x 16¾ x 4½″
Collection Paul Falcone and Jean Falcone, Lexington, MA

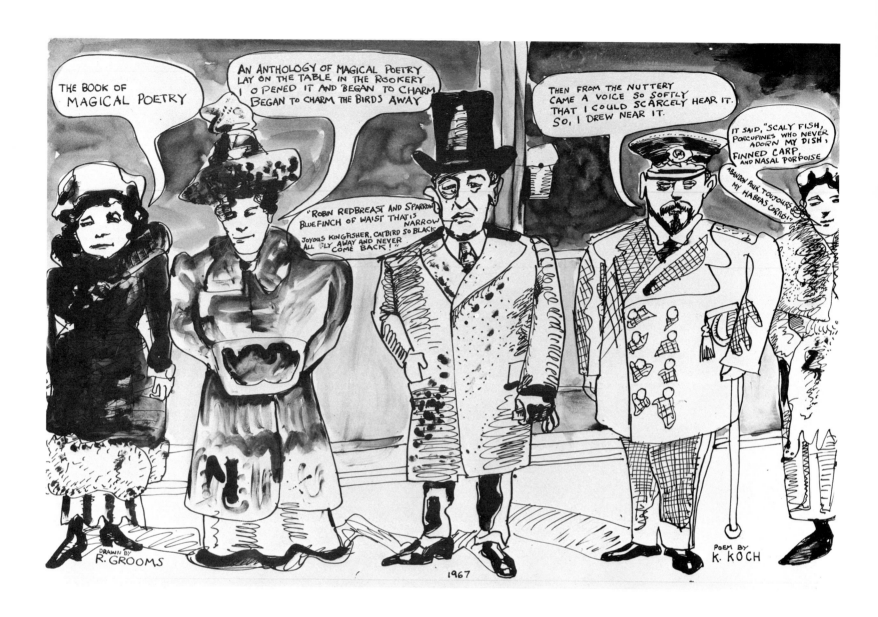

133. **Book of Magical Poetry** 1967
 Felt-tip pen and wash on heavy wove white paper
 35 x 23"
 Collection Allen Memorial Art Museum Fund for Contemporary Art, Oberlin College, Oberlin, OH
 Poem copyright 1966, Kenneth Koch

Global Politics

"[I like] the idea of Noah making this compact thing. He built it and then he . . . saved himself by work, by building this thing and floating away. And it was . . . man triumphing through hard work and a kind of simple mechanical ingenuity."

Cummings interview, 1974

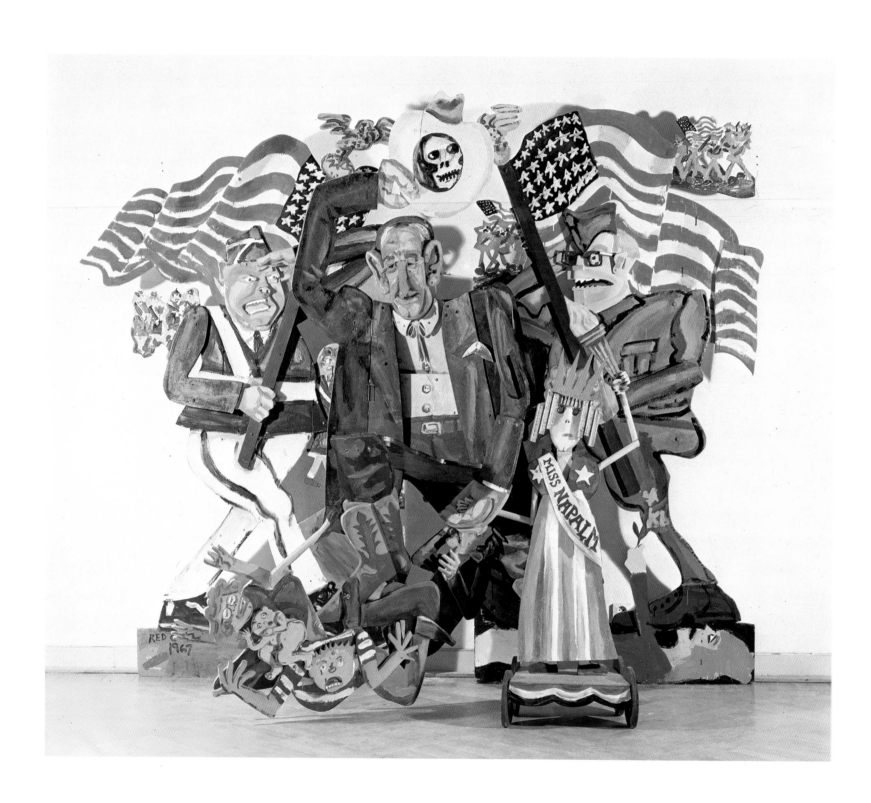

134. **Patriot's Parade** 1967
Construction, painted wood
8′4″ x 11′ x 40″
Collection Moderna Museet, National Museum, Stockholm, Sweden

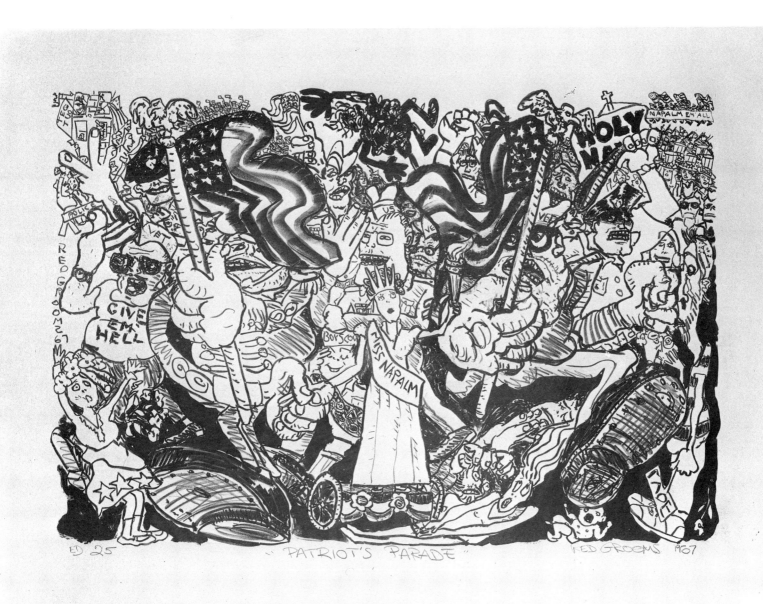

135. **Patriot's Parade** 1967
 Lithograph in black on Rives BFK
 28½ x 38⅜"
 Published by the artist
 Collection Saskia Grooms, New York, NY

136. **Exploding Room** 1983
Gouache and ink on paper
40 x 60"
Collection Mr. and Mrs. Gerald Lennard, New Canaan, CT
Exhibited in Philadelphia

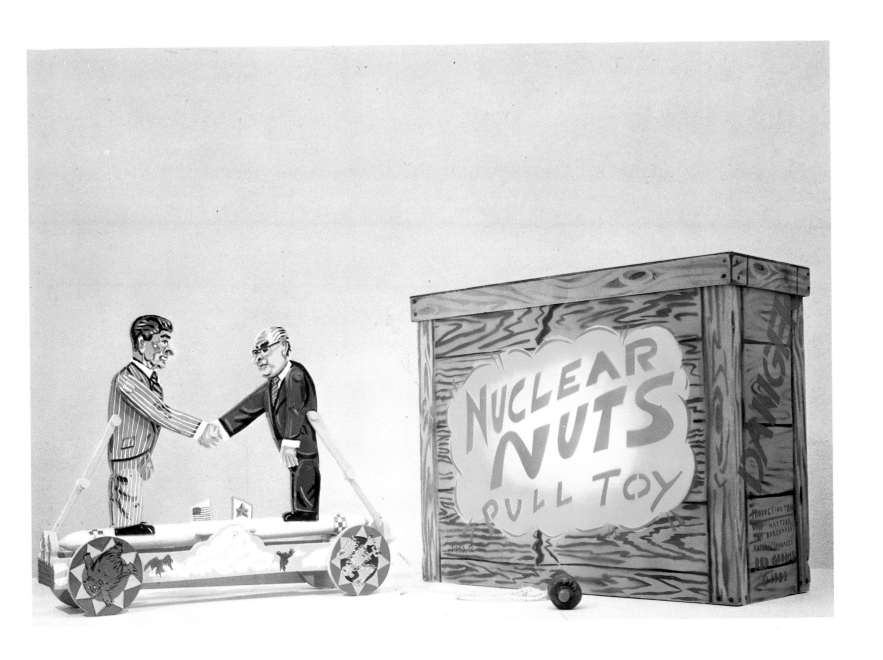

137. **Nuclear Nuts** 1983
Hand-assembled and painted enamel on wood
Box: 22⅛ x 28⅜ x 10¾"
Missile: 19½ x 25¼ x 6¾"
Collection Marlborough Gallery, New York, NY

Subjects: France, Japan, Great Britain

"Seeing another culture . . . clarified the peculiarities of our culture more."

Cummings interview, 1974

138. **French Bread** 1963
Extension painting on canvas
52 x 37"
Abrams Family Collection, New York, NY

139. **Dans le Metro** 1977
Gouache, cut-out paper
43⅔ x 32⅓ x 14"
Collection Mr. and Mrs. Walter G. Knestrick, Nashville, TN

140. **Quick Elysées** 1977
Acrylic on wood and paper
8′ 10″ x 5′ x 1′ 10½″
Collection Graham Gund, Cambridge, MA

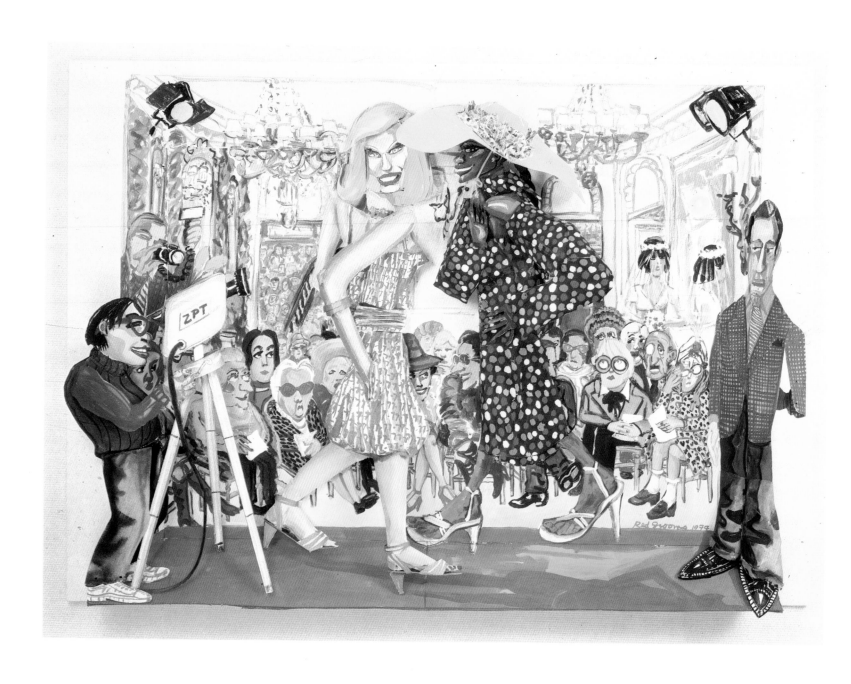

141. **Dior Printemps** 1977
Painted construction
42 x 59½ x 12″
Collection Barbara and A. A. Jacobson, Beverly Hills, CA

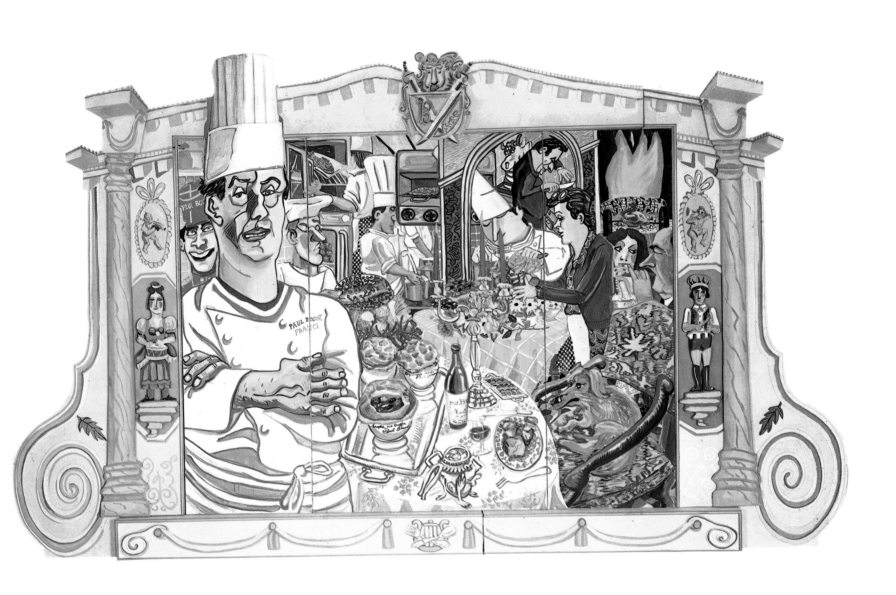

142. **Paul Bocuse's World** 1977
Acrylic on canvas with wood frame
125 x 181 x 8½"
Collection Red Grooms, New York, NY

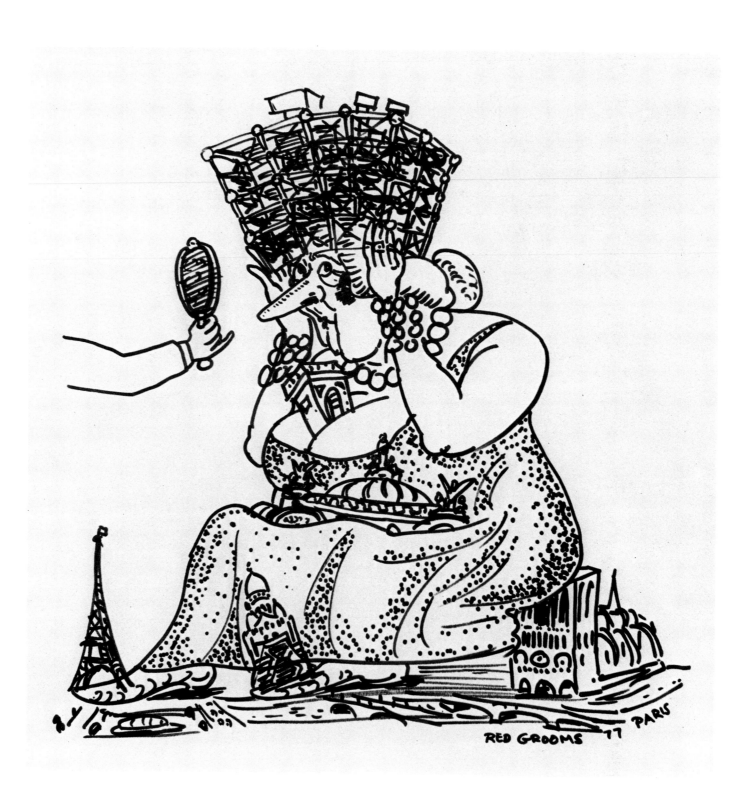

143. **Mme. Paris Tries on a New Hat** 1977
Pen and ink on paper
18⅛ x 16⅝"
Collection Red Grooms, New York, NY

144. **Geisha in a Tub** 1983-84
Polychromed aluminum
86 x 70 x 70"
Collection Marlborough Gallery, New York, NY

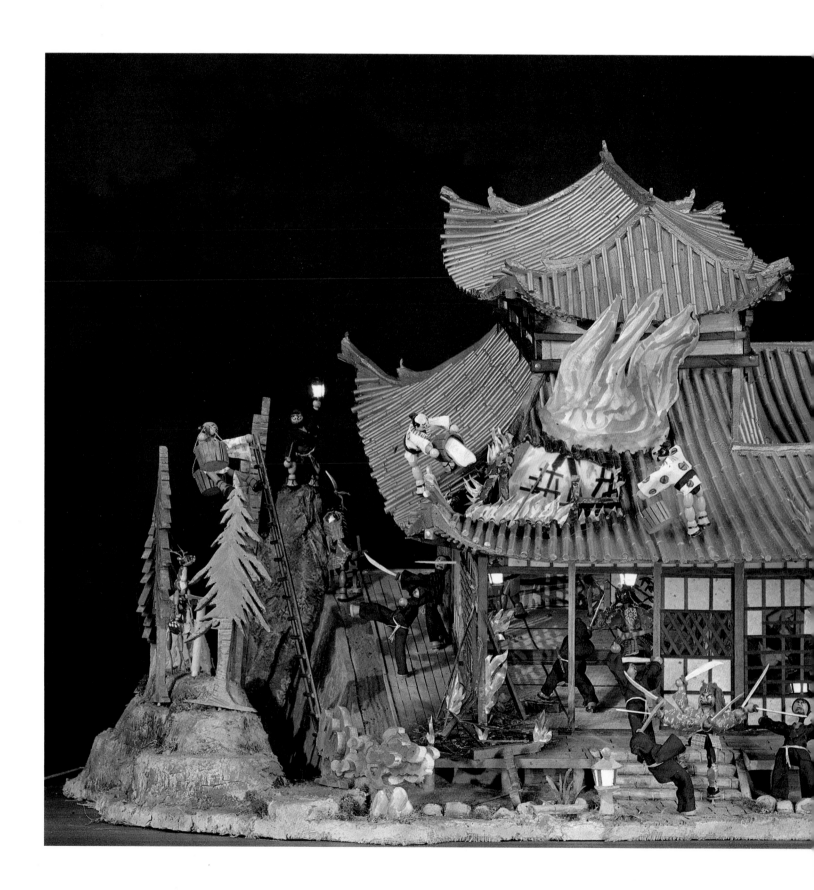

145. **Night Raid on Nijo Castle** 1983-1984
Mixed media
60 x 107 x 73"
Collection Marlborough Gallery, New York, NY

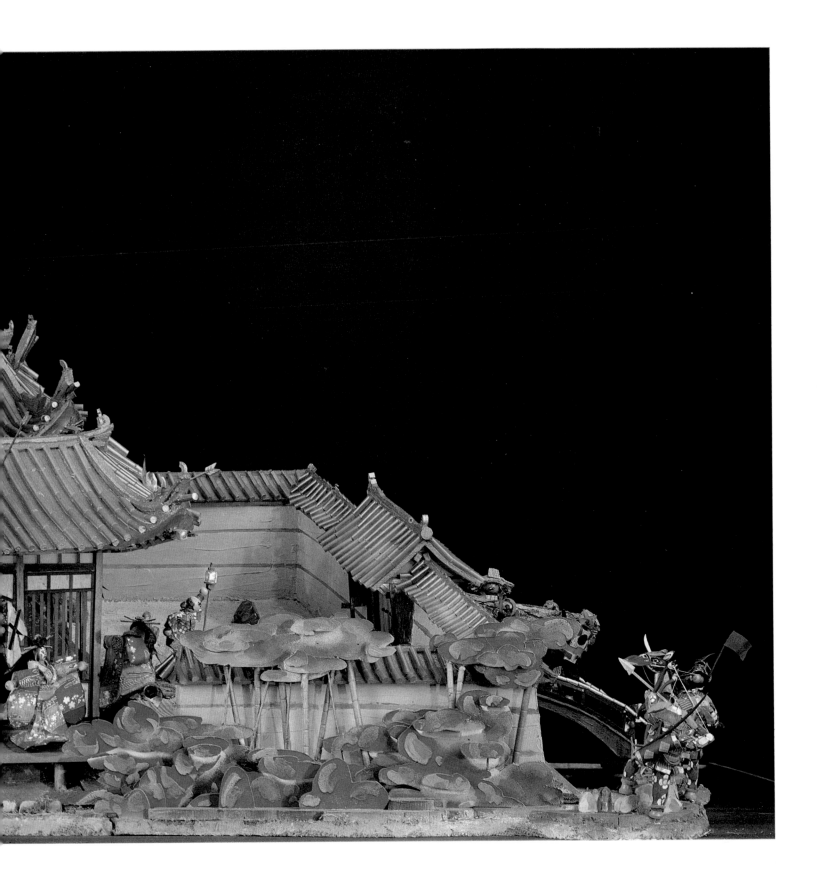

146. **London Bus** 1984
Color lithograph, cut-out, in Plexiglas box
14 x 20 x 22"
Printer: Bud Shark
Collection Bud Shark, Shark's Lithography, Ltd., Boulder, CO

Fantasies

"I like to be extravagant. I should have someone like King Ludwig supporting me."

New York Times Magazine, March 4, 1979

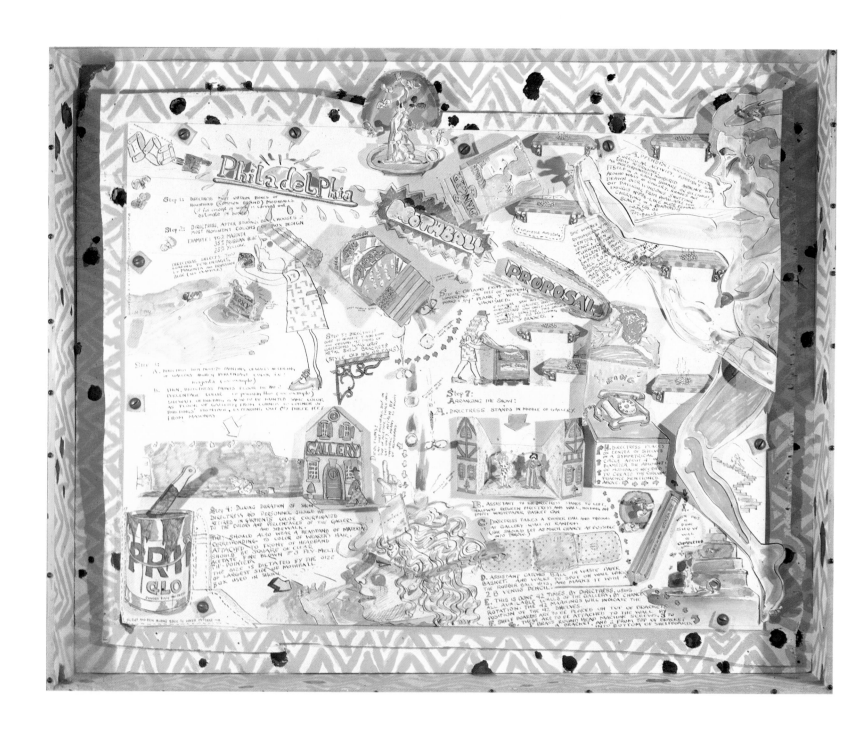

147. **Philadelphia Mothball Proposal** 1970
Watercolor, pen, ink, paper and mothballs on wood
38 x 47½ x 6¼″
Collection Ann and Walter Nathan, Glencoe, IL

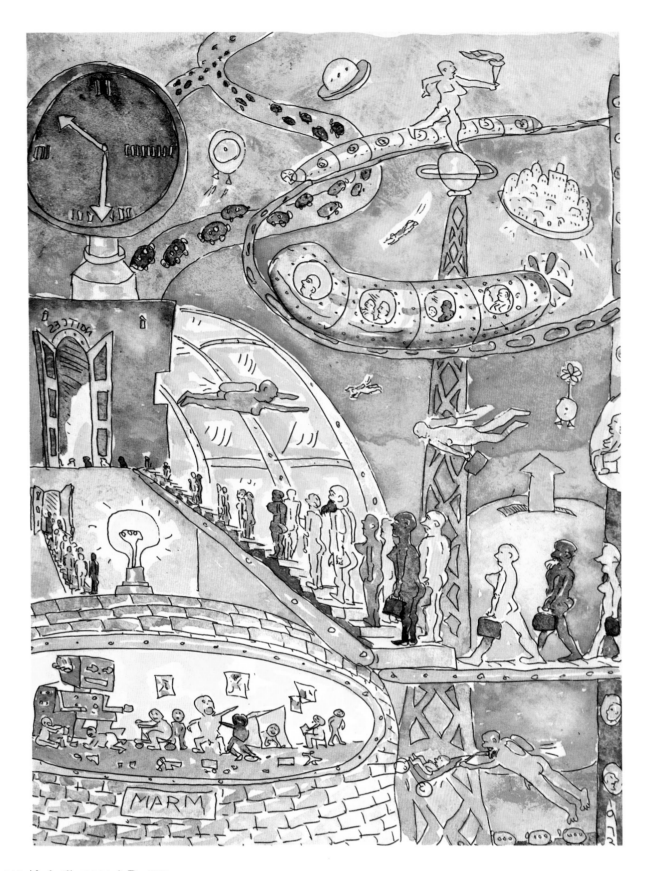

148. **Nashville 2001 A.D.** 1973
Etching in black on Dutch etching paper, hand-colored, watercolor
Edition 20
15 x 12″
Printer: Jennifer Melby
Collection Brooke Alexander, Inc., New York, NY

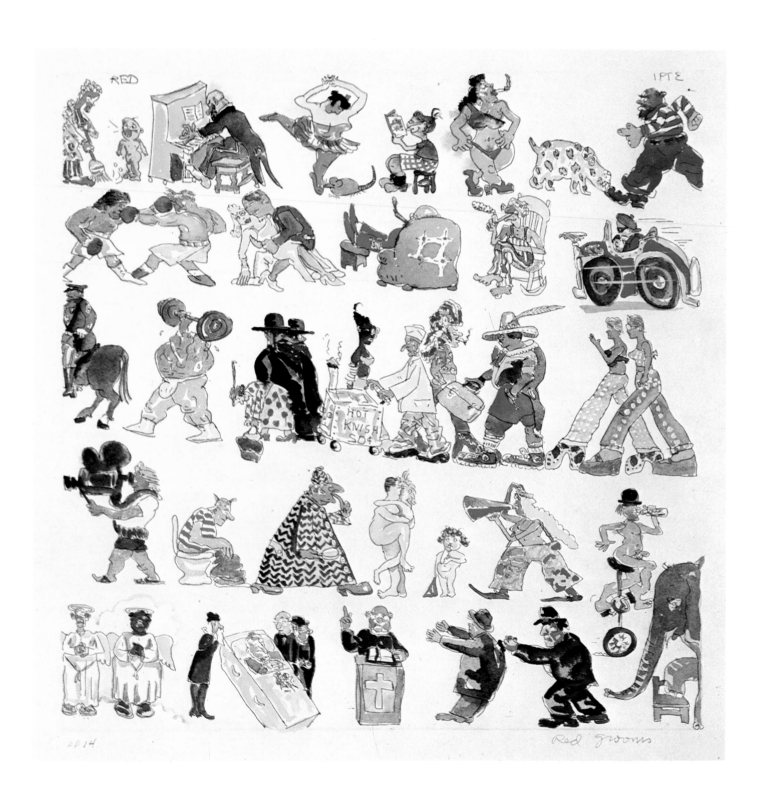

149 **45 Characters** 1973
Etching on Dutch etching paper, hand-colored, watercolor
A.P. #14
19 x 17¾"
Printer: Jennifer Melby
Collection Brooke Alexander, Inc., New York, NY

150. **Carve Here and Press** 1975
Watercolor
13 x 10″
Collection Saskia Grooms, New York, NY

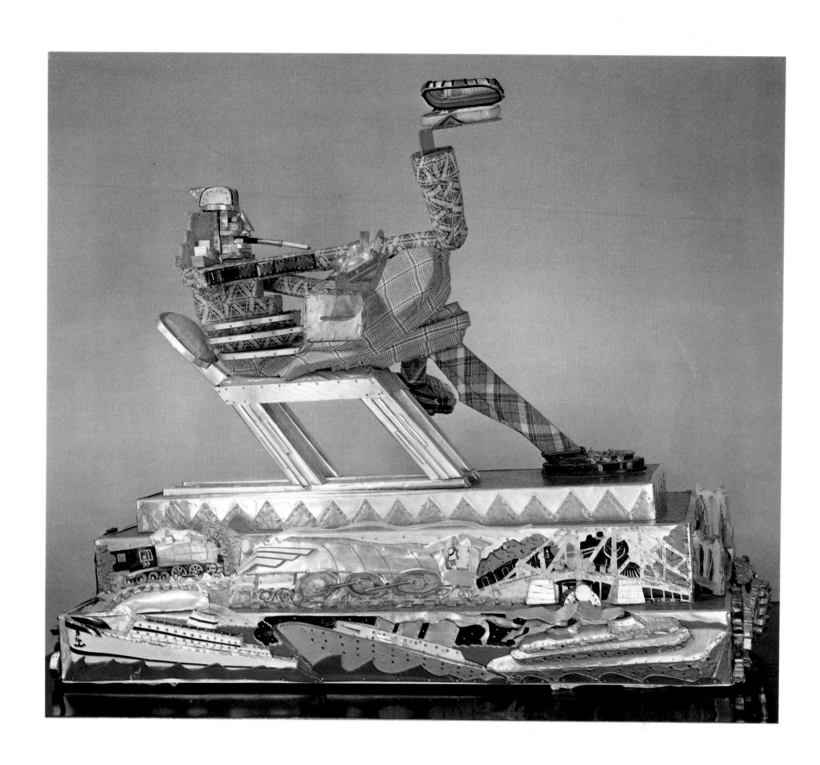

151. **The Minister of Transportation** 1974-1975
Mixed media
53 x 38 x 68"
Collection Marc and Livia Straus, Chappaqua, NY

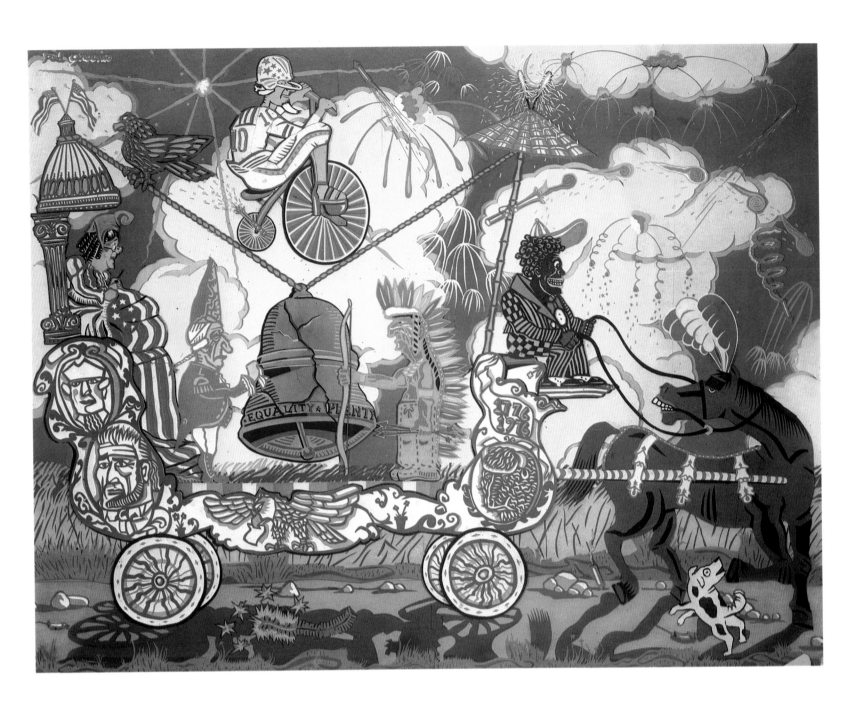

152. **Bicentennial Bandwagon** 1976
Cut colored paper
49 x 37½″
Collection Red Grooms, New York, NY

153. **Lumberjack** 1977
Acrylic on wood
57½ x 43½"
Collection Martin Sklar, New York, NY

154. **Lumberjack** 1977-1984
Painted bronze
99 x 47 x 18"
Collection Marlborough Gallery, New York, NY

155. **Lorna Doone** 1979-1980
Color lithograph with collage and rubber-stamp impressions
24½ x 32″ each of two sheets
Printer: Steven M. Andersen, Vermillion Press Ltd., MN
Collection Brooke Alexander, Inc., New York, NY

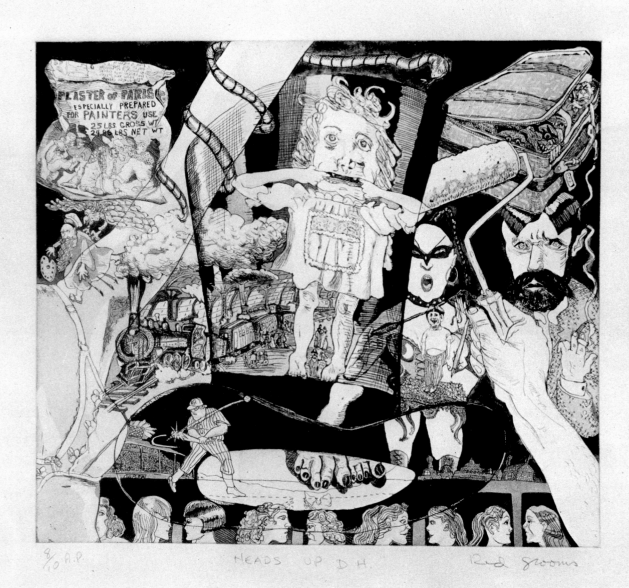

156. **Heads Up D.H.** 1980
Etching and aquatint in black on Rives BFK
26¾ x 30″
Published by Brooke Alexander, Inc., NY
Printer: Jennifer Melby
Collection Brooke Alexander, Inc., New York, NY

157. **The Tattoo Artist** 1980-1981
Color lithograph on Chauke
Edition 38
38 x 24¾"
Published by Brooke Alexander, Inc., NY
Printer: Steven M. Andersen, Vermillion Press Ltd., MN
Collection Brooke Alexander, Inc., New York, NY

Sports

"I think the imagery [more than critics or dealers] has the greatest power. It's like having record books without having athletes. It wouldn't make any sense. The athlete has to create the feat. That's what an artist does when he breaks through with an image. It's kind of a moment of genius, really. I say genius because they have to create something which is so communicative to a large number of people that it has to have something which is taken from the whole society and time."

Artlines, 1983

158. **Fran Tarkenton** 1979
Hand-painted vinyl, aluminum armature and polyester stuffing
Edition 8
96 x 48 x 8″
Co-published by Brooke Alexander, Inc., and Marlborough Graphics, Inc., NY
Project coordinator and printer: Steven M. Andersen, Vermillion Press Ltd., MN
Collection Brooke Alexander, Inc., New York, NY

159. **Jack Beal Watching the Super Bowl** 1980
Etching and aquatint in black on Somerset
18 x 14¾"
Published by Brooke Alexander, Inc.
Printer: Jennifer Melby
Collection Brooke Alexander, Inc., New York, NY

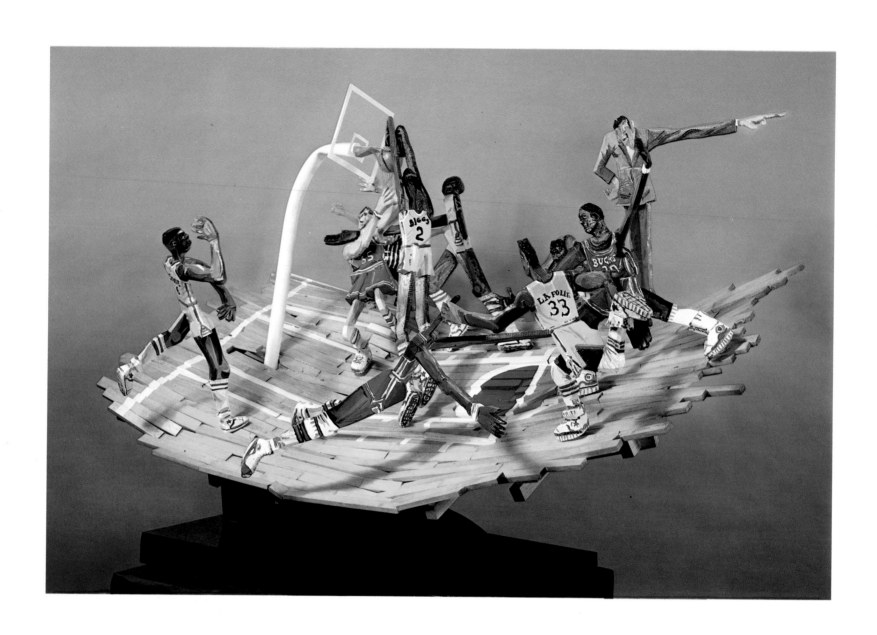

160. **Fast Break** 1983-1984
Painted wood
48 x 68½ x 36″
Private collection
Exhibited in Philadelphia

Self-Portraits

"Art is such a personal thing. It's just one person, one ego, almost singly envisioning the world to their own size. It's so small it's sort of ridiculous, old-fashioned really."

Cummings interview, 1974

161. **Double Self-Portrait** 1965
Watercolor
22 x 28"
Collection Lyzon Gallery, Nashville, TN

162. **Self-Portrait** 1965
Acrylic on wood
24 x 28 x 12"
Collection Mimi Gross, New York, NY

163. **Self-Portrait** c. 1970
Watercolor
15 x 11"
Collection Renee and Chaim Gross, New York, NY

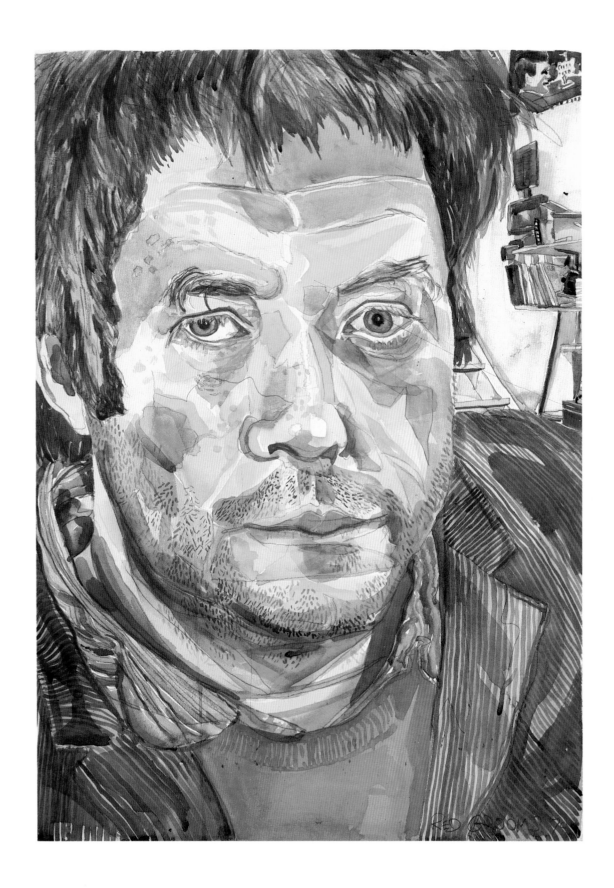

164. **Self-Portrait** 1974
Watercolor and pencil on paper
25½ x 22¼"
Collection Robin Pell, New York, NY

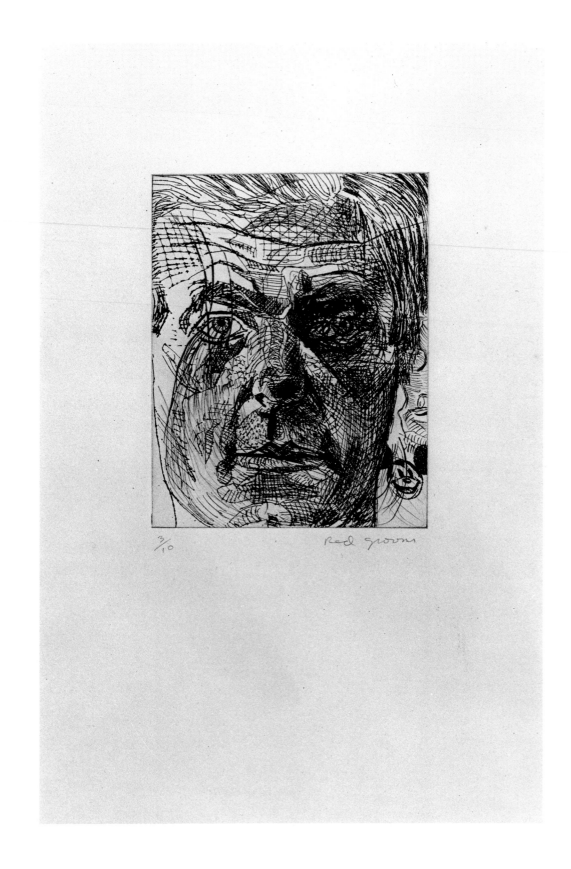

165. **Self-Portrait** 1976
Etching in black on Somerset
22¾ x 15"
Published by the artist
Printer: Jennifer Melby
Collection Saskia Grooms, New York, NY

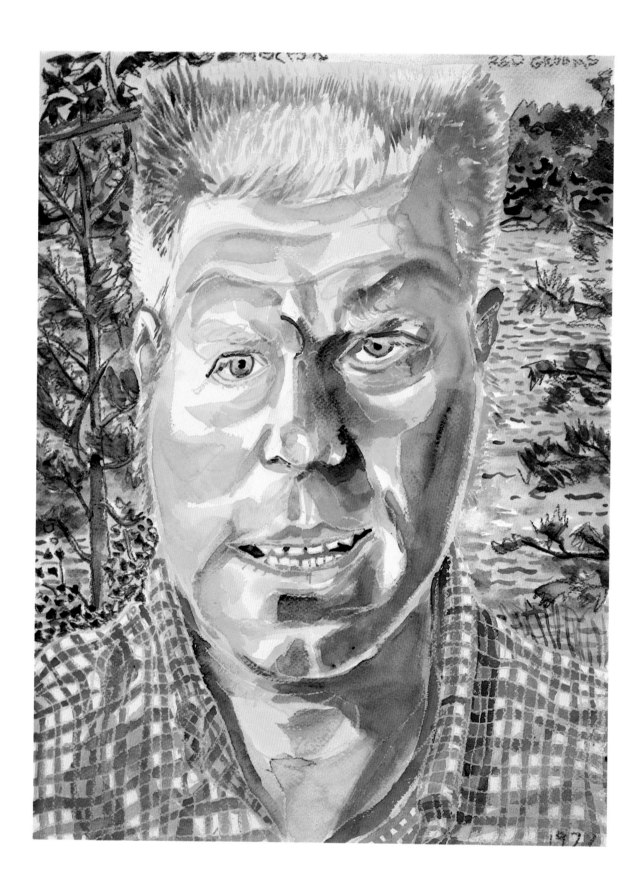

166. **Self-Portrait with Flat Top, Maine** 1977
Watercolor and crayon on paper
24 x 18″
Collection Mrs. Sidney Merians, Princeton, NJ

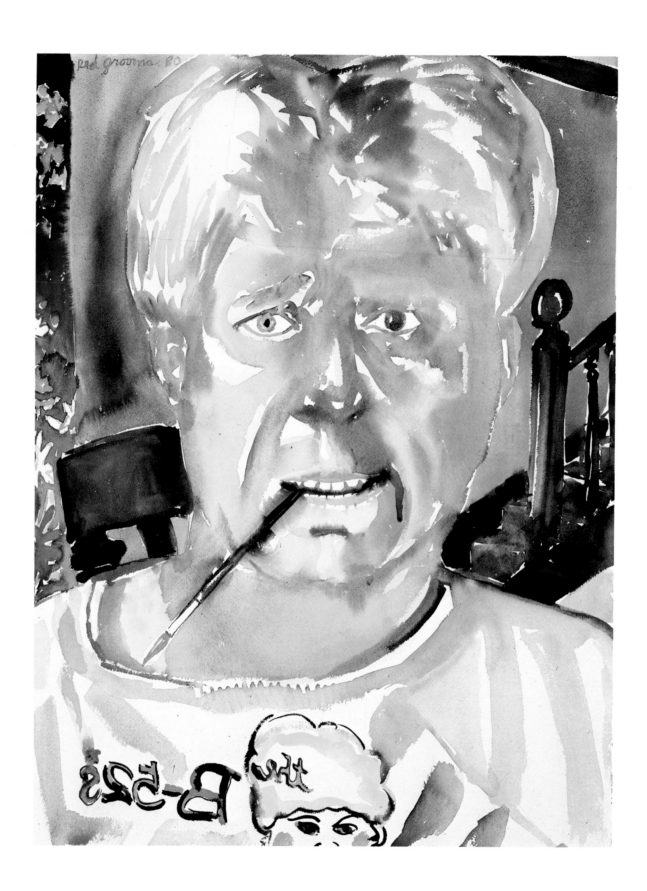

167. **Self-Portrait in Brittany** 1980
Watercolor
24 x 18"
Collection Brooke and Carolyn Alexander, New York, NY

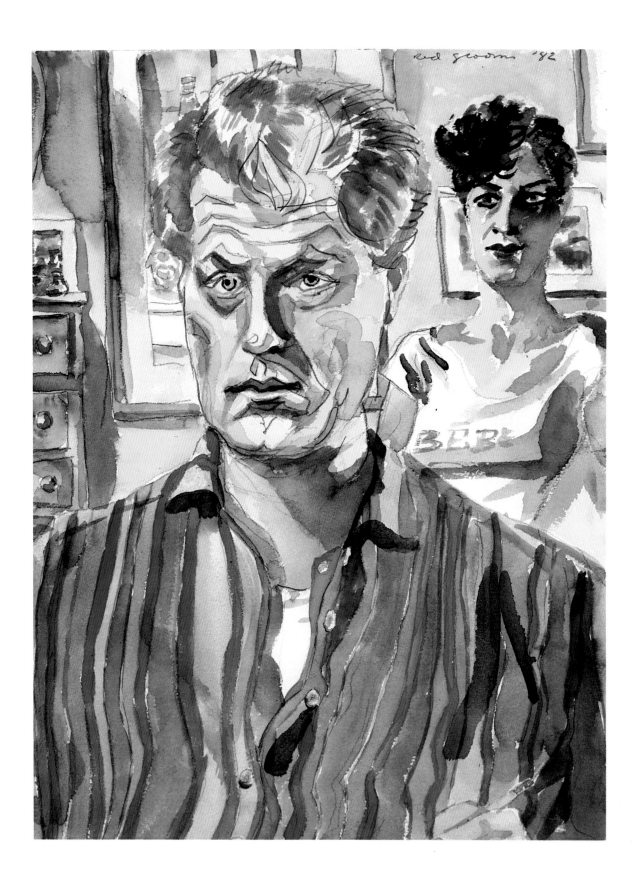

168. **Self-Portrait with Lizzy** 1982
Watercolor
16 x 12"
Collection Mr. and Mrs. Walter G. Knestrick, Nashville, TN

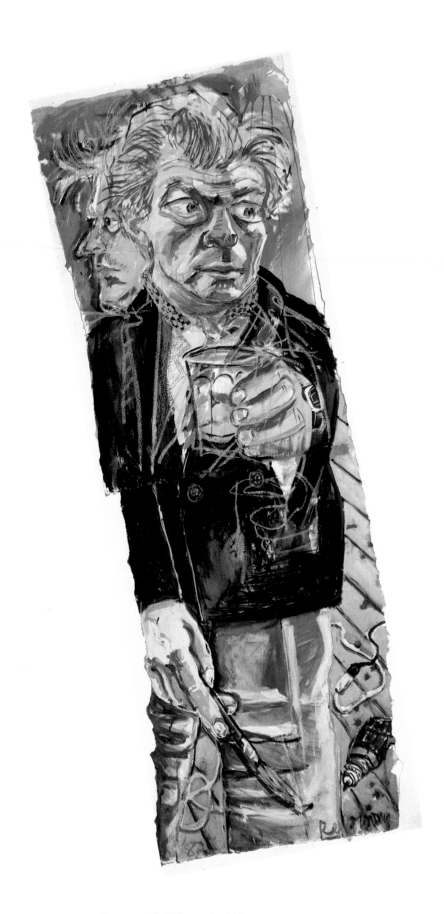

169. **Diagonal Self-Portrait** 1982
Gouache on paper
85 x 30½"
Collection Leslie and Stanley Westreich, Bethesda, MD
Exhibited in Philadelphia

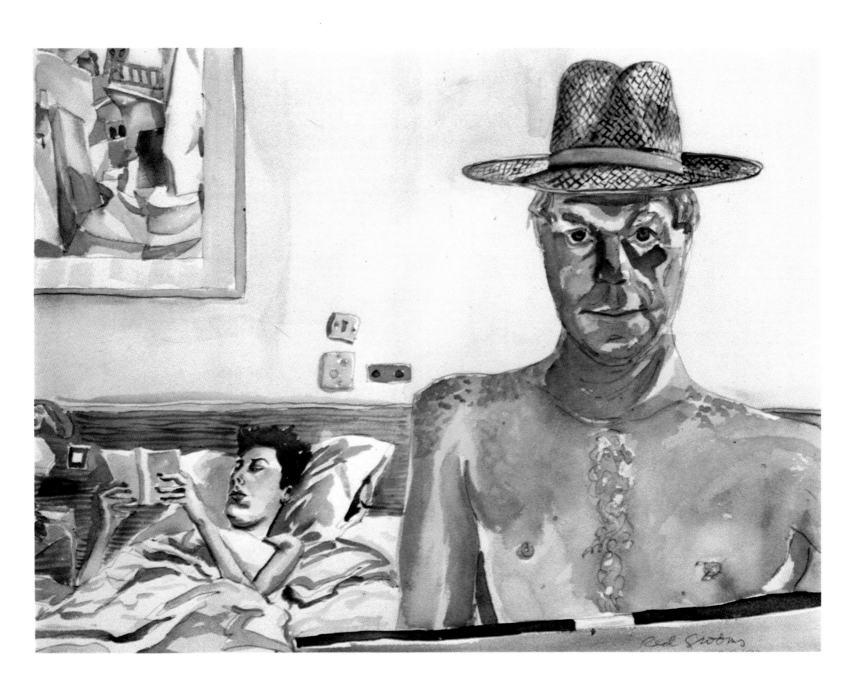

170. **Hotel Room in Athens with Elisabeth Ross** 1983
Watercolor
18 x 24″
Collection Robin Quist, Woodside, CA

Chronological Bibliography & Exhibition History

compiled by **Jennifer Way**

The literature on Red Grooms consists primarily of periodical reviews and exhibition catalogues. For each year, the bibliography and data unrelated to specific exhibitions have been combined. Listings of exhibitions follow, with catalogues, when applicable; solo shows are denoted by an asterisk. Pertinent reviews appear after each exhibition, and are indented.

Happenings, films, commissions, and teaching appointments, as well as exhibitions, are italicized throughout.

1952

National Scholastic Art Contest, winner. Exhibition held at Carnegie Institute, Pittsburgh, PA.

"2 Hillsboro Students Win National Art Recognition." *The Tennessean*, May 3, 1952.

1954

United Nations International Children's Emergency Fund, poster contest winner.

"Poster Contest Winners." *Nashville Banner*, November 3, 1954.

1955

School of The Art Institute of Chicago, IL. Education.

LeQuire, Louise. "September 13 Deadline for State Fair Entries." *Nashville Banner*, August 19, 1955.

Lyzon's Gallery, Nashville, TN. "Charles Grooms and Walter Knestrick" (35 paintings exhibited by these Hillsboro High School seniors). February 13–February 28.

LeQuire, Louise. "2 Hillsboro Students Plan Exhibit; Dance, Music Enhance Peabody Event." *Nashville Banner*, February 11, 1955.

1956

George Peabody College for Teachers, Nashville, TN. Education.
New School for Social Research, New York, NY. Education.

1957

Hans Hofmann School of Fine Arts, Provincetown, MA. Education.
Sun Gallery, Provincetown, MA. "Celebration of the Death of the Sun" (Red and Yvonne Andersen create a two-person painting over successive midnight sessions).

1958

Salisbury, MA. Billboards near amusement park painted by Red, Lester Johnson, and Yvonne Andersen. Spring.
Sun Gallery, Provincetown, MA. "The Duality of City Life, and Life in the Sun" (group exhibition). Summer.
Sun Gallery, Provincetown, MA. Solo exhibition. August.

LeQuire, Louise. "Southeastern Show Scheduled in Atlanta." *Nashville Banner*, August 1, 1958.

Sun Gallery, Provincetown, MA. A Play Called Fire (performance during which a large painting was executed. August.
City Gallery, New York, NY. Founded and run by Red and Jay Milder as an alternative exhibition space. Exhibitions continued through 1959 and included, among others, Lester Johnson and Marcia Marcus.

1959

City Gallery, New York, NY. "Jay Milder and Red Grooms." February 6–March 1.

H[ale], H[erbert D.]. "Reviews and Previews: New Names This Month—Milder and Grooms." *Art News*, 57 (February 1959), p. 19.

City Gallery, New York, NY. Red gives Claes Oldenburg his first group exhibition opportunity. May–June.
Sun Gallery, Provincetown, MA. Solo exhibition. September.
Sun Gallery, Provincetown, MA. Walking Man (performance). September.
Reuben Gallery, New York, NY. 18 Happenings in 6 Parts (Red performed in this event created by Allan Kaprow). October 4.
Delancey Street Museum, New York, NY. An exhibition space founded by Red in his Delancey Street studio. The Burning Building (performance). December 4–December 11.

Ratliff, Marc, ed. "The Burning Building of Red Grooms." *Exodus*, published by the Judson Studio in Greenwich Village, 3 (Spring–Summer 1960); p. 14.

Reuben Gallery, New York, NY. "Below Zero" (group exhibition). December 18, 1959–January 5, 1960.

1960

Delancey Street Museum, New York, NY. The Garden, a ballet happening by Marcia Marcus, with Red, Bob Thompson, and Richard Bellamy participating.
Reuben Gallery, New York, NY. The Magic Train Ride, first entitled Fireman's Dream (performed as part of a series with Robert Whitman and Allan Kaprow entitled Four Evenings). January 6–January 11.

Tallmer, Jerry. "Theatre (?): Three New Happenings." *Village Voice*, January 13, 1960.

Reuben Gallery, New York, NY. "Red Grooms," paintings, collages, and constructions for stage sets. Solo exhibition, January 9–January 28.

Hess, Thomas B. "The Year's Best: 1960." *Art News*, 59 (January 1961), pp. 25 and 50.

S[eelye], A[nne]. "Reviews and Previews: New Names This Month—Red Grooms." *Art News*, 58 (February 1960), p. 18.

V[entura], A[nita]. "In the Galleries: Red Grooms." *Arts Magazine*, 34 (February 1960), p. 67.

Reuben Gallery, New York, NY. "Paintings" (group exhibition). January 29–February 18.

Porter, Fairfield. "Art." *The Nation*, 190 (February 13, 1960), p. 154.

Judson Gallery, Judson Memorial Church, New York, NY. Red and other artists create comic books for "Ray Gun" (an installation by Claes Oldenburg and Jim Dine). January through February.
Judson Gallery, Judson Memorial Church, New York, NY. The Big Leap (performance scheduled for February 29 in conjunction with a series of happenings entitled Ray Gun Spex). Red's performance was cancelled.
Rutgers University Art Gallery, New Brunswick, NJ. Allan Kaprow curates an exhibition of Red's paintings. Spring.
Martha Jackson Gallery, New York, NY. "New Media—New Forms in Painting and Sculpture" (group exhibition). June 6–June 24. Catalogue: published October 1960 and entitled "New Forms—New Media I," essays by Lawrence Alloway and Allan Kaprow.

"Art: Here Today . . ." *Time*, 74 (June 20, 1960), p. 62.

B[urrows], C[lyde]. "New Media, Forms." *New York Herald Tribune*, June 12, 1960.

Canaday, John. "Art: A Wild, but Curious, End-of-Season Treat." *New York Times*, June 7, 1960, p. 32.

Hess, Thomas B. "Mixed Mediums for a Soft Revolution." *Art News*, 59 (Summer 1960), pp. 45 and 62.

Sandler, Irving H. "Ash Can Revisited, a New York Letter." *Art International*, 4 (October 1960), pp. 29 and 30.

Travels: three months in Florentine studio; six weeks of travel with a puppet show from Florence to Ravenna; five months to Scotland, London, and Paris; and visits to Greece, Mycenae, Egypt, and Israel. Beginning in July and continuing into 1961.

Hieronymus, Clara. "Nashville Artist Now in Europe, Charles Grooms Is Traveling, Developing New Ideas in Art." *The Tennessean*, July 24, 1960.

1961

Constable, Rosalind. "Scouting Report on the Avant-Garde." *Esquire*, 55 (June 1961), pp. 86–88.

Franklin, Corinne. "Red Grooms Deeply Involved in Happy and Intense Life." *Nashville Banner*, December 30, 1961.

Grooms, Red, and Mimi Gross. *A Book of Drawings*. Privately published in Florence, Italy. Drawings from recent travels.

Kaprow, Allan. "'Happenings' in the New York Scene." *Art News*, 60 (May 1961), p. 37.

LeQuire, Louise. "Charles Grooms, The Artist at 23." *Motive*, 31 (March 1961), pp. 21–29.

McDarrah, Fred, with introduction by Thomas Hess. *The Artist's World in Pictures*. New York: E.P. Dutton & Co., p. 184.

1962

Janis, Harriet, and Rudi Blesh. *Collage; Personalities, Concepts, Techniques*. Philadelphia: Chilton Co., pp. 273–276.

**Nashville Artist Guild, Nashville, TN. "Charles 'Red' Grooms with Paintings, Drawings, and Theatre Designs." May 13–May 27. Announcement drawn by Red.*

Franklin, Corinne. "Red Grooms' Work Shows Big Spark of Spontaneity." *Nashville Banner*, May 12, 1962.

Hieronymus, Clara. "Alas, Festival Grows Up." *The Tennessean*, May 13, 1962.

**Tibor de Nagy Gallery, New York, NY. Group exhibition. Fall.*

Johnston, Jill. "Happenings, New York Scene." *Encore*, September/October.

1963

Katz, Alex. "Rudolph Burckhardt: Multiple Fugitive." *Art News*, 62 (December 1963), p. 40.

Hunter College Playhouse, New York, NY. Designs by Red and other artists for Two New Ballets, by James Waring Dance Company. February 3.

Hardware Poets Playhouse, New York, NY; George Segal's Farm, NJ; Smolin Gallery, New York, NY. Red and many other artists and musicians participate in Yam Festival (happenings, performances, dance, music, and events). May 1–May 31.

**Tibor de Nagy Gallery, New York, NY. "Red Grooms." October 15–November 2.*

Hieronymus, Clara. "A Bright Occasion." *The Tennessean*, November 17, 1963.

Rose, Barbara. "New York Letter." *Art International*, 7 (December 5, 1963), pp. 62 and 63.

Sandler, Irving H. "In the Galleries: Red Grooms." *New York Post*, October 27, 1963.

S[wenson], G[ene] R. "Reviews and Previews: New Names This Month." *Art News*, 62 (October 1963), p. 14.

T[illim], S[idney]. "In the Galleries: Red Grooms." *Arts Magazine*, 38 (December 1963), pp. 63–64.

1964

Bryant, Edward, and Daniel Robbins. "New Talent: Old Problems." *Art in America*, 52 (August 1964), p. 108.

International Avant-Garde. Milan: Galleria Schwartz (twenty artists' original etchings, edition of 100).

Koch, Kenneth. *Death of Kangaroo (a play for which costumes and sets were designed by Red). First performed at the American Theater for Poets, Inc., New York, NY.*

Koch, Kenneth. *Guinevere. Sets commissioned for this play.*

Kozloff, Max. "Art and the New York Avant-Garde." *Partisan Review*, 31 (Fall 1964), p. 550.

Finch College, New York, NY. "Artists Select" (group exhibition).

Tirca-Karlis Gallery, Provincetown, MA. Group exhibition.

Art Institute of Chicago, Chicago, IL. "Directions in Contemporary Painting and Sculpture—67th American Exhibition" (group exhibition). February 28–April 12. Catalogue: foreword by A. James Speyer.

Wadsworth Atheneum, Hartford, CT. "Contemporary American Figure Painting" (group exhibition). May 7–May 31.

**Tibor de Nagy Gallery, New York, NY. "Red Grooms." June 2–June 27.*

Oeri, Georgine. "The Object of Art." *Quadrum*, 16 (Summary 1964), pp. 20–21.

Fischbach Gallery, New York, NY. Group exhibition. June 16–July 2.

1965

Archives of American Art, Smithsonian Institution, Washington, DC. Transcribed interview of Red and Marisol by an unknown interviewer.

Hansen, Al. *A Primer of Happenings & Time/Space Art*. New York: Something Else Press, p. 68.

Kirby, Michael, ed. "Red Grooms." *Happenings, An Illustrated Anthology*. New York: E.P. Dutton & Co., pp. 118–133.

Matusow, Harvey Marshall. *The Art Collectors Almanac*. Huntington Station, NY: Jerome E. Treisman, p. 244.

Tirca-Karlis Gallery, Provincetown, MA. Group exhibition.

Solomon R. Guggenheim Museum, New York, NY. "Eleven from the Reuben Gallery" (group exhibition). Catalogue: introduction by Lawrence Alloway.

New School for Social Research Art Center, New York, NY. "Portraits from the American Art World" (group exhibition). February 2–February 27. Catalogue: statement by Paul Mocsanyi.

Worcester Art Museum, MA. "The New American Realism" (group exhibition). February 18–April 4. Catalogue: note by Daniel Catton Rich, introduction by Martin Carey.

**Tibor de Nagy Gallery, New York, NY. "Red Grooms." April 1–April 17.*

B[errigan], T[ed]. "Reviews and Previews: Red Grooms." *Art News*, 64 (April 1965), p. 10.

G[oldin], A[my]. "Red Grooms." *Arts Magazine*, 39 (May/June 1965), p. 57.

"Painting: Grand Pop Moses." *Time*, 85 (April 9, 1965), p. 76.

Parrish Art Museum, Southampton, NY. "Eighteen Painters Invitational Exhibition" (group exhibition). August 8–August 29. Work selected by Fairfield Porter. Brochure: foreword by Fairfield Porter.

Pan Am Building, American Greetings Gallery, New York, NY. "16 Toys" (group exhibition). November 22, 1965–January 3, 1966.

P[iene], N[an]. "Christmas for Children." *Art in America*, 53 (December 1965), pp. 25 and 26.

1966

Berrigan, Ted. "Red Power." *Art News*, 65 (December 1966), pp. 44–46.

Cummings, Paul. *Dictionary of Contemporary American Artists*. New York: St. Martin's Press, p. 181.

Gilbert, Dorothy, ed. *Who's Who in American Art*, volume 9. New York: R.R. Bowker Co., p. 181.

Kaprow, Allan. *Assemblage, Environments & Happenings*. New York: Harry N. Abrams.

Lippard, Lucy R. *Pop Art*. New York: Frederick A. Praeger, Inc., pp. 74 and 135.

The Paper Bag Players and American Federation of Arts, New York, NY. Poster commission for List Art Poster Program.

Sontag, Susan. "Happenings: An Art of Radical Juxtaposition" (1962). In *Against Interpretation*. New York: Farrar, Straus & Giroux, p. 264.

Finch College, New York, NY. "Projected Art" (group exhibition).

Tirca-Karlis Gallery, Provincetown, MA. Group exhibition.

Museum of Modern Art, New York, NY. "Contemporary American Still Life" (group exhibition circulating between 1966 and 1968). Catalogue: statement by William H. Gerdts.

New School for Social Research Art Center, New York, NY. "Contemporary Urban Visions" (group exhibition). January 25–February 24. Catalogue: statement by Paul Mocsanyi.

Judson Memorial Church, New York, NY. Performs with Trisha Brown and Deborah Hay in A Contract of Dance. March 29.

**Tibor de Nagy Gallery, New York, NY. "Red Grooms." Spring.*

B[urton], S[cott]. "Reviews and Previews: Red Grooms." *Art News*, 65 (Summer 1966), pp. 10 and 12.

The Jewish Museum, New York, NY. "Harry N. Abrams Family Collection" (group exhibition). June 29–September 5. Catalogue: essay by Allan Solomon, interview with Harry N. Abrams.

Art Institute of Chicago, IL. "68th American Exhibition" (group exhibition). August 19–October 16. Brochure.

Aldrich Museum of Contemporary Art, Ridgefield, CT. "Selections from the John G. Powers Collection" (group exhibition). September 25–December 11. Catalogue: introduction by John G. Powers.

1967

Annecy Animation Festival, Annecy, France. Film citation awarded for Fat Feet.

Feldman, Edmund Burke. *Art as Image and Idea*. Englewood Cliffs, NJ: Prentice-Hall, Inc., p. 340.

Lee and Jules Brenner Gallery, Provincetown, MA. Red's work exhibited between 1967 and 1972.

**Tibor de Nagy Gallery, New York, NY. "Props and Animations from Fat Feet plus Movie Personalities." January.*

Glueck, Grace. "A Swinger from Dogpatch." *New York Times*, January 8, 1967, sec. 2, p. D26.

Kroll, Jack. "People Painter." *Newsweek*, January 30, 1967, pp. 48–49.

Rosenberg, Harold. "The Art World: Defining Art." *The New Yorker*, 43 (February 25, 1967), pp. 100, 102, 105, and 106.

S., I. "Red Grooms." *Arts Magazine*, 41 (February 1967), p. 59.

Vanderlip Gallery, Philadelphia, PA. Group exhibition (Red created William Penn's Treaty with the Indians for the gallery's premier exhibition). March through April.

Yale University School of Art and Architecture, New Haven, CT. Assistant teaching position. April through May.

New School for Social Research Art Center, New York, NY. "Protest and Hope: An Exhibition of Contemporary American Art" (group exhibition). October 24–December 2. Catalogue: foreword by Paul Mocsanyi.

1968

"Collectors." *Time*, 91 (March 29, 1968), p. 71.

Ingram Merrill Foundation, grant.

Kostelanetz, Richard. *The Theatre of Mixed Means; An Introduction to Happenings, Kinetic Environments, and Other Mixed-Media Performances.* New York: The Dial Press, p. 135.

University of California, Berkeley, CA. Berkeley Eruption, performance.

**Allan Frumkin Gallery, Chicago, IL. "City of Chicago." January 12–March 10. Traveled to: 34th Biennale in Venice; National Collection of Fine Arts in Washington, DC; Art Institute of Chicago, IL; Sheldon Memorial Art Gallery, NB; Madison Art Center, WI; Chicago Public Library Cultural Center and Chicago Art Fair, IL.*

Previews:

Anderson, Jon. "A Pop Chicago: Larger than Life and Smaller, Too." *Chicago Sunday Times*, December 24, 1967.

Kay, Virginia. "Virginia Kay Column." *Chicago Daily News*, December 31, 1967.

Williams, Michaela. "Son of Smokey Stover." *Chicago Daily News*, December 30, 1967.

Reviews:

Drick, George. "Red's Chicago." *ChicagoLand*, 5 (January 1968), pp. 32–34.

Fink, John. "See Chicago First," p. 3; and Jones, Mary Lou, "Red Grooms Creates a Roomful of Bold Chicago Impressions," pp. 36, 37, and 40. *Chicago Tribune Sunday Magazine*, February 25, 1968.

Glueck, Grace. "The More the Media: Chicagorama." *New York Times*, February 4, 1968, sec. 2, p. 35.

"It's . . . It's . . . Double Take . . . Why It's Chicago." *Chicago Sun Times*, January 22, 1968.

Kay, Virginia. "Virginia Kay Column." *Chicago Daily News*, January 19, 1968.

The American Federation of Arts, organizer. "Patriotic Images in American Art" (group exhibition). Traveled to: Cedar Rapids Museum of Art, IA, January 19–February 9; Decatur Art Center, IL, March 2–March 23; Greenville County Museum of Art, SC, April 13–May 4. Brochure: text by Elizabeth C. Baker.

Wilmington Society of the Fine Arts, Delaware Art Center, DE. "Contemporary American Painting from New York Galleries" (group exhibition). February 9–March 3. Catalogue: statement by Rowland Elzea.

**Museum of Contemporary Art, Chicago, IL. "Chicago, Magic City of the West" (billboard commission for Foster and Kleiser Co.). Spring.*

Fink, John. "Art's the Big Picture." *Chicago Tribune*, June 9, 1968.

Venice, Italy. "XXXIV Esposizione Biennale Internazionale d'Arte di Venezia" (group exhibition). June 22–October 20. Catalogue: statements by S. Dillon Ripley, David W. Scott, Clifford Hardin; essay by Norman A. Geske.

Balchen, Bess. "One Guy's Chicago." "That's Grooms' Chicago." *AIA Journal*, 51 (June 1969), pp. 87–94.

"Biennale von Venedig." *Werk*, 55 (September 1968), p. 603.

Das Kunstwerk. August/September 1968, p. 21.

Feldman, Anita. "The Figurative, the Literary, the Literal: American Figurative Tradition at the Venice Biennale." *Arts Magazine*, 42 (Summer 1968), pp. 22, 25, and 26.

Irwin, D. "The Venice Biennale: The Breaking of Boundaries." *Apollo*, 88 (October 1968), pp. 292–294.

"Venezia 34 Biennale." *Domus*, 466 (September 9, 1968), p. 50.

Summer travels to Yugoslavia, Italy, Sicily.

Museum of Contemporary Art, Chicago, IL. "Selections from the Collection of Mr. and Mrs. Robert B. Mayer" (group exhibition). July 13–September 8. Catalogue: statement by Jan van der Marck and David H. Katzive.

National Collection of Fine Arts, Smithsonian Institution, Washington, DC. "Venice Biennale" (group exhibition). December 19, 1968–February 2, 1969. Catalogue from the 1968 Biennale in Italy.

Canaday, John. "Venice on the Potomac." *New York Times*, January 5, 1969, sec. 2, p. D29.

Hieronymus, Clara. "Red's Chicago, Bridges and All Go to Venice." *The Tennessean*, February 25, 1968.

Richard, Paul. "Biennale Entry Is Confusing." *Washington Post*, December 3, 1968.

Sommerville, Gerald. "Wood and Paper Sculpture, Chicago Satire Arrives for a Long Stay." *The Evening Star*, December 17, 1968.

1969

American Academy and Institute of Arts and Letters. Grant awarded.

Gentili, Giorgio. "Euphoric Design for the Consumer." *Casabella*, 33 (August/September 1969), p. 339.

Myers, John Bernard, ed. *The Poets of the New York School*. Philadelphia: University of Pennsylvania, Graduate School of Fine Arts, pp. 64, 68.

Sheldon Memorial Art Gallery, University of Nebraska, Lincoln, NB. "Venice Biennale" (group exhibition). March 17–April 13. Catalogue from the 1968 Biennale in Italy.

> Howard, Leslie. "City of Chicago, Builder Lucky." *The Lincoln Star*, March 18, 1969.

Vanderlip Gallery, Philadelphia, PA. Group exhibition (final show for which Red created a poster). April.

**Tibor de Nagy Gallery, New York, NY. "Mimi and Red Hit the Road." May 10–June 13.*

> B[arker], J. "In the Galleries: Mimi and Red Grooms." *Arts Magazine*, 43 (Summer 1969), p. 67.

> Canaday, John. "Red Grooms and Mimi Gross." *New York Times*, May 31, 1969, p. 19.

> Gollin, June. "Reviews and Previews: Red Grooms." *Art News*, 68 (Summer 1969), p. 14.

> Schjeldahl, Peter. "Red Grooms: He Dares to Make Art That Is Fun." *New York Times*, June 15, 1969, sec. 2, p. 25.

**Art Institute of Chicago, Chicago, IL. Purchases the "City of Chicago." August 29.*

> Butler, Joseph T. "The American Way with Art: Red Grooms' 'City of Chicago.'" *Connoisseur*, 173 (March 1970), pp. 148–149.

> Goodrich, David. "Anybody Want to Buy Chicago?" *The Saturday Evening Post*, February 8, 1969, pp. 36–39.

Institute of Contemporary Art, University of Pennsylvania, Philadelphia, PA. "Spirit of the Comics" (group exhibition). October 1–November 9. Catalogue: acknowledgments by Stephen Prokopoff, essay by Joan Siegfried.

Weatherspoon Art Gallery, Greensboro, NC. "Art on Paper" (group exhibition). November 16–December 19. Catalogue: foreword by Gilbert Carpenter.

**Marlin McCleaf Gallery, Philadelphia, PA. "Red Grooms and Mimi Gross." December 23, 1969–January 9, 1970.*

> Donohoe, Victoria. "Philadelphia Art Scene, McCleaf Gallery." *Philadelphia Inquirer*, January 4, 1970.

1970

CAPS grant awarded for film.

Compton, Michael. *Pop Art*. London, New York, Sydney, Toronto: Hamlyn Publishing Group, p. 92.

Gilbert, Dorothy, ed. *Who's Who in American Art*, volume 10. New York: R.R. Bowker Co., p. 160.

Who's Who in American Art, achievement award.

Koelnischen Kunstverein, Cologne, Germany. "Happenings & Fluxus" (group exhibition). Traveled to: Wuerttembergischen Kunstverein, Stuttgart; Stedelijk Museum in Amsterdam; Der Neuen Gesellschaft fuer Bildende Kunst, Berlin. Catalogue: Red is mentioned under the following headings—"1963 Feb. 3," "1966 March 29," "New Happenings at Reuben Gallery," "Ray Gun Spex at Judson Gallery," "Burning Building," "18 Happenings in 6 Parts."

Contemporary Art Society, Indianapolis Museum of Art, Indianapolis, IN. "Painting and Sculpture Today" (group exhibition). April. Catalogue: introduction by Richard Warrum.

**Tibor de Nagy Gallery, New York, NY. "Red Grooms." May–June.*

De Neve, Rose. "Red Grooms: The Artist as Animator." *Print*, 24 (September/October 1970), pp. 59–65.

Glueck, Grace. "Collectible vs Conceptual." *Art in America*, 58 (May/June 1970), p. 36.

Kramer, Hilton. "Frivolous or Serious?" *New York Times*, June 21, 1970, sec. 2, p. 21.

Walker Art Center, Minneapolis, MN, organizer. "Figures/Environments" (group exhibition). First seen at Dayton's Department Store in Minneapolis. May 15–June 13. Traveled to: Cincinnati Art Museum, OH; Dallas Museum of Fine Arts, TX. Catalogue: essay by Martin Friedman.

1971

Johnson, Ellen H. *Claes Oldenburg*. Baltimore: Penguin Books, Ltd., pp. 12–14.

Kneubühler, Theo. "The Happening: History, Theory and Consequences." *Werk*, February 1971, pp. 142–143.

**John Bernard Myers Gallery, New York, NY. "Target Discount Store." February 4–February 28.*

> Canaday, John. "Happy Thing in Art: 'Discount Store.'" *New York Times*, February 4, 1971, p. 28.

> Canaday, John. "Intruder in the Hothouse." *New York Times*, February 7, 1971, sec. 2, p. D21.

> G., J. "Reviews and Previews: Red Grooms." *Art News*, 70 (April 1971), p. 14.

**Institute of Contemporary Art, Boston, MA, organizer. "Target Discount Store." Seen in Cambridge, MA. March 16–April 25.*

> "Red Grooms' Room." *Around the Hub*, March 1971.

> Richard, Paul. "Big Time Corn-ucopia." *Washington Post*, April 4, 1971.

**Harry N. Abrams Gallery, New York, NY. "Abrams Original Editions—'No Gas' Lithos." November 1971–January 1972.*

Experiments in Art and Technology, Automation House, New York, NY. Art cash made for benefit auction. December 2 and 3.

**John Bernard Myers Gallery, New York, NY. "Red Grooms." December 4, 1971–January 6, 1972.*

> Kramer, Hilton. "Red Grooms's 'Mr. & Mrs. Rembrandt.'" *New York Times*, December 11, 1971, p. 27.

> Ratcliff, Carter. "New York Letter." *Art International*, 16 (February 1972), pp. 32–35.

1972

Current Biography, 33 (December 1972). New York: H.W. Wilson Company.

Hunter, Sam. *American Art of the 20th Century*. New York: Harry N. Abrams Inc., p. 568.

**Allan Frumkin Gallery, Chicago, IL. Solo exhibition.*

**Fine Arts Center, Cheekwood, Nashville, TN. Solo exhibition.*

Graphics One and Two, Boston, MA. Group exhibition.

Solomon R. Guggenheim Museum, New York, NY. "Ten Independents: An Artist-Initiated Exhibition" (group exhibition). January 14–February 27. Catalogue: preface by Thomas M. Messer, essay by Dore Ashton.

> Constable, Rosalind. "New Realism in Sculpture: Look Alive!" *Saturday Review*, 55 (April 22, 1972), pp. 38–40.

> Richard, Paul. "Moonscape Diorama." *Washington Post*, January 19, 1972.

> Schwartz, Barbara. "Letter from New York." *Craft Horizons*, 32 (April 1972), p. 58.

**Fendrick Gallery, Washington, DC. "Fire Engines, Astronauts, Subway Cars and Other Marvels." March–April 8. Brochure.*

> Lewis, Jo Ann. "The Art of Red Grooms: Fun, but Not So Funny." *The Evening Star*, March 14, 1972.

Richard, Paul. "Modern Messes and Marvels." *Washington Post*, March 22, 1972.

Whitney Museum of American Art, New York, NY. Shoot the Moon (film) April 12–April 19.

Greenspun, Roger. "Screen: Palette of Art." *New York Times*, April 14, 1972, p. 23.

Fogg Art Museum, Harvard University, Cambridge, MA. "Recent Figure Sculpture" (group exhibition). September 15–October 24. Traveled to: Rhode Island School of Design, RI; Bowdoin College, ME; Dartmouth College, NH; and Vassar College, NY. Catalogue: introduction by Jeanne Wasserman.

John Bernard Myers Gallery, New York, NY. "Grooms and Other Specials." December 4, 1972–January 6, 1973.

Canaday, John. "Grooms and Other Specials." *New York Times*, December 16, 1972, p. 27.

Henry, Gerrit. Review: "Red Grooms." *Art News*, 72 (January 1973), p. 77.

Schwartz, Sanford. "New York Letter." *Art International*, 17 (March 1973), p. 54.

1973

Havlice, Patricia Pate. *Index to Artistic Biography*, volume 1, A–H. Metuchen, NJ: The Scarecrow Press, p. 543.

Film Forum, New York, NY. Hippodrome Hardware (film). February 23–February 25.

Argelander, Ronald. "Red Grooms' Hippodrome Hardware." *Drama Review*, 16 (June 1973), pp. 95–100.

Greenspun, Roger. "Screen: 'Hippodrome Hardware.'" *New York Times*, February 17, 1973, p. 39.

Mekas, Jonas. "Movie Journal." *Village Voice*, March 8, 1973.

Voorhees Hall, Rutgers University Art Gallery, New Brunswick, NJ. "The Ruckus World of Red Grooms." September 30–November 21. Traveled to New York Cultural Center, New York, NY; Museo de Arte Contemporaneo, Venezuela. Catalogue: essay by Phillip Dennis Cate.

Glueck, Grace. "Odd Man Out: Red Grooms, the Ruckus Kid." *Art News*, 72 (December 1973), pp. 23–27.

Halasz, Piri. "Rutgers Exhibiting Diverting Art Show." *New York Times*, September 30, 1973, p. 78.

Whitney Museum of American Art, New York, NY. "Extraordinary Realities" (group exhibition). October 16–December 2. Traveled to Everson Museum in Syracuse, NY; Contemporary Arts Center in Cincinnati, OH. Catalogue: essays by Edward Gorey and Robert Doty.

Moderna Museet, Sweden. "New York Collection for Stockholm" (group exhibition). October 27–December 2. Catalogue: essay by Pontus Hultén and Emile de Antonio.

Brooke Alexander Gallery, New York, NY. "Hand-Colored Prints" (group exhibition). November. Catalogue: commentary by Carter Ratcliff.

Weatherspoon Art Gallery, University of North Carolina, Greensboro, NC. "Art on Paper" (group exhibition). November 18–December 16. Catalogue: introduction by Gilbert Carpenter.

New York Cultural Center, New York, NY. "The Ruckus World of Red Grooms." December 5, 1973–January 20, 1974.

Canaday, John. "Art: The Ruckus World of Red Grooms." *New York Times*, December 8, 1973, p. 29.

Canaday, John. "Ruckus on Columbus Circle." *New York Times*, December 16, 1973, sec. 2, p. D25.

Kingsley, April. "New York Letter." *Art International*, 18 (March 20, 1974), pp. 50 and 58.

Naumann, Francis. "The Ruckus World of Red Grooms." *Artforum*, 12 (March 1974), pp. 78–79.

Rose, Barbara. "Good and Plenty at the Cultural Center." *New York*, December 24, 1973, pp. 70–71.

John Bernard Myers Gallery, New York, NY. "Red Grooms." December 8, 1973–January 17, 1974.

1974

Archives of American Art, Smithsonian Institution. Transcribed interview with Paul Cummings, March 4, 1974.

Brownstein, Michael. *Country Cousins*. New York: George Braziller, Inc., cover illus.

Henri, Adrian. *Total Art: Environments, Happenings, and Performance*. New York and Toronto: Oxford University Press, pp. 33, 88, 89, 107, 157.

"A Portfolio—Red Grooms." *The Paris Review*, 57 (Spring 1974), pp. 131–138.

"Vita in Citta." Cantrill's Film Notes. *Il Giornale D'Italia*, 17–18 (June 1974).

Allan Frumkin Gallery, New York, NY. "1961: American Painting in the Watershed Year" (group exhibition). March 9–April 15. Catalogue: introduction by Allan Frumkin.

Caracas, Venezuela. "Red Grooms." April. Catalogue.

Wilmington Society of the Fine Arts, Delaware Art Museum, Wilmington, DE. "Contemporary American Paintings from the Lewis Collection" (group exhibition). September 13–October 27. Catalogue: statement by Charles L. Wyrick, Jr.

Joseph Hirshhorn Museum and Sculpture Garden, Washington, DC. "Inaugural Exhibition" (group exhibition). October 4, 1974–May 12, 1976. Catalogue.

Helen Drutt Gallery, Philadelphia, PA. "Embody Art" (group exhibition). October 10–31.

Stein, Judith. "Reviews and Previews—Embody Art." *Art Philadelphia*, October 1974, p. 15.

Whitney Museum of American Art, Downtown Branch, New York, NY. "New Portraits" (group exhibition). November 7–December 12. Brochure.

Dallas Museum of Fine Arts and Pollock Galleries at the Southern Methodist University, TX. "Poets of the Cities/New York and San Francisco, 1950–1965" (group exhibition). November 20–December 29. Traveled to: San Francisco Museum of Art, CA; Wadsworth Atheneum, Hartford, CT. Catalogue.

1975

Alloway, Lawrence. "The Reuben Gallery: A Chronology." *Topics in American Art Since 1945*. New York: W.W. Norton & Co., Inc., pp. 151–153.

Andersen, Wayne. *American Sculpture in Process 1930/1970*. New York: Little, Brown and Co.; Boston: New York Graphic Society, p. 179.

Lorillard, division of Loews Theatres. Bicentennial silkscreen commission.

Brooke Alexander, sponsor, and E.D.O. Comprehensive Exhibitions Services of Los Angeles, organizer. Traveling group exhibition of prints. January 1975–January 1976 to: University of Redlands, CA; San Jose Museum of Art, CA; Tacoma Art Museum, WA; Simon Fraser University, BC; University of Saskatchewan, SK; Fine Arts Gallery of San Diego, CA; Philbrook Art Center, OK.

The Clocktower, Institute for Art and Urban Resources, New York, NY. "Artists Make Toys" (group exhibition). January.

Gerston, Jill. "A Quiet 'Hello' to the New Year." *New York Times*, January 2, 1975, p. 37.

Massachusetts College of Art, MA. The Mouse That Died (film, part of Anti-Hollywood Animation Series). February.

Gonick, Larry. "Film Review." *The Real Paper*, February 12, 1975.

Brooke Alexander Gallery, New York, NY. "Works on Paper." March 22–April 19. Checklist.

Bourdon, David. "Art." *Village Voice*, April 17, 1975.

Derfner, Phyllis. "Red Grooms." *Art International*, 19 (May 15, 1975), p. 68.

Ellenzweig, Allen. "Art Reviews: Red Grooms." *Arts Magazine*, 49 (June 1975), p. 11.

Kramer, Hilton. "Art: Red Grooms." *New York Times*, March 29, 1975, p. 11.

Mint Museum of Art, Charlotte, NC. "Reflections: The '60s and '70s" (group exhibition). May 18–June 22.

Doar, Harriet. "Pop Goes to the 60's and 70's in the Mint Museum." *The Charlotte Observer*, June 15, 1975.

Doar, Harriet. "Reflections: The '60s and '70s." *The Charlotte Observer*, May 18, 1975.

Kunsthalle, Darmstadt, Germany. "Realism und Realität" (group exhibition). May 24–July 6. Catalogue: essay by Bernd Krimmel.

City Hall, Battery Park, sponsored by Cooper-Hewitt Museum, The Smithsonian Institution's National Museum of Design, NY. "Immovable Objects" (group exhibition). June. Printed guide: essay by Lisa Taylor.

"Collage." *Art News*, 74 (September 1975), p. 118.

"News Reports, A Fashion Show of Manhattan Buildings." *Progressive Architecture*, August 1975, p. 19.

Vanderbilt University Art Gallery, Nashville, TN. Group exhibition from the permanent collection. October.

Pursell, Julie. "Art Acquisitions Crown VU Centennial." *Nashville Banner*, October 2, 1975.

"'Tappy Toes' Joins 'Fat Feet.'" *Cheekwood Mirror*, 16 (June 1975).

**88 Pine Street, New York, NY. Sponsored by Creative Time Project, Inc., Orient Overseas Association, Marlborough Gallery, New York Council on the Arts, and the National Endowment for the Arts.* "Ruckus Manhattan." November 1975–January 1976. Newspaper: "The Daily Ruckus," sold at installation.

"Big Board's Baby Brother." *At the Market*, 8 (December 1975).

Davis, Douglas. "What's in the Galleries." *Newsweek*, 86 (December 8, 1975), pp. 106 and 107.

Genauer, Emily. "Art and the Artist." *New York Post*, December 27, 1975.

Glueck, Grace. "In 'Rebuilt' Manhattan, Trade Center Rises 30 Feet and Woolworth Building Is Wooden." *New York Times*, May 27, 1975, p. 31.

Glueck, Grace. "Tennessee Raises Manhattan Ruckus." *New York Times*, June 8, 1975.

Glueck, Grace. "3-Dimensional Comic Strip of Downtown on View." *New York Times*, November 28, 1975, p. 39.

Grillo, Jean Bergantini. "What the Ruckus Is All About." *New York Sunday News*, December 14, 1975.

Hughes, Robert. "Gorgeous Parody." *Time*, January 19, 1976, p. 72.

Huxtable, Ada Louise. "Architectural View: Grooms's Zany 'Manhattan' Puts the City in Focus." *New York Times*, December 21, 1975, sec. 2, pp. 1 and 41.

Lasky, Arthur. "I'll Take Manhattan." *World Trade Community News*, 1 (September 2, 1975), p. 6.

Patton, Phil. "Red Grooms." *Artforum*, 14 (March 1976), pp. 67 and 68.

Pursell, Julie. "A Nashvillean Creates a New York Ruckus." *Nashville Banner*, January 23, 1976.

Ratcliff, Carter. "New York Letter." *Art International*, 20 (March/April 1976), p. 74.

Richard, Paul. "Red's Big Apple: Mad Hatter's Manhattan." *Washington Post*, November 19, 1975, p. G1.

Tully, Judd. "Ruckus Resurrects—From Della Robbia with Love." *SoHo Weekly News*, November 27, 1975.

Zucker, Barbara. "Grooms Is Constructing Manhattan, Indoors." *Village Voice*, November 24, 1975.

1976

Hand, Judson. "Underground Art, How Artists Look at Our Subways." *New York Sunday News*, October 17, 1976.

Institute of Contemporary Art, Boston, MA. Commission for the Boston Marathon.

Pursell, Julie. "Treasures Museums Buy to Show." *Nashville Banner*, October 28, 1976.

Tomkins, Calvin. *The Scene: Reports on Post-Modern Art.* New York: Viking Press, p. 202.

Brooke Alexander, sponsor, and E.D.O. Comprehensive Exhibition Services of Los

Angeles, organizer. Traveling group exhibition of prints, January through December. Seen: University of Oklahoma, OK; Tyler Museum of Art, TX; Wichita Falls Museum and Art Center, TX; Arkansas Arts Center, AR; Hunter Museum of Art, TN; San Francisco, CA.

Fort Worth Art Museum, Fort Worth, TX. "The Great American Rodeo" (group exhibition). January 25–April 11. Traveled to: Colorado Springs Fine Arts Center, CO; Witte Memorial Museum in San Antonio, TX. Catalogue: essays by Jay Belloli and Richard Koshalek.

Glueck, Grace. "Notes: Auctions, Agents and the Arts of Texas." *New York Times*, February 8, 1976, sec. 2, p. D35.

Kutner, Janet. "Art, the Cowboy, and the Fatstock." *Dallas Morning News*, February 15, 1976.

**Marlborough Gallery, New York, NY.* "Ruckus Manhattan, Part II: A Sculptural Novel About New York." May 1–July 16.

Andre, Michael. "Ruckus Manhattan." *Art News*, 75 (April 1976), pp. 118–119.

Baker, Sherry. *Atlanta Gazette*, July 7, 1976.

Bourdon, David. "Manhattan Is Groomed, American Ephemera Preserved." *Village Voice*, May 24, 1976.

Buckley, Tom. "About New York: Collectible Manhattan." *New York Times*, June 7, 1976, p. 57.

Cultural Information Service, June 1976.

"Distorted Porn." *Screw*, June 7, 1976.

"Fun City's Best Fun." *Mademoiselle*, 82 (March 1976), pp. 118–119.

Gifford, J. Nebraska, and M.B. Shestack. "Red Grooms." *Cue*, June 12, 1976, pp. 8–9.

Glueck, Grace. "The City's Biggest Gallery Show Twits the City." *New York Times*, June 13, 1976, sec. 2, pp. 1 and 35.

Hess, Thomas B. "Grooms, Goya, and the Grotesque." *New York*, June 28, 1976, pp. 76–77.

Hoelterhoff, Manuela. "The Ruckus Gang Takes on Manhattan." *The Wall Street Journal*, June 2, 1976.

Hughes, Robert. "Gorgeous Parody." *Time*, January 19, 1976.

Kirkpatrick, Peggy O. "Red Grooms." *Nashville Banner*, July 2, 1976.

Kramer, Hilton. "Art: After Grooms, BMT Is Bucolic." *New York Times*, May 7, 1976, p. C12.

Kramer, Hilton. "Nashvillean Scores High in New York." *The Tennessean*, July 12, 1976.

Loercher, Diana. "'Ruckus Manhattan' Is Art—and Also Fun." *The Christian Science Monitor*, June 28, 1976.

Lorber, Richard. "Red Grooms." *Arts Magazine*, 51 (September 1976), p. 30.

O'Beil, Hedy. "A Funhouse Odyssey." *Eastside Courier*, June 3, 1976.

Rose, Barbara. "Find a Mad City Inside New York Gallery Walls." *Vogue*, July 19, 1976, p. 54.

"Ruckus Manhattan Company." *Scholastic*, 6 (1976), pp. 7, 9.

Schwartz, Barbara. "Exhibitions and Letters, New York." *Craft Horizons*, 36 (August 1976), p. 50.

"The Talk of the Town—Four Civic Gatherings." *The New Yorker*, 52 (May 31, 1976), pp. 29–30.

Tallmer, Jerry. "A Little City With a Big Art." *New York Post*, June 19, 1976.

Wallach, Amei. "Making New York a Fun City." *Newsday*, Part II, May 9, 1976, pp. 4, 5, 28.

Pennsylvania Academy of the Fine Arts, Philadelphia, PA, in cooperation with Dickinson College. "Symbols of Peace: William Penn's Treaty with the Indians" (group exhibition). May 12–September 26. Catalogue: preface by Richard J. Boyle and Paul Kaylor, essays by Charles Sellers and Anthony Garvan.

Forman, Nessa. "The Nurturing of a Native Icon." *The Sunday Bulletin*, May 30, 1976.

Stamford Museum, Stamford, CT. "American Salon des Refusés: Contemporary American Sculptors Not Included in the Whitney Museum's Concurrent '200 Years of American Sculpture' Exhibition" (group exhibition). July–August. Catalogue.

> Kramer, Hilton. "A Successful Counterexhibition Inspired by the Whitney's Failure." New York Times, July 18, 1976, p. D22.

*Van Straaten Gallery, Chicago, IL. "Red Grooms." October.

Hathorn Gallery, Skidmore College, Saratoga Springs, NY. "An Exhibition of Contemporary American Figurative Drawings, Paintings and Sculptures Selected from the Oakleigh Collection" (group exhibition). October 7–October 31. Catalogue: statement by the Founders of the Oakleigh Collection.

> Gaugh, Harry F. "Oakleigh Collection." Arts Magazine, 51 (January 1977), p. 17.

School of the Art Institute of Chicago, Chicago, IL. "Visions—Painting and Sculpture: Distinguished Alumni 1945 to the Present" (group exhibition). October 7–December 10. Catalogue.

> Haydon, Harold. "Cheers and Hurrahs for SAIC." Chicago Sun Times, September 26, 1976.

Brooklyn Museum, Brooklyn, NY. "30 Years of American Printmaking" (group exhibition). November 20–January 30. Catalogue: essay by Gene Baro.

> Kramer, Hilton. "Art: 30 Years of American Prints." New York Times, November 19, 1976, p. C18.

Marlborough Gallery, New York, NY. "Recent Work" (group exhibition). November 30–December 31. Catalogue.

> Cavaliere, Barbara. "Figurative Painting." Arts Magazine, 51 (February 1977), pp. 19 and 20.

Artists' Choice Museum, New York, NY. "Artists' Choice: Figurative Art in New York" (group exhibition shown in 5 SoHo galleries). December. Catalogue: essay by Lawrence Alloway.

> Glueck, Grace. "Art People." New York Times, November 26, 1976, p. C18.

1977

Conway, Madeleine, and Nancy Kirk. The Artists' Cookbook. New York: Museum of Modern Art, pp. 59–62.

Cummings, Paul. Dictionary of Contemporary American Artists. New York: St. Martin's Press, p. 223.

Herrera, Hayden. "Manhattan Seven." Art in America, 65 (July/August 1977), pp. 59–61.

Tully, Judd. Red Grooms and Ruckus Manhattan. New York: George Braziller, Inc.

*Marlborough Graphics, New York, NY. Solo exhibition.

*Benjamin Mangel Gallery, Bala Cynwyd, PA. "Famous Artists and Ruckus Manhattan." March.

*Brooklyn Museum, Brooklyn, NY. "Dame of the Narrows" (sculpture from "Ruckus Manhattan" displayed in the rotunda). March 16–May.

> Glueck, Grace. "Art People." New York Times, March 11, 1977, p. C22.

Hathorn Gallery, Skidmore College, Saratoga Springs, NY. "The Artist and the Livre Deluxe" (group exhibition). March 31–April 19.

Everson Museum of Art, Syracuse, NY, and Provincetown Art Association, MA. "Provincetown Painters 1890's–1970's" (group exhibition). Seen at Everson, April 1–June 26, and in Provincetown, August 15–September 5. Catalogue: essays by Ronald Kuchta and Dorothy Seckler.

Oklahoma Art Center, Oklahoma City, OK. "Manscape: 77" (group exhibition). May 6–June 5. Catalogue: essay by Franz Schulze.

> "Seeing the Message." The Sunday Oklahoman, May 1, 1977.

*Roger d'Amécourt Gallery, Paris, France. "Red Grooms à Paris." May 25–July 9. Catalogue: statement by Roger d'Amécourt.

> Blume, Mary. "Archetypal Yokel in Nervous City." International Herald Tribune, June 26, 1977.

> Dittiere, Monique. "Sans Jamais Tomber Dans le Vulgaire." L'Aurore, June 29, 1977.

> Hieronymus, Clara. "Red Grooms Finds Hometown Elegant." The Tennessean, June 29, 1977.

> Micha, René. "Paris." Art International, 21 (July/August 1977), p. 65.

> "Paris Review: Roger d'Amécourt." International Herald Tribune, June 4, 1977.

> "Red Grooms." Connaissance des Arts, 304 (June 1977), p. 13.

> Warnold, Jeanine. "Les Guignols de Red Grooms." Le Figaro, June 20, 1977.

*Contemporary Graphics Center, Santa Barbara Museum of Art, Santa Barbara, CA. "Red Grooms, Drawings and Prints." July 15–August 14.

Guild Hall Museum, East Hampton, NY. Set designs by Red and others for Red Robins, a play by Kenneth Koch. August. Seen also at P.S. 1 and at St. Clement's Church in New York in 1978. Red Robins was published in New York by the Performing Arts Journal Publications, pp. 29, 38.

> Glueck, Grace. "Scenery Takes Bow in Queens." New York Times, December 30, 1977, p. C3.

> "Miss Bellamy Is Guest 'Preacher' at St. Clement's." New York Times, January 30, 1978, p. A18.

Brooke Alexander Gallery, New York, NY. "Selected Prints, 1960–1977" (group exhibition). Part I: September 13–October 8. Part II: October 15–November. Catalogue.

Philadelphia College of Art, Philadelphia, PA. "Artists' Sets and Costumes: Recent Collaboration Between Painters, Sculptors, Dance, Opera, and Theater" (group exhibition). October 31–December 17. Catalogue: essay by Janet Kardon.

Art Gallery, Brainerd Hall, State University College, Potsdam, NY. "Off the Beaten Path" (group exhibition). November 11–December 16. Catalogue: introduction by Benedict Goldsmith.

*New Gallery of Contemporary Art, Cleveland, OH. November 18–December 24. Checklist.

Marlborough Gallery, New York, NY. "Figurative Painting: 6 Artists" (group exhibition). November 30–December 31.

> Schwartz, Ellen. "Ad Reinhardt and Red Grooms." Art News, 77 (January 1978), pp. 140 and 142.

Madison Art Center, Madison, WI. "Recent Works on Paper by American Artists" (group exhibition). December 4, 1977–January 15, 1978. Catalogue: preface by Victor Kord, essay by Joseph Wilfer.

Tibor de Nagy Gallery, New York, NY. Group exhibition. December 4–December 31.

> Turner, Norman. "25th Anniversary Show: Tibor de Nagy." Arts Magazine, 51 (March 1977), pp. 33–34.

1978

Downes, Rackstraw, ed. Fairfield Porter: Art in Its Own Terms, Selected Criticism 1935–1975. New York: Taplinger Publishing Co., pp. 124–127.

Sandler, Irving. The New York School: The Painters and Sculptors of the Fifties. New York: Harper & Row, pp. 34, 41, 196, 197, 208, 210, 299, 301, 306, 323.

Genesis Gallery, New York, NY. "The Human Figure in Painting and Sculpture" (group exhibition).

*Film Forum, New York, NY. Ruckus Manhattan and Fat Feet (films). January.

> Canby, Vincent. "Film Forum: 'Ruckus.'" New York Times, January 27, 1978, p. C18.

> Carroll, Noel. "Red Grooms at Film Forum, Son of Whopper." SoHo News, January 26, 1978.

Heath Gallery, Atlanta, GA. Group exhibition. February 1–February 25.

Boston University Art Gallery, Boston, MA. "Brooke Alexander: A Decade of Print Publishing" (group exhibition). February 3–February 26. Catalogue: cover illustration.

*Neuberger Museum, State University of New York at Purchase, NY. "Target Discount Store." May 2–September 10.

> Beals, Katherine. "Love, Laughter, Come to Neuberger Museum." Westchester Weekend, May 5, 1978.

Russell, John. "De-complication Is the Aim." *New York Times*, May 14, 1978, sec. 2, p. 27.

Shirey, David L. "Life Is Earnest, Art Is Fun." *New York Times*, June 11, 1978, p. 16.

Zbytniewski, Joann. *Progressive Grocer*, 58 (January 1978), pp. 96–98.

Wave Hill Sculpture Garden, Bronx, NY. "Figure in Landscape" (group exhibition). May 14–October 31. Catalogue: introduction by John Perreault.

Whitney Museum of American Art, New York, NY. "Art about Art" (group exhibition). July 19–September 24. Traveled to: North Carolina Museum of Art, NC; Frederick S. Wight Art Gallery in Los Angeles, CA; Portland Art Museum, OR. Catalogue: introduction by Leo Steinberg; essays by Jean Lipman and Richard Marshall.

 Ashbery, John. "Something Borrowed, Something New." *New York*, 11 (August 7, 1978), pp. 54 and 55.

 LeQuire, Louise. "Art about Art." *Artweek*, 10 (January 27, 1978), pp. 1 and 24.

**Chicago Public Library Cultural Center, Chicago, IL. "City of Chicago." September–December.*

 Hanson, Henry. "Art—Red Grooms's Chicago Returns." *Chicago*, September 1978, pp. 230–231, 233.

Museo de Arte Contemporaneo, Venezuela. "12 artistas internacionales en la colección del museo de arte contemporaneo de Caracas" (group exhibition). November. Catalogue: essay by Gloria Carnevali.

**Martin Wiley Gallery, Nashville, TN. "Work of Red Grooms." November 19–December 31.*

 Hieronymus, Clara. "Well Worth the Wait." *The Tennessean*, November 26, 1978.

 Seawright, Sandy. "Red Grooms: Home Is Always Nashville." *Art Voices/South*, November/December 1978, p. 9.

Marlborough Gallery, New York, NY. "Works in Small Format" (group exhibition). December.

1979

Baigell, Matthew. *A Dictionary of American Art*. New York: Harper and Row, p. 145.

Hegeman, William. "A Printer for the Jet Age." *Art News*, 78 (September 1979), pp. 87–89.

Strasser, Todd. "Interview: Red Grooms." *Ocular*, 4 (Winter 1979), pp. 50–60.

University of New Mexico, NM. Guest artist for a week.

Nancy Hoffman Gallery, New York, NY. "Works on Paper" (group exhibition). January 10–February 9.

**Hudson River Museum, Yonkers, NY. "The Bookstore" (a commissioned permanent installation). March 10, opening.*

 Previews:

 Glueck, Grace. "Art People—The Morgan Groomsized." *New York Times*, December 22, 1978, p. C28.

 Glueck, Grace. "Hudson Museum in Heroic Role." *New York Times*, June 9, 1978, p. C20.

 Reviews:

 Beals, Katherine. "Visions of Red Grooms." *Gannett Westchester*, March 18, 1979.

 Emerson, Ken. "Grooving with Grooms in Yonkers." *New York Times Magazine*, March 4, 1979, pp. 19–21.

 Glueck, Grace. "Art People—Art, Too, Gets Used Up." *New York Times*, November 13, 1981, p. C25.

 Lerner, Harriet. "Good Grooming at the Hudson River Museum." *Illustrated Westchester*, 43 (March 1979), pp. 23 and 29.

 Marchionni, Carmel Camise. "Bookstore, Out of Pages of Imagination." *Gannett Westchester*, March 4, 1979.

 McFadden, Sarah. "Going Places, Part I: Beyond Museum Row." *Art in America*, 68 (February 1980), p. 72.

 "Real Books and Plastic Customers Meet in Red Grooms Bookstore." *The Riverdale Press*, May 10, 1979.

 Russell, John. "Art: Red Grooms and Dan Flavin." *New York Times*, August 3, 1979, p. C19.

 Shirey, David L. "Hudson River Museum." *New York Times*, May 15, 1979, p. 16.

 Siwek, Polly. "Bookstore." *Westchester Magazine*, II, March 1979.

 Wilson, Janet. "And Now, From the Folks Who Brought You Ruckus Manhattan." *Art News*, 78 (March 1979), pp. 102–103.

Institute of Contemporary Art, University of Pennsylvania, Philadelphia, PA. "Late Twentieth Century Art from the Sydney and Frances Lewis Foundation" (group exhibition). March 22–May 2. Catalogue: introduction by Susan L. Butler.

Anderson Gallery, Virginia Commonwealth University, VA. Group exhibition. March 24–April 19.

 Merritt, Robert. "Art: Discount Store Set." *Richmond Times Dispatch*, March 28, 1979.

 Proctor, Roy. "The Discount Store, What Is Grooms Trying to Say." *Richmond Times News Leader*, March 31, 1979.

**Northern Kentucky University, Highland Heights, KY. "Way Down East" (commissioned sculpture). Installed April 12.*

 Dugan, I.W., Jr. "Art in Public Places." *Beaux Arts*, 2 (Summer 1979), pp. 21 and 22.

 Findsen, Owen. "Red Grooms: A New Idiom for American Sculpture." *Cincinnati Enquirer*, April 15, 1979.

 Findsen, Owen. "Red Grooms Ruckus Lands in Kentucky." *Courier Journal*, April 15, 1979.

 Hawthorne, Don. "Does the Public Want Public Sculpture?" *Art News*, 81 (May 1982), p. 63.

 Lansdell, Sarah. "New Sculptures at NKU." *Courier Journal*, April 15, 1979.

 Lansdell, Sarah. "Red Grooms: 'Way Down East' Sculptor Samples the South." *Courier Journal*, April 15, 1979.

 Tully, Judd. "Way Down East: Red Grooms's Monument to D.W. Griffith." *Horizon*, 22 (August 1979), pp. 59–61.

**AFA Film Distributors. Showing of Ruckus Manhattan (film). September.*

 "A Viewer's Journal." *Film News*, 1979, p. 9.

 Vogel, Amos. "Independents." *Film Comments*, September/October 1979, pp. 76, 77.

Terry Dintenfass Gallery, Artists' Choice Museum, New York, NY. "Figurative/Realist Art" (group exhibition at six 57th Street galleries). September 8–22.

 Kramer, Hilton. "2 Streams of American Art at the Whitney." *New York Times*, September 4, 1979.

**80 Langton Street, San Francisco, CA. Showing of Shoot the Moon, Fat Feet, and Red Riding Hood (films). October.*

 Stofflet-Santiago, Mary. "Three Films by Red Grooms." *Artweek*, 10 (October 20, 1979), pp. 12–13.

**Benjamin Mangel Gallery, Bala Cynwyd, PA. "Red Grooms." October–November 2.*

 Cochran, J.R. "Aarrgh! Sigh! Red Grooms Misses Punch and the Joke!" *The Philadelphia Bulletin*, October 28, 1979.

Independent Curators, Hudson River Museum, Yonkers, NY. "Super Show" (group exhibition). October 20–December 9. Traveled to: Minneapolis Museum of Art, MN; Fine Arts Center in Mesa, AZ; New Gallery of Contemporary Art in Cleveland, OH. Catalogue.

 Rickey, Carrie. "The More the Merrier." *Village Voice*, October 29, 1979.

Denver Art Museum, Denver, CO. "Poets & Painters" (group exhibition). November 21, 1979–January 13, 1980. Traveled to: Kansas City, MO; La Jolla, CA. Cata-

logue: foreword by Dianne Perry Vanderlip, essay by David Shapiro, "Red Grooms" by Kenneth Koch.

Art Institute of Chicago, Chicago, IL. Centennial Exhibition, Alumni of The School of the Art Institute of Chicago, "100 Artists, 100 Years" (group exhibition). November 23, 1979–January 20, 1980. Catalogue: commentary by Katharine Kuh.

Marzio, Peter. "A Museum and a School: An Uneasy but Creative Union." Chicago History, III (Spring 1979), p. 48.

1980

Arthur, John. Realist Drawings and Watercolors. Boston: New York Graphic Society; New York: Little, Brown and Company, pp. 70, 71, 77.

Berkvist, Robert. "From 'Breaking Away' to 'Division Street'—In Love with America." New York Times, October 5, 1980, sec. 2, p. 1 (illus.).

Betti, Claudia, and Teel Sale. Drawing, A Contemporary Approach. New York: Holt, Rinehart and Winston, pp. 155, 209, 259, 348 (illus.).

Forsling, Stephen. "Fizzles, Savage Breeze, Kitty Hawk and a Message from Degas." Art News, 79 (September 1980), p. 127 (illus.).

Glueck, Grace. "How Picasso's Vision Affects American Artists." New York Times, June 22, 1980, sec. 2, p. 25.

Goldman, Judith. "Izdavanje I Stampanje Grafika U Aminiki." Pregled, 211 (May/June 1980), p. 9.

"Multiples & Objects & Artists' Books. Red Grooms, Peking Delight," a wood multiple. The Print Collector's Newsletter, 10 (January/February 1980), p. 203.

"New York City." Special issue of The Sciences, 20 (1980), cover illus.

Phillips, Deborah C. "New Editions." Red Grooms's Lorna Doone, a color lithograph. Art News, 79 (September 1980), pp. 44, 46.

"Prints and Photographs Published. Red Grooms, Lorna Doone," a color lithograph. The Print Collector's Newsletter, 11 (March/April 1980), p. 16.

Southern Illinois University. Teaching post.

Tomkins, Calvin. Off the Wall: Robert Rauschenberg and the Art World of Our Time. Garden City, NY: Doubleday & Company, Inc., pp. 152–153, 154.

Walter P. Chrysler Museum, Norfolk, VA. "American Figure Painting: 1950–1980" (group exhibition).

Dublin, Ireland. "ROSC '80: The Poetry of Vision" (an international group exhibition of modern painting and Chinese art). Catalogue: essay by Marilyn Shen Fu and Dorothy Walker.

99 Prince Street, New York, NY. In 32 Chromosomes (performance by Elisabeth Ross). Red plays the character "Death."

Eye and Ear Theater, New York, NY. Sets and costumes by Red for City Junket, a play by Kenward Elmslie. Performed at Playhouse 46, New York.

Welish, Marjorie. "'City Junket' at Playhouse 46." Art in America, 69 (January 1981), p. 127.

*Lowe Art Museum, University of Miami, FL. "Red Grooms Discount Store and Film Festival." January–February.

Glueck, Grace. "Art People—The Earth Is Their Palette." New York Times, April 4, 1980, p. C24.

Kohen, Helen. "Seeing Red." Miami Herald, February 3, 1980.

Kohen, Helen. "Some Stand-Outs and Other Sights Stay in Mind's Eye." Miami Herald, January 1, 1980.

Rose Art Museum, Brandeis University, Waltham, MA. "Aspects of the 70's—Mavericks" (six museums in the Boston area, each exhibit an "aspect" group exhibition). May 22–June 29. Catalogue: text by Michael Leja.

39th Venice Biennale 1980. United States Pavilion, Venice, Italy. "Drawings: The Pluralist Decade" (group exhibition). June 1–September 30. Traveled to: Copenhagen, Denmark; Onstad, Norway; Madrid, Spain; Lisbon, Portugal. Catalogue: essay by Janet Kardon.

*Clark Hatton Gallery, Colorado State University, CO. "Red Grooms: Works from the 60's." September 1–26. Traveled to: Signet Fine Prints, St. Louis, MO.

Clurman, Irene. "Early Antics of Red Grooms on Display at CSU." Rocky Mountain News, September 1980.

Mary and Leigh Block Gallery, Northwestern University, IL. "Collaborations" (group exhibition). September 28–October 26. Catalogue: introduction by Kathy Kelsey Foley.

Artner, Alan G. "Exhibits Focus on Still-Life Photos and Collaborations." Chicago Tribune, October 19, 1980.

Institute of Contemporary Art, University of Pennsylvania, Philadelphia, PA. "Drawings: The Pluralist Decade—An American Version of the Venice Biennale" (group exhibition). October 4–November 9. Traveled to: Museum of Contemporary Art, Chicago, IL. Catalogue: introduction by Janet Kardon.

Harold Reed Gallery, New York, NY. "Selected 20th Century American Self Portraits" (group exhibition). October 18–November 15. Catalogue: essay by John Perreault.

Brooklyn Museum, Brooklyn, NY. "American Drawings in Black and White, 1970–1980" (group exhibition). November 22, 1980–January 18, 1981. Catalogue: statement by Gene Baro.

1981

Goodyear, Frank H., Jr. Contemporary American Realism since 1960. New York: Little, Brown and Co.; Boston: New York Graphic Society, p. 216.

Osborne, Harold. The Oxford Companion to Twentieth Century Art. New York: Oxford University Press, p. 236.

Ratcliff, Carter. "Red Grooms' Human Comedy." Portfolio, 3 (March/April 1981), pp. 56–61.

Renz, M.A. "Little Red Riding Hood." Young Viewer/Film Review Supplement, 3/4 (April 1981), pp. 26, 27.

Simpson, Charles R. SoHo: The Artist in the City. Chicago and London: University of Chicago Press, p. 27.

*Marlborough Gallery, New York, NY. "Red Grooms, Recent Works." April 3–May 5. Catalogue.

Ashbery, John. "Painting the Town Red." Newsweek, April 20, 1981, pp. 86 and 89.

Baro, Gene. "Marlborough Exhibition." Art International, 24 (August/September 1981), p. 122.

Glueck, Grace. "Red Grooms Reshapes His Loony World." New York Times, March 29, 1981, sec. 2, pp. 1 and 20.

Larson, Kay. "He Who Laughs Less." New York, April 20, 1981, pp. 50–51.

Phillips, Deborah C. "Red Grooms." Art News, 80 (October 1981), pp. 217–218.

Russell, John. "Art: Ellsworth Kelly and Red Grooms Shows." New York Times, April 17, 1981, p. C18.

Vishny, Michele. "Red Grooms." Arts Magazine, 55 (April 1981), p. 3.

Empire Safe Company, Grand Street, New York, NY. "Safes As Combinations of Art and Security" (group exhibition). May 6–30.

Slesin, Suzanne. "Safes As Combinations of Art and Security." New York Times, April 30, 1981, p. C8.

Newport Harbor Art Museum, Newport Beach, CA. "Inside/Out: Self Beyond Likeness" (group exhibition). May 22–July 12, 1981. Traveled to: Portland Art Museum, Portland, OR; Joslyn Art Museum, Omaha, NB. Catalogue: introduction by Lynn Gamwell and Victoria Kogan.

Provincetown Art Association and Museum, Provincetown, MA. "The Sun Gallery" (group exhibition). July 24–August 30. Catalogue: essay by Irving Sandler, curated by Ellen O'Donnell and Anthony Vevers.

*Fine Arts Center, Cheekwood, Nashville, TN. "Red Grooms: Prints of the Seventies." August 9–September 13. Traveling exhibition circulated by The Southern Arts Federation. Catalogue: "Red Grooms: A Catalogue Raisonné of his Graphic Work, 1957–1981, foreword by Kevin Grogan, introduction by Louise LeQuire, essay by Paul Richard, catalogue raisonné by Brooke Alexander and Virginia Cowles.

McNeilly, Caroline. "Friend Brings Grooms Art Home." Nashville Banner, August 6, 1981.

*Montgomery Bell Academy, Nashville, TN. "Red Grooms: Originals from Local Collections." September 20–October 9.

Muhlenberg College Center for the Arts, Muhlenberg, PA. "Art in Pursuit of a Smile" (group exhibition). November 8–December 16. Catalogue: essay by Linda Weintraub.

*Burlington House, New York, NY. "Ruckus Manhattan." December 18, 1981–March 1982.

 Glueck, Grace. "New Home, New Look for 'Ruckus Manhattan.'" New York Times, December 18, 1981, p. C32.

1982

Deitz, Paula. "Design Notebook." New York Times, April 8, 1982, p. C9.

Hornick, Lita. Night Flight. New York: The Kulcher Foundation, pp. 9, 179–181.

Johnson, Ellen, ed. American Artists on Art from 1940–1980. New York: Harper Row, p. 59.

MacPherson, Kitta. "Artists Applaud a Paterson 'Work in Progress.'" The Star-Ledger, December 2, 1982.

Tulenko, Karelei. "From 'Ruckus Manhattan' to 'Ruckus Roxy', The Art of Red Grooms Bemuses and Delights." Art Voices, January/February 1982, pp. 15–19.

University of Bridgeport, CT. Albert Dorne Visiting Professor of Art.

*Seibu Art Museum, Tokyo, Japan. "Red Grooms: Ruckus Manhattan." Catalogue: essay by John Ashbery.

*Fort Worth Art Museum, TX. Reinstallation of "Ruckus Rodeo." February 20–April 25.

*Carlson Gallery, University of Bridgeport, CT. "Red Grooms: Selected Works." February 21–March 21. Catalogue.

 Baldwin, Roger. "Red Grooms at UB: Creating a Ruckus." Fairfield Advocate, March 10, 1982.

 Moss, Jacqueline. "Grooms Wacky, Sordid Wisdom: From 42nd St. to Disney World." Connecticut Newspapers, Inc., March 7, 1982.

 Raynor, Vivien. "A Jocular View of the Art World." New York Times, March 14, 1982, sec. 2, p. 22.

 "Red Grooms Brings Prop-and-People-Packed Art to UB." Bridgeport Sunday Post, February 21, 1982.

 Scott, Martha B. "Fun Art of Red Grooms Has the Flair of a P.T. Barnum." Bridgeport Sunday Post, February 28, 1982.

*Hirshhorn Museum and Sculpture Garden, Washington, DC. "Red Grooms from the Museum's Collection." February 25–May 2.

 Canaday, John. "An Evening with Red Grooms." The Smithsonian Associate, 10 (February/March 1982), pp. 1 and 10.

 "February Spotlights—Art—A Grooms Retrospective." Saturday Review, 9 (February 1982), p. 8.

 Ostrow, Joanne. "Red Grooms & His Ruckus." Washington Post, February 26, 1982.

 Richard, Paul. "The Unbridled Grooms." Washington Post, March 2, 1982.

Contemporary Arts Center, New Orleans, LA. "The Human Figure" (group exhibition). March. Catalogue: essay by Alexandra Monett.

Museum of Fine Arts, Boston, MA. "Recent Painting and Sculpture from the Graham Gund Collection" (group exhibition). March 1–April 4.

 Russell, John. "In Boston: From the Old World to the New." New York Times, March 14, 1982, sec. 2, p. 33.

*New Gallery of Contemporary Art, Cleveland, OH. "Red Grooms' Welcome to Cleveland." March 6–May 1. Catalogue: essays by Marjorie Talalay, Mark Gottlieb, and William Olander.

 Gottlieb, Mark. "Getting Around." Northern Ohio Live, 2 (April 1982), pp. 26, 29–31.

 Kiefer, Geraldine Wojno. "Red Grooms." Arts Magazine, 56 (May 1982), p. 8.

Olander, William. "Red Grooms." Art News, 81 (September 1982), pp. 120–121.

University of Wisconsin and Madison Art Center, WI. "New Graphics 2, Contemporary American Prints" (group exhibition). March 13–April 25.

New School for Social Research. Symposium: "Artists and Architects: Humanism Rediscovered." "A Dialogue Between Two Artists," Red Grooms and Richard Haas. March. Sponsored by Skowhegan School of Painting and Sculpture and the Committee on Design of the American Institute of Architects.

Burchfield Center, Buffalo, NY. "The Kitchen and the Gallery: The Artist and the Chef" (group exhibition). May 9–June 20. Brochure.

Aldrich Museum of Contemporary Art, Ridgefield, CT. "Homo Sapiens: The Many Images" (group exhibition). May 9–September 5. Catalogue: introduction by Martin Sosnoff.

Library of the Boston Atheneum, Boston, MA. "Sculpture: Red Grooms, Dimitri Hadzi, Reuben Nakian, Tony Rosenthal, H.C. Westermann" (group exhibition). June 3–June 30. Checklist.

*Benjamin Mangel Gallery, Philadelphia, PA. "Red Grooms." June 12–July 6.

 Keating, Douglas, and Victoria Donohoe. "A Cornucopia of Humor from Artist Red Grooms." Philadelphia Inquirer, June 11, 1982.

*Institute of Contemporary Art, University of Pennsylvania, Philadelphia, PA. "Red Grooms: A Philadelphia Cornucopia," commissioned by ICA for the Century IV citywide celebration. June 15–September 12. Catalogue: "Red Grooms, Philadelphia Cornucopia and Other Sculpto-Pictoramas," essays by Janet Kardon, Paula Marincola, Carter Ratcliff, and Carrie Rickey. Reinstalled in National Park Service Visitors Center, Philadelphia, March 1983.

 "A Wondrous Work of Art." Philadelphia Inquirer, June 22, 1982.

 Brenson, Michael. "Art People: Art Lights Up Times Square." New York Times, June 25, 1982, p. C26.

 Brewster, Todd. "Slaphappy Birthday, Philadelphia!" Life, August, pp. 45–48.

 Conheim, Maryanne. "'Cornucopia' Installation Is Delayed." Philadelphia Inquirer, March 27, 1983.

 Donohoe, Victoria. "Looking for Permanent Place for Philadelphia Cornucopia." Philadelphia Inquirer, August 22, 1982.

 Donohoe, Victoria. "To the Fun, Grooms Adds Some History." Philadelphia Inquirer, June 13, 1982.

 Hieronymous, Clara. "Red Grooms Joins in Birthday Celebration." The Tennessean, August 15, 1982.

 Hine, Thomas. "Popular Walk-Through History of Phila. Returns to Public View." Philadelphia Inquirer, March 19, 1983.

 Kalin, Diane. "Red Grooms Turning Philadelphia into a Saturday Morning Cartoon." City Paper, July 1982.

 Keating, Douglas. "Art Makes History and Makes It Fun, Too." Philadelphia Inquirer, June 22, 1982.

 "No Place for Pigeons." Focus, 657 (May 27, 1982).

 Raynor, Vivien. "Art People: 'Not Afraid' in the Subway." New York Times, May 21, 1982, p. 26.

 Russell, John. "Art View." New York Times, August 8, 1982, p. H24.

 Sozanski, Edward J. "'Cornucopia'—An Appraisal by 4 Noted Subjects." Philadelphia Inquirer, March 29, 1983.

 Sozanski, Edward J. "'Cornucopia,' Witty Where It Was, Looks Like a Bad Joke Where It Is." Philadelphia Inquirer, March 13, 1983.

 Stein, Judith. "An Impish Artist Sculpts a Whimsical Philadelphia." Philadelphia Inquirer, May 28, 1982.

 Stein, Judith. "Red Grooms at the ICA." Art in America, 70 (December 1982), p. 129.

Laumeier International Sculpture Park and Gallery, Sunset Hills, MO. "Cast in Carbondale" (group exhibition). July 18–September 12. Traveled to: Alexandria Museum in Louisiana. Catalogue: introduction by Beej Nierengarten-Smith, essays by Thomas Walsh and R.J. Evans.

*Boulder, CO. Shoot-out, commissioned bronze sculpture publicly installed September 1982. Due to ensuing public protests, location changed in September 1983. It was purchased in October 1983 by the Denver Art Museum.

Carroll, Vincent. "At Times, Art Appreciation Requires Some Artfulness." Rocky Mountain News, November 17, 1983.

Clurman, Irene. "Eye on Art—Grooms' 'Shoot-Out' a Rib-tickling Sculpture." Rocky Mountain News, September 10, 1982.

Clurman, Irene. "Shifting Fate for Grooms' 'Shoot-out.'" Rocky Mountain News, November 22, 1982.

"For Irate Citizens, Public Sculptures Belong Anywhere but on a Pedestal." People, 20 (November 14, 1983).

Hoving, Thomas. "How to Commission a Monument." Connoisseur, 213 (January 1983).

Martin, Claire. "The Comic Cosmos of Red Grooms." The Denver Post, November 6, 1983.

Morson, Berny. "Artists Crash Protest." Rocky Mountain News, September 29, 1983.

"News, Public Sculpture Down but Not Out." Artline, 4 (February 1983).

"Not Funny." Rocky Mountain News, September 30, 1983.

Price, Max. "Controversial Sculpture to Move." Denver Post, September 29, 1983.

"Task for Arts Commission." Denver Post, September 30, 1983.

"The Vasari Diary—O, Give Me a Home. . . ." Art News, 82 (December 1983), p. 11.

Grapestake Gallery, San Francisco, CA. "Motor Trends: The Artist and the Automobile" (group exhibition). October.

Cebulski, Frank. "Auto Art." Artweek, 13 (October 16; 1982).

Museum of Art, Carnegie Institute, Pittsburgh, PA. "1982 Carnegie International" (group exhibition). October 23, 1982–January 2, 1983. Traveled to: Seattle Art Museum, WA, and to Australia. Catalogue: foreword by John R. Lane, essay by Gene Baro.

Sculpture Center, Artists' Choice Museum, New York, NY. "Narrative Sculpture" (group exhibition). November 2–November 30. Catalogue: essay by Richard Rosenblum.

Allan Frumkin Gallery, New York, NY. "Self-Portraits: From the Mirror, Part I" (group exhibition). December. Catalogue published in 1983 to accompany Part II.

Russell, John. "Contemporary Self-Portraits." New York Times, December 10, 1982, p. C29.

1983

Art Teachers of New York, 3rd Annual Arts Education Convention, New York, NY. "Artist of the Year" award.

Bartholomew, Caroline. "Artist Red Grooms Just Loves to Help Create a Ruckus." Nashville Banner, May 6, 1983.

Glueck, Grace. "Revival of the Portrait." New York Times Magazine, November 6, 1983, pp. 56–57, 74.

Goleas, Janet. "Red Grooms." Contemporary Arts, second edition. New York: St. Martin's Press, pp. 366, 367.

Lower Manhattan Cultural Council, New York, NY. "The Brickie Award," for "Ruckus Manhattan" at Burlington House.

Myers, John Bernard. Tracking the Marvelous. New York: Random House, cover drawing, pp. 202–206, 210.

Ratcliff, Carter. "The Short Life of the Sincere Stroke." Art in America, 71 (January 1983), p. 74.

Wintour, Anna. "Painting the Town." New York, August 29, 1983, illus. p. 59.

Pratt Graphics Center, New York, NY. "From the Beginning: A Graphics Exhibit of 24 Major American Artists" (group exhibition).

Allan Frumkin Gallery, New York, NY. "Self-Portraits: The Antic Vision, Part II" (group exhibition). January 4–January 27. Catalogue: statement by Allan Frumkin.

Schulman, Daniel. "Self-Portraits, Part II: The Antic Vision." Arts Magazine, 57 (March 1983), p. 31.

Reading Public Museum and Art Gallery, Reading, PA, and Artists' Choice Museum, New York, NY. "Painted Light" (group exhibition). January 16–March 20. Traveled to: Queens Museum, NY; Colby College Art Museum, ME; Butler Institute of American Art, OH. Catalogue: introduction by Joe Giordano and Jeff Anderson Gore, essay by Judd Tully.

*Anderson Ranch, Snowmass, CO. "Maquettes, Monotypes, and Graphics." March.

Aspen, CO. Commission to record Winternationals World Cup Ski Races. March.

Allan Frumkin Gallery, New York, NY. "The Early Sixties: Red Grooms and Peter Saul" (two-artist exhibition). March 1–March 31. Catalogue.

Levin, Kim. "Allan Frumkin: Peter Saul/Red Grooms." Village Voice, March 15, 1983.

Raynor, Vivien. "Art: Saul and Grooms." New York Times, March 18, 1983, p. C24.

Wolff, Theodore F. "Early Works of Famous Artists Can Surprise You." Christian Science Monitor, March 15, 1983.

Monique Knowlton Gallery, New York, NY. "The Painterly Figure: Veteran Expressionist Figure Painters" (group exhibition). March 2–March 26. Comments by Carter Ratcliff.

H[enry], G[errit]. "The Painterly Figure." Art News, 82 (May 1983), p. 164.

Center Gallery, Bucknell University, Lewisburg, PA. "Faces Since the 50's: A Generation of American Portraiture" (group exhibition). March 11–April 17. Catalogue: essay by Joseph Jacobs.

Brooklyn Museum, Brooklyn, NY. "The Great East River Bridge, 1883–1983" (group exhibition). March 19–June 19. Catalogue.

Filler, Martin. "The Brooklyn Bridge at 100." Art in America, 71 (Summer 1983), p. 148.

Goldberger, Paul. "Brooklyn Salutes Its Great Bridge at 100 with Paintings, Photos and Words." New York Times, March 18, 1983, p. C11.

Unicorn Gallery, Aspen, CO. "Graphics from the 80's" (group exhibition). May.

Rettig, Dave. "Red Ruckus Grooms: Kind of Controlled Chaos." Interview. Artlines, 4 (May 1983), pp. 6–8.

*Tampa Museum, Tampa, FL. "Public Works—Private Patrons: Images of Modern Times by Red Grooms." May 22–August 21. Traveled to: Hunter Museum of Art, Chattanooga, TN. Catalogue: essay by Bradley J. Nickels.

Benbow, Charles. "Grooms Art a Playful 'Ruckus.'" St. Petersburg Times, May 30, 1983.

Crane, Jeanette. "Tampa Museum Is Offering Five Special Attractions." St. Petersburg Independent, June 2, 1983.

Milani, Joanne. "Hot Art: Big City Heat." Tampa Bay Monthly, August 1983.

Felt Forum, New York, NY. Set designs and illustrations for 5th Annual Jacques d'Amboise National Dance Institute. May 23.

Anderson, Jack. "Red Grooms Designs 'Musketeers' for d'Amboise." New York Times, May 15, 1983.

"Dance Festival." New York Times, May 15, 1983, p. 49.

Artists' Choice Museum, New York, NY. "Bodies & Souls" (group exhibition). September. Catalogue: introduction by John Yau, curator's note by Jim Wilson.

Marlborough Gallery, New York, NY. "Works on Paper" (group exhibition). November 5–November 29. Catalogue.

Tampa Museum, Tampa, FL. "Time Out: Sport and Leisure in America Today" (group exhibition). November 20, 1983–March 11, 1984. Catalogue: essay by Molly E. Jensen, introduction by Genevieve Linnehan.

1984

Cummings, Paul. *Twentieth Century American Drawings: The Figure in Context.* Washington, DC: International Foundation, pp. 64 and 65.

Glueck, Grace. "'Family' Revived Art on Cape Cod." *New York Times,* August 1, 1984, p. C17.

Grooms, Red. "One Artist's Paris." *New York Times Magazine: The Sophisticated Traveler, Summer and Water,* March 18, 1984, p. 90.

Russell, John. "City Art: Lessons for a Critic." *New York Times Magazine,* November 4, 1984, pp. 105 and 146.

Schaire, Jeffrey. "Taking Liberties." *Arts and Antiques,* June 1984.

Tully, Judd. "Red Grooms—Recent Works." *Re-Dact, An Anthology of Art Criticism,* edited by Peter Frank. New York: Willis, Locker & Owens, pp. 195–196.

Whitney Museum of American Art, Downtown Branch, New York. "Metamanhattan" (group exhibition). January 12–March 15. Brochure.

Aldrich Museum of Contemporary Art, Ridgefield, CT. "Intermedia: Between Painting and Sculpture" (group exhibition). January 14–May 6. Brochure: essay by Martin Sosnoff.

Minneapolis Institute of Arts, Minneapolis, MN. "The Vermillion Touch: Master Prints from a Minneapolis Studio's Archives" (group exhibition). January 21–March 18. Catalogue exists in the form of a videotape which includes an interview with Red.

 Doss, Erika. "Uncommon Prints." *Arts, Minneapolis Society of Fine Arts,* 7 (January 1984), pp. 13–16.

 Howell, Camille. "Troubled Times for a Premier Printmaker." *Picture magazine, Minneapolis Tribune,* April 1, 1984, p. 18.

University Art Museum, California State University, Long Beach, CA. "Figurative Sculpture: Ten Artists/Two Decades" (group exhibition). March 12–April 29. Catalogue: essay by Jane K. Bledsoe.

Hillwood Art Gallery, Long Island University, C.W. Post Campus, NY. "Artist in the Theater" (group exhibition). March 16–April 12. Traveled to: Guild Hall Museum in East Hampton, NY. Catalogue: essays by Helen A. Harrison and Judy K. Van Wagner.

Palm Springs Desert Museum, Palm Springs, CA. "Return of the Narrative" (group exhibition). March 17–June 3. Catalogue: essay by Katherine Hough and Roberta Cove.

**Marlborough Gallery, New York, NY. "Red Grooms: Recent Work." April 6–May 1. Catalogue.*

 Glueck, Grace. "Red Grooms on the Road." *New York Times,* April 13, 1984, pp. C1 and C26.

Guild Hall Museum, East Hampton, NY. "Art and Friendship: A Tribute to Fairfield Porter" (group exhibition). April 14–June 3. Traveled to: Artists' Choice Museum, NY; New Britain Museum of American Art, CT. Catalogue: essays by Helen Harrison and Prescott D. Schutz.

National Dance Institute, NY. Set design commission for Creation of the World, by Jacques d'Amboise. June.

Whitney Museum of American Art, New York, NY. "Blam! The Explosion of Pop, Minimalism, and Performance, 1958–1964" (group exhibition). September 20–December 2. Catalogue: essays by Barbara Haskell and John G. Hanhardt.

 Danto, Arthur. "Art." *The Nation,* October 20, 1984, pp. 390–393.

 Glueck, Grace. "Art: Exploring 6 Years of Pop and Minimalism." *New York Times,* September 28, 1984, p. C27.

 Russell, John. "When Art Came Out of the Studio and Mingled." *New York Times,* October 28, 1984, p. H33.

 Smith, Roberta. "Splat!" *Village Voice,* October 16, 1984.

Whitney Museum of American Art at Philip Morris, New York, NY. "On 42nd Street" (group exhibition). September 26–December 5. Brochure: essay by Susan Lubowsky.

 Glueck, Grace. "On 42nd Street: Artists' Vision." *New York Times,* October 26, 1984, p. C15.

John Berggruen Gallery, San Francisco, CA. "Monotypes from the Garner Tullis Workshop" (group exhibition). October 17–November 17.

Newark Museum, Newark, NJ. "American Bronze Sculpture: 1850 to the Present" (group exhibition). October 18, 1984–February 3, 1985. Catalogue: foreword by Samuel Miller, introduction by Gary Reynolds.

 Glueck, Grace. "Bronze in the Hands of American Sculptors." *New York Times,* December 23, 1984, p. H29.

Acknowledgments

The realization of this project has been facilitated, at every stage, by the wisdom, expertise, and dedication of numerous individuals. With deep appreciation I acknowledge the assistance of those listed below:

—for graciously granting time for interviews, Red Grooms, Mimi Gross, Mr. and Mrs. R.D. Grooms, Louise LeQuire, Terry Martin, Val Falcone, Yvonne Andersen;

—for countless kindnesses and speedy responses to requests for information, Laura Broom, Karen Chambers, secretaries to Red Grooms, Lois de la Haba, Luna Carne-Ross of Lois de la Haba Associates, Gene Waters, Creative Lithography, Inc., Doug Walla, Pierre Levai, Marlborough Gallery, Carolyn Alexander, Brooke Alexander, Inc., George Adams, Allan Frumkin Gallery, Meg Perlman, Curator to Carter Burden;

—for installation, transportation and conservation assistance, Atkin, Voith and Associates, architects, William F. Zamprelli, Vice President, Eagle Fine Arts, Tamsen Fuller, sculpture conservator, Laurie Friedman, David Saunders, Andy Yoder, Peter Kunz, Daniel Berlin, studio assistants to Red Grooms;

I owe particular thanks to all my colleagues at the Academy, especially Frank H. Goodyear, Jr., President, Linda Bantel, Director, Elizabeth Romanella, Assistant to the Director for Program, Kirby Smith, Public Information Officer, Elaine Breslow, Director of Development, Gale Rawson, Associate Registrar, Robert Arthur Harman, Manager of Rights and Reproductions, Marietta Bushnell, Librarian, Joseph Amoratico, Painting Conservator, Randy Cleaver, Chief Preparator and his staff, Fred Kelley, Museum Shop Manager.

My assistants Trudy Wilner and Jennifer Way, and secretaries Bea Steinberg and Rose Mari Fitzpatrick, the editing acumen of Evelyn Schapiro, Maura Walsh, and Sarah McFadden, and the quiet writing retreat provided by Helen and Leonard Evelev, were essential to the completion and formation of this catalogue.

To Dianne Perry Vanderlip and Deborah C. Jordy of the Denver Art Museum, Julia Brown and Richard Koshalek, Museum of Contemporary Art, Los Angeles and Lois Riggins, Tennessee State Museum, who share the Academy's enthusiasm for the art of Red Grooms, to Peter McKenzie, for designing and producing this catalogue, and to Jonathan and Rachel Stein, my husband and daughter, for their stalwart support, I hereby express my special appreciation.

Credits

Designed by Peter K. McKenzie

Contributing photographers to this book include:

Art Institute of Chicago, Berger and Associates, Bolotsky, Lee Brian, Brooke Alexander, Inc., R. Bruhn, Jacob Burckhardt, Cheekwood Fine Arts Center, Creative Image Corporation, Ramashwar Das, David Anderson Gallery, The Denver Art Museum, Larry Dixon, Rick Echelmeyer, Everson Museum of Art, Frederick R. Weisman Foundation of Art, Mimi Gross, Mary Grover, Barry Hayes, Hirshhorn Museum and Sculpture Garden, Bruce Kiefer, Robert A. Klass, Jerry Kobylecky, Marjorie Lenk, James D. Mahoney, Marlborough Gallery, Inc., Robert E. Mates, Robert Mickus, Eric Mitchell, Gene Mopsik, The National Swedish Art Museums, New Jersey State Museum, Kevin Noble, Eric Pollitzer, Princeton Photographics, Inc., Earl Ripling, Curt Royston, Albert J. Schlocker, Marc Schuman, Jack N. Schwab, Steven Sloman, Southern Illinois University, Jill Sternberg, Tennessee State Art Museum, Michael Tropea.

Typeset in Weiss by Alltype Typographers, Ltd., New York City

Printing, binding and color separations by Industrie Grafiche Editoriali Fratelli Pagano S.p.A., Genoa, Italy

Production management and coordination by Peter K. McKenzie